THE ART OF THE VIDEO GAME

BY JOSH JENISCH

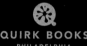

QUIRK BOOKS
PHILADELPHIA

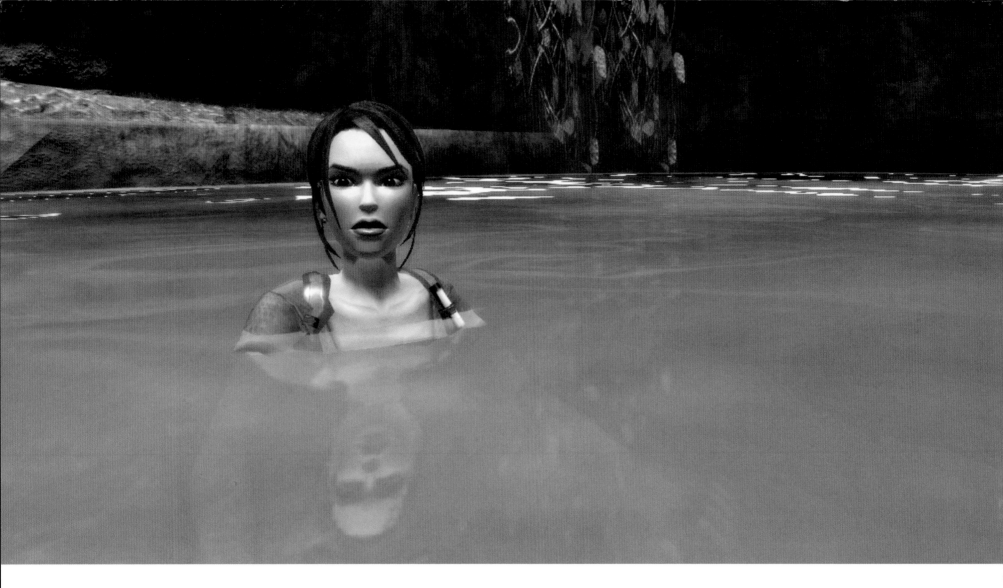

Library of Congress Cataloging in Publication Number:
2008929857

ISBN: 978-1-59474-277-4

Printed in Singapore
Typeset in TradeGothic

Designed by Doogie Horner

Distributed in North America by Chronicle Books
680 Second Street
San Francisco, CA 94107

10 9 8 7 6 5 4 3 2 1

Quirk Books
215 Church Street
Philadelphia, PA 19106
www.quirkbooks.com

CONTENTS

Preface

I've put off writing this preface for a long time. You see, I'm here to make the argument that video games should be considered art. I believe that great video games can move and excite and inspire people—that they are every bit as worthy of our attention as great films, great paintings, great novels, and great symphonies.

RIGHT: *Charr Efigy*, by Daniel Dociu, from ArenaNet's *Guild Wars*.

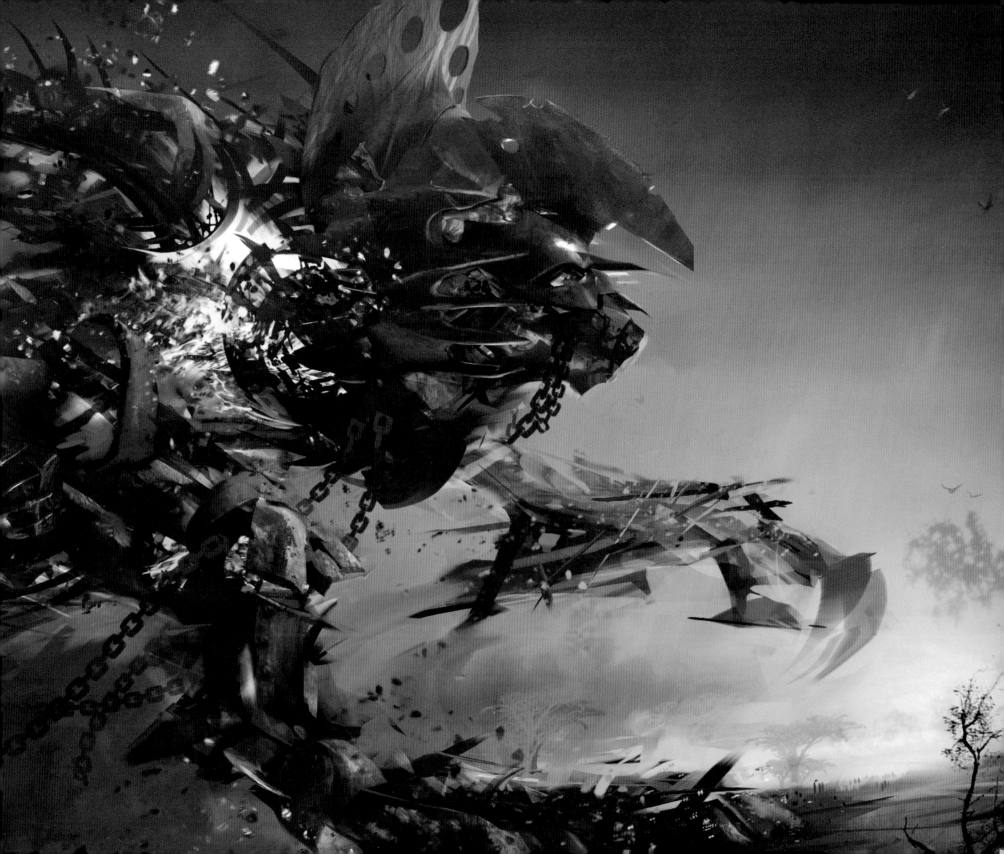

I know there are plenty of people who disagree. But when I glance through the hundreds of images submitted to me by video game studios and publishers, I know I am looking at some of the most compelling, gorgeously rendered artwork of the new century. The images display an enormous range of styles, from surrealist to impressionist to neoclassicist to futurist. Each has a voice as certain and powerful as a kick to the skull. Even though these images are mostly low-resolution printouts from my Canon inkjet, I find myself profoundly moved.

Many people are understandably reluctant to bestow "arthood" on video games. Some are even unnecessarily vociferous on the subject, arguing fervidly about the idea of art versus entertainment. The debate recalls the passionate diatribes of early twentieth-century critics who famously derided film as a fanciful visual exercise with little substance. In 1927 social critic H. L. Mencken wrote (with considerable vitriol) about his feelings about movies and the people who made them:

How can one work up any rational interest in a fable that changes its locale and its characters 10 times a minute? Worse, this dizzy jumping about is plainly unnecessary; all it shows is the professional incompetence of the gilded pants-pressers, decayed actors, and other such half-wits to whom the making of movies seems to be entrusted.

It was a persistent and passionate objection: To many, movies simply lacked the ability to convey true human drama. They would never possess the intimacy or pure gravitas of live theater. They would never be *real* art. Then came such seminal titles as *Citizen Kane* and *Gone with the Wind*, followed by the staggering achievements of the French New Wave cinema. Suddenly, even the most vocal critics had shut their yaps.

Allow me to assert that gaming's numerous critics will eventually follow suit. In the meantime, remember: Art isn't art because people say it is. Art is art because *you* say it is. There doesn't need to be collective consensus on what defines art for you to study, enjoy, and respond to the pieces collected herein. *The Art of the Video Game* celebrates what may well become the dominant art form of the twenty-first century.

A Brief History of Video Game Art

To better understand and appreciate the quality of contemporary video game art (and the huge advances during the last few decades), it is important to look back to the industry's origins.

IN THE BEGINNING

Until the late 1950s, computers were so large that no one even conceived of using them for entertainment. (Some mainframes covered an area equal to a city block!) Yet unwieldy vacuum tubes eventually gave way to transistors, and computers became more manageable. By 1958 primitive computers could be found in many large universities, research facilities, and business enterprises. That same year, while at Brookhaven National Laboratory in New York, American physicist William Higinbotham created the first original computer game.

Higinbotham was given the task of entertaining guests on the company's annual Visitors Day to prevent them not only from becoming bored but also from touching expensive lab equipment. He whipped up a little program called *Tennis for Two* that visitors could play on an oscilloscope. (Imagine a submarine radar screen from a 1950s B-movie, and you'll have a pretty good sense of what the game looked like.) Players controlled the angle of a simplistically rendered tennis racket, serving a small ball to an opponent who then determined the angle of the return shot. Controlling the "ball" with a knob and paddle, players could adjust its trajectory and, with a little luck, spark a decent volley. By today's standards, *Tennis for Two* was as exciting to watch as a Senate Judiciary Committee hearing. Still, Higinbotham earns a place of honor in this book because, without *Tennis for Two*, *Grand Theft Auto IV* might never have been created.

Another early gaming pioneer was Steve Russell. As a student at MIT in 1961, Russell (and a group of science-fiction-obsessed friends) invented *Spacewar!*, a game that pushed the university's new mainframe to its limit. Taking full advantage of the machine's built-in monitor, the game involved two ships firing missiles at each other until one was destroyed. From an artistic standpoint, *Spacewar!* was hardly better than *Tennis for Two*. However, the mainframe manufacturer liked it so much, it decided to bundle *Spacewar!* with each new computer it sold. Throughout the country, students with too much time on their hands soon experienced the game for themselves. Sufficiently inspired, they embarked on a campaign of classic American one-upsmanship. Although it would be years before these pioneers cut their hair and traded tie-dye for ties, the great gaming race had begun.

The leader of this new age of digital discovery was Nolan Bushnell, widely considered the father of modern gaming. Having experienced the glory of *Spacewar!*, Bushnell dreamed of arcades filled with computers instead of pinball machines, skill cranes, and Skee-Ball games, and he created a hardwired device that could play a *Spacewar!* clone on an ordinary television set. Dubbed *Computer Space*, the unit was sold by Bushnell to Nutting Associates,

which released the futuristic device in 1971 to an apathetic public (who found it too difficult to play).

The next year, Bushnell established Atari. He quickly hired Al Alcorn and directed him to develop a ping-pong simulator, a device that became known simply as *Pong*. Bushnell tested the game by installing the cabinet at Andy Capp's Tavern in Sunnyvale, California. Within either one day or two weeks (depending on which story you believe), Bushnell received news from the owner that *Pong* was malfunctioning. Bushnell's initial disappointment turned to elation when he realized that the cabinet was merely stuffed with quarters, and loose coins had jammed a switch. The game was a hit, and the great arcade craze had begun.

ARCADE FEVER

Soon *Pong* machines (and, much to Atari's chagrin, an unfathomably large number of clones) were popping up in restaurants, convenience stores, shopping malls, and bars across the United States and around the world. These were followed by full-fledged video arcades, which were modeled on the popular pinball parlors of previous decades. With money pouring in, technology developed by leaps and bounds. *Pong* was eclipsed by more ambitious titles such as *Breakout*, *Space Invaders*, *Asteroids*, *Galaxian*, and the immortal

Pac-Man (originally known as *Puck-Man*, by the way, before corporate executives changed the name, fearing that graffiti artists might tamper with the game cabinet).

In their heyday, the arcade machines boasted technology superior to any of the rudimentary home-gaming consoles then appearing in stores. Consider Ralph Baer's *Magnavox Odyssey*, which could render only black and white dots and lines; the system was packaged with a series of color transparencies that viewers placed onto their television screens to improve the effects. Compared with the cinematic drama of *Missile Command* and *Berzerk* (one of the first games to use synthesized human speech), the home experience just didn't measure up.

Cabinets of the arcade machines also evolved to create a more immersive experience. In *Battlezone*, players peered through a periscope; *Fire Truck* players sat in (you guessed it) a fire truck. Dedicated laser guns, racing simulators shaped like real cars, and force-feedback cabinets that vibrated on cue all resulted from this era of rapid expansion.

Often, in discussions of video game history, an overlooked subject is the influence of the business model of arcades on the content and aesthetics of video games. Arcade machines were designed to collect quarters, plain and simple. For twenty-five

cents, they delivered an immediate, action-packed experience that usually lasted about a minute or two. There was little time for narrative, characters, story, or any of the elements that enrich today's games. But during three decades of home console development (for which programmers did not have to focus on collecting quarters, of course), all that changed.

THE SECOND GENERATION

It's tempting to skip ahead to the ColecoVision (one of the first home consoles offering graphics as good as arcade machines), but no discussion of home consoles would be complete without mentioning the Atari VCS (later renamed the Atari 2600). This system was by far the most successful of its time. Released in 1976, the removable cartridge system could render 128 colors at extremely low resolution. Armed with a mere 128 bytes, programmers delivered such original classics as *Pitfall!* and *Yars' Revenge* as well as adaptations of such arcade favorites as *Space Invaders* and *Pac-Man*. This last was the best-selling VCS game of all time, with some 7 million units sold. The classic VCS game *Adventure* is sometimes credited with sparking the action/adventure genre we know and love today; in the game, players were challenged to move a small square (yes, a square) through a multi-screen environment of mazes, keys,

swords, and dragons. Despite being simple to the point of absurdity by contemporary standards, *Adventure* was the *Elder Scrolls* of its day; more than one million gamers participated in the phenomenon.

In 1978 Magnavox and Ralph Baer took another shot at the console market with the Odyssey 2, a removable cartridge system with a 16-color palette. Running at a speed of just under 1.8 MHz, the system boasted 192 bytes of RAM—not a heck of a lot, but enough to handle adaptations of such popular arcade games as *Frogger*, *Q-Bert*, and *Popeye*. I suspect it was the success of *Adventure* that inspired Magnavox to release *Quest for the Rings!*, a game that stole gleefully from J. R. R. Tolkien while foreshadowing many of today's most successful fantasy titles.

The year 1982 brought two systems that upped the ante regarding good graphics. The Atari 5200 was the first console that featured dual processors (twin 1.8 MHz beauties) and the ability to present 256 colors (16 per line). For about $330, players could enjoy 4-channel sound and 16 kilobytes of RAM. Most of the system's games were adaptations of popular arcade titles, such as *Galaxian* and *Pac-Man*, and featured graphics far superior to the old Atari VCS adaptations. Yet the system performed poorly, perhaps because most players already had those old

VCS adaptations, and these cartridges could not be played on the new 5200 system.

More successful was the release of the beloved ColecoVision, which offered a large game library and promised graphics equal to those of arcade machines. With a speed of 3.58 MHz and 48 kilobytes of RAM, ColecoVision easily delivered the goods. Nearly every machine came bundled with a *Donkey Kong* cartridge that was virtually indistinguishable from its arcade counterpart. Other games soon followed, including *Zaxxon*, *Lady Bug*, and *Smurf: Rescue from Gargamel's Castle*.

But trouble lurked on the horizon. Video game developers began gambling large sums on licensing fees, hoping that games based on popular movies and sports franchises would yield high sales. Perhaps the most famous example of industry excess was the 1982 Atari VCS game *E.T.: The Extra-Terrestrial*. Atari paid more than $20 million for the licensing rights to Steven Spielberg's box-office smash. Executives needed a holiday launch to guarantee a hit, but negotiations with Spielberg's team took longer than expected. By the time the paperwork was signed, Atari programmer Howard Scott Warshaw had only six weeks to create the product: The result was one of the most atrocious games ever produced. It consisted of a crudely rendered E.T. wandering through a series of

THE ROLE OF THE ARTIST

At this point in gaming history, artists played no direct role in the creation of video games. Development teams consisted of a group of programmers (or sometimes just one) buried neck-deep in computer code. The main focus was on game-play dynamic, not the visual environment; artists wouldn't find a place on development teams for more than a decade. However, some of the greatest fantasy artists of the day were hired by gaming companies to create ancillary art (posters, box designs, instruction manuals, game cabinets, and the like). In the absence of truly engaging in-game art, manufacturers tried to capture gamers' imaginations via auxiliary aesthetics.

murky environments and falling in holes (!?) to collect the scattered pieces of a device that would allow him to "phone home." The game was massively overproduced, and more than three million cartridges remained unsold. According to rumor, these were later buried in a landfill in New Mexico.

Atari wasn't the only company struggling. There were simply too many consoles and games for consumers to choose from. In addition to those already described, other systems included Mattel's Intellivision, Bally's Astrocade, the Fairchild Channel F System II, the Emerson Arcadia 2001, the Sears

Tele-Games system, Vectrex, Tandyvision, and more. The marketplace was saturated, several prominent companies went belly-up, and critics began predicting the industry's unceremonious ruin. The famous video game crash of 1983 had begun.

Yet hope lingered, tantalizingly. Hope, I name ye, Nintendo.

THE THIRD GENERATION

Having weathered the crash, Nintendo released its phenomenally popular Nintendo Entertainment System (NES) to widespread acclaim in 1985. Running at 3.5 MHz with the ability to display just 16 colors per scanline, the system nevertheless boasted a library of countless memorable titles, notably *Super Mario Bros.*, which forever changed the face of home gaming. In addition to an appealing cast of characters, a stellar theme song, and a highly satisfying control scheme, *Super Mario Bros.* was among the first home console games to utilize the side-scrolling format, in which characters traverse the landscape from left to right, confronting enemies and completing various tasks. The game eventually sold more than 40 million copies, and for years side-scrolling dominated home gaming. The rest of the NES slate was equally innovative, featuring games like *Excitebike* (in which gamers designed and then raced on their own motocross tracks) and *Duck Hunt* (which had gamers shooting ducks out of the sky with a special light gun controller). According to Nintendo, the NES sold more than 60 million units during its lifetime.

Sega fired back with its Sega Master System (SMS), which was also released in 1985. Running at 3.6 MHz and with 16 KB of video RAM, the SMS enjoyed a Yamaha sound chip, which allowed for more sophisticated and dramatic-sounding beeps and boops. Among its most popular games was *Astro Warrior*, a top-down shooter in which players navigated open space while collecting power-ups and dispatching enemies. *Safari Hunt*, a *Duck Hunt*–style game, was also available and allowed gamers to slaughter all manner of furry woodland creatures. The SMS never really caught on in the United States (by 1986 Nintendo claimed nearly 90 percent of the console marketplace), but it enjoyed tremendous success in Europe and some of the smaller international markets.

The mid-1980s also spelled the beginning of the end for the arcade industry. Any dark place where teenagers gather is certain to be reviled by adults, so it's no surprise that gaming parlors carried a reputation as harboring illegal activity. But the real cause of their demise was the evolution of home consoles. By the late 1980s, these systems had developed so highly that their games rivaled (and often exceeded) those offered at the arcades. Why waste quarters when you can play better games at home? Manufacturers tried to stay relevant, releasing a handful of classic titles including *Double Dragon*, *Outrun*, *Running Thunder*, and *Mortal Kombat*, but it was too late. The audience for these games had already moved on to Gameboys, personal computers, and the next generation of home consoles.

THE FOURTH GENERATION

Sega made quite a stir in 1989 with the unveiling of

the Genesis, a 16-bit console with gorgeous graphics. Running with two processors (7.61 MHz and 3.6 MHz) and the ability to generate 512 colors, the unit managed to effect a dent in Nintendo's marketplace dominance (although certainly not as much of a dent as Sega wanted). Many excellent games were designed for the system, notably *Sonic the Hedgehog*, one of the most popular of all time. The hardware of the Genesis allowed Sonic to move with unprecedented speed; the game features large passages in which the background is literally a blur. *Pac-Man* seemed lethargic by comparison.

The next major advancement in home gaming arrived with the Neo-Geo console, from Japanese company SNK. With two processors (running at a swift 12 and 4 MHz, respectively), the Neo-Geo offered gamers impressive visuals and relatively realistic sprites. One game included with the system was the wonderfully involving *Magician Lord*, which featured a wizard named Elta who could change his form at will. However, priced at $600, the home unit was for extremely dedicated gamers and sold poorly in the United States. Most players experienced the system only in hotels, where the machines were often available for rental.

In 1991 Nintendo finally introduced its own 16-bit system: the Super Nintendo, or Super NES.

Although slow compared to its contemporaries (the processor ran at a mere 3.6 MHz), the Super NES compensated with terrific graphics and a tremendous game library. It was an instant sensation and kept players captivated long after the release of the next generation of consoles. Part of Nintendo's success stemmed from their idea to include small coprocessors in the cartridges of new games as the console aged. These processors helped the unit remain competitive in a crowded marketplace even as the Super Nintendo's hardware became obsolete. The signature game for the Super NES was probably *Super Mario World*, a sophisticated side-scroller with gorgeous environments and true stereo sound. The game featured the same kind of whimsical, colorful, family-friendly aesthetics that had become Nintendo's defining visual style.

In the end, however, some of the best games of the early 1990s were probably played on personal computers. This trend was not new in gaming; for most of the 1980s, owners of home computers, like the Atari 800 and the Commodore 64, had been exposed to thousands of innovative games. Yet the earlier machines were too expensive to be dedicated solely to games, and computer companies were understandably reluctant to market their sophisticated products as "toys."

THE ROLE OF THE ARTIST

At this time in video game history, programmers were still the major workhorses of production, and most had little interest or training in art history, aesthetics, or design. But as the graphics capabilities of the machines increased, programmers were increasingly asked to showcase such features, and those with natural visual instincts found themselves on the fast track to success. One example is Shigeru Miyamoto, who became Nintendo's golden boy. As the creator of such properties as *Donkey Kong*, *Super Mario Bros.*, and *Legend of Zelda*, Miyamoto was single-handedly responsible for bringing in billions of dollars of revenue (not to mention the colorful and whimsical look that influenced many of the company's other titles). Miyamoto's knack for combining interesting visuals with superior game architecture is renowned to this day.

By the early 1990s, however, computers had become more affordable and more powerful; when equipped with sound cards and sophisticated graphic cards, they even outpaced their console rivals. Two games of this era, *Myst* and *Wolfenstein 3D*, captured the attention of the gaming public. *Wolfenstein*, an update of a popular two-dimensional '80s title, was a World War II–based three-dimensional combat game that is credited with single-handedly popularizing the first-person shooter genre (laying

THE ROLE OF THE ARTIST

At this point, many game companies began hiring concept artists to solidify a title's overall appearance. These artists worked in the early stages of game development, creating sketches and illustrations that set the tone for characters, environments, gameplay, moods, and atmosphere. Unfortunately, technology was still unable to fully replicate any of these concept illustrations "in-game," so none of this work was ever seen by home players. But when programmers were faithful to the original concept art, gamers could feel its influence in every minute of gameplay.

the groundwork for *Doom* a few years later). At the opposite end of the spectrum was *Myst*, a first-person adventure and puzzle game, set in a brilliantly realized mystical realm with very few enemies. Despite a conspicuous lack of open combat, *Myst* would become the best-selling PC game until overtaken by *The Sims* nearly a decade later.

THE FIFTH GENERATION

Atari took another shot at market dominance in 1993 with the Jaguar console. Widely touted as the world's first 64-bit system, it boasted a nearly 26 MHz processor and could display some 16.8

million colors on the screen. Unfortunately, the system came with an unbelievably complicated 15-button controller and was hampered by some absolutely horrible launch titles (does anyone remember *Trevor McFur and the Crescent Galaxy*?). Perhaps the best game to take advantage of the system's hardware was the gorgeous and atmospheric *Alien vs. Predator*, in which gruesome space freaks traipsed around dark interiors, killing slightly more gruesome space freaks. But for most players, it was too little too late. The system was a commercial failure, and Atari made a hasty exit from the hardware business.

In 1994 Sega released its Saturn console, a quick machine (28 MHz) with two central processors, six ancillary ones, and terrific graphic capabilities. Yet many programmers found the system difficult to work with, and it was handicapped by an unremarkable game library. Sega also made the incomprehensible decision to move up the Saturn's launch date by six months to beat the Sony Playstation to market. Software developers were angered, and Sega was forced to launch with relatively few titles. It is unfortunate that a truly capable machine was given nothing to do. Despite all the problems, several notable titles were released for the Saturn, including *Virtua Fighter*, a remarkably realistic 3-D fighting game.

After much anticipation, the Playstation arrived on the scene in 1995. It was a brilliantly sophisticated console that eventually sold more than 100 million units. The system ran on a hard-to-hack variant of the CD-ROM and is widely considered to be the impetus for the demise of the gaming cartridge. Running at just under 34 MHz and with 2 MB of RAM and 1 MB of video RAM, the system rendered graphics with unparalleled photorealism. The speed of the central processor meant that 1.5 million single-color polygons could be displayed per second, allowing developers to design a host of gorgeous titles, among them *Metal Gear Solid* and *Gran Turismo*. The console-defining *Final Fantasy VII* placed gamers in a highly interactive techno-magical world and featured gorgeous cinematics and an incomparably rich storyline.

Not to be outdone, Nintendo unveiled the Nintendo 64 in 1996. The system ran at almost 94 MHz and could display nearly 17 million colors, but it was somewhat limited by its reliance on cartridges instead of CD-ROMs. In addition, an oversight during the N64's design phase left only a small amount of memory available to developers for storing textures. This meant that designers were forced to stretch a small amount of texture over large areas, resulting in blurry graphics. Nevertheless, many of

the cartoonish properties in Nintendo's library were unaffected by such limitations, and games like *Super Mario 64* and *Starfox 64* proved to be genre-defining. In the widely hailed *Legend of Zelda: The Ocarina of Time*, young Link traveled back and forth in time to defeat Ganondorf while exploring vast environments of vivid beauty.

THE SIXTH GENERATION

In 1999 Sega unveiled the Dreamcast system with promises of Internet support and online gaming capabilities. Far ahead of its time (perhaps *too* far), the Dreamcast was powered by a 200 MHz CPU with 16 MB of RAM and was capable of complex "trilinear filtering," in which multiple texture levels were seamlessly blended for a smoother appearance. The system was also capable of displaying nearly 17 million simultaneous colors and more than 7 million polygons per second. The Dreamcast's signature game was probably *Soulcalibur*, widely regarded as the best fighting game of all time. The real innovation proffered by *Soulcalibur* was the eight-way run, which allowed gamers to move their fighters in three-dimensional space, rather than the two-dimensional environments common to other fighting games. Though it was released some 15 months before the Playstation 2, the Dreamcast didn't earn enough of a market share to threaten Sony. Nintendo's and Microsoft's announcements of new consoles in 2000 drove the nails into Dreamcast's coffin and prompted Sega's unceremonious retreat from the hardware market.

Unveiled in 2000, the Playstation 2 is the best-selling console in U.S. history, with more than 120 million units sold. A fantastic early marketing campaign fostered widespread frenzy, with fans around the globe clamoring to get their hands on a PS2. Huge shortages resulted in the unit selling on online auction sites for more than $1,000, a healthy $700 profit. The PS2 was certainly powerful, though not decisively so (its 294 MHz "EmotionEngine" was sophisticated but not especially fleet-footed), but it came packed with a host of technological advancements in whose development Sony had invested millions of dollars. It could display images at a fill rate of about 650 megapixels per second and had an output resolution of up to 1280 by 1024 pixels. The PS2 also enjoyed a killer early library that included *Metal Gear Solid: Sons of Liberty*, a title celebrated for its innovative gameplay, complex characters, and deep (if occasionally meandering) storyline.

In 2001 Nintendo introduced its own addition to the so-called sixth-generation consoles, issuing the GameCube, the first of its units to utilize an optical disc drive. The GameCube ran at an impressive

THE ROLE OF THE ARTIST

By the late 1990s, technology had nearly caught up with creative ambition, and nearly anything an artist imagined could be incorporated into a video game. Artists had become crucial members of game design teams and often followed their creations from early concepts to final in-game rendering. Overseeing all aesthetic aspects was an art director, who (along with a stable of artists) was responsible for establishing the game's overall artistic vision and then shepherding that vision through all stages of development. These members usually made up about 40 percent of a development team, with the remainder consisting of those whose job was, by and large, to execute their vision in code. This new organizational hierarchy helped usher in an era of great creative achievement.

485 MHz and offered 24 MB of RAM, with the ability to fill in 648 megapixels per second. *Metroid Prime* (which, along with *Legend of Zelda: Wind Walker*, was the unit's signature title) pushed the system to its limits with brilliantly rendered science-fiction settings and frenetic first-person action. But the gaming demographic continued to skew upward—average gamers at this time were in their late teens and twenties—and Nintendo's emphasis on family-friendly gaming failed to capture this critical older audience.

THE ROLE OF THE ARTIST

Today, quite simply, the artist is king. On larger games, it is not uncommon to see artists outnumber programmers by a ratio of three to one. As before, concept artists get their projects rolling—but now, instead of giving their work to programmers, they turn instead to 3-D modelers, who render their creations in virtual space and ensure that a character's movement will be realistic and practical. Next come the texture artists, who add layers of color, shading, and surface texture over the models for a realistic final appearance. Working in concert, these teams can craft masterful symphonies of design in which all elements—characters, backgrounds, items and weapons—function and blend seamlessly together. We are living in an era of great technical and artistic accomplishment, and the resultant games are easily among the best ever produced.

The Xbox arrived on the scene in late 2001 as the first dedicated gaming console from computer giant Microsoft. It was an impressive machine, with 64 MB of RAM and a central processor running at 733 MHz. In addition to its formidable speed, the Xbox was also the first console to include a hard disc drive, which allowed players to save game progress. Gone were the days of misplacing those flimsy memory cards each time you filled one up. (I still can't find my early *Resident Evil* saves.) The console,

which included a convenient, if bulky, DVD-ROM drive, was released at a $299 price tag and became enormously popular, though it would fail to overtake the Playstation 2 as the dominant sixth-generation console. *Halo*, perhaps the most influential game of all time, was available as a launch title and helped secure the Xbox's early success. An engaging story, killer weapons, and a fun vehicle interface made *Halo* one of the best-selling games in history.

AND THEN THERE WERE THREE: THE MODERN ERA

Spurred by the success of the original Xbox console, Microsoft immediately began development of a follow-up unit, and in 2005 they were ready to release it. So confident were Microsoft executives that they released the Xbox 360 simultaneously in all three of the world's largest economic regions. Sound like another Atari-like set-up for massive failure? Nope. It turns out that Microsoft's confidence was well founded. The system's numbers are suitably astounding. It's powered by three (count 'em, three) central processors, each running at 3.2 GHz, along with a dedicated video processor running swiftly at 500 MHz. Additionally, the console has 512 MB of memory and offers audio in 5.1 surround sound. Part of the Xbox 360's early popularity was due to a pair

of highly touted (and aggressively marketed) launch titles: *Elder Scrolls: Oblivion*, and *Gears of War*. The former is a semi-open-ended fantasy title offering absolutely breathtaking scenery and truly deep gameplay; the latter is an innovative third-person shooter populated by a gruesome cast of enemies and featuring, most important, a gun with a *chainsaw* on the end. These universally well-reviewed titles were so highly sought after that many consumers purchased a 360 console simply for the opportunity to play them. Since its launch, the Xbox 360 has sold more than 18 million units, finally enabling Microsoft to overtake Sony in the console wars.

Soon after the launch of Xbox 360, Nintendo unveiled the Wii, which sacrificed state-of-the-art performance in exchange for a relatively modest price tag ($250). Its central processor runs at a respectable 730 MHz and boasts an independent graphics processor, but the system isn't capable of outputting in high definition. Of course, none of that really mattered, because everyone was raving about the game's revolutionary motion-sensing game controllers. Instead of twitching joysticks and pushing buttons, you simply strap the controller to your wrist and emulate the action you'd like to see on screen: If you want to swing a tennis racket, raise your arm over your head and swing away. Finally here were

video games that even your grandmother could enjoy.

In 2006 Sony finally arrived on the scene with its much-ballyhooed Playstation 3, an extraordinarily expensive unit with some extraordinary capabilities. Running with a 3.2 GHz Cell Broadband Engine processor and 256 MB of RAM, the PS3 also has a dedicated graphics processor (running at 700 MHz) and the ability to play 7.1-channel audio in Dolby TruHD. The unit is also the first of the seventh-generation consoles to come equipped with the ability to play a next-generation video format (Blu-Ray), meaning that both games and movies are output in 1080p high definition. The two biggest strikes against the PS3 are its price—a whopping $599 for the well-equipped 60-gig version—and a lack of launch games taking full advantage of the machine's considerable processing ability. Since its release, numerous memorable (and lauded) PS3 titles have been made available, including *Call of Duty 4: Modern Warfare* and *Resistance: Fall of Man*. The former brings the venerable franchise into the current military era with a terrifyingly authentic take on modern combat, and the latter's realistic modern warfare pits the player against a considerably more alien foe. In fact, *Resistance* is so realistic that the Church of England is suing developers for the game's detailed depiction of Manchester Cathedral. (Note to programmers: If you're going to have gamers shoot up a church, even in the defense of humankind, you might want to, you know, use a *fake* one.) Though the console is selling strongly, its price is still seen as the biggest impediment to wider success. The Playstation 3 currently trails both the Wii and the Xbox 360 in terms of total units sold.

BEHOLD: THE FUTURE!

It's tough to say what the future will hold for an industry as successful—yet as risky—as video gaming. Sony reportedly spent billions developing the technology in the Playstation 3 and initially sold them at a *loss* of nearly $250 each. How can a company continue to pioneer gaming technology while enduring such staggering operational losses? (They lost nearly $2 billion on the gaming unit in 2007.) All things considered, it should be impossible to develop the "next big thing" when your ship has a hole in it the size of, oh, I don't know, several million Nintendo Wiis. That said, a Sony vice president was recently quoted as saying that there will be a Playstation 4, though its release is scheduled for 2010 at the earliest.

For years virtual reality has been touted as the logical successor to our current concept of video gaming. Unfortunately, after an initial period of tremendous hype, the financial realities of developing virtual-reality technology set in, dissuading many potential investors. There just isn't enough money in the marketplace. But if virtual reality isn't a viable financial option for the entertainment industry, it has seen widespread use in the defense and aerospace industries (which, as we all know, is where the *real* money is). The best we can hope for is that an application will be developed within one of these two areas and eventually trickle down to us, the humble gaming masses.

In the meantime, there's plenty to celebrate in modern gaming. Graphics have never been better, production values have never been higher, and some of the best and brightest minds are devoted to improving electronic entertainment. It's an era of great change and innovation, and it's a terrific time to be a gamer. If you're like me, you can't wait to see what's next.

About the Art

The art in this book falls into three categories: concept art, development art, and in-game art. Most works fall into the in-game category, but we've taken the liberty to include all three types to provide the broadest survey of the world of video game artistry and design. Each image offers a snapshot of a particular developmental phase.

In the early stages of production, after basic story and structure have been established, concept artists are called on to craft a particular vision for the game. Often allowed considerable artistic latitude, they endeavor to create a game's visual identity, constructing a design language that will be spoken throughout development.

Next, the skilled modelers, painters, texture artists, and animators take the art provided by the concept artists and translate it into the digital realm. Often the initial grandiose design aspirations of the concept artists need to be contained somewhat to accommodate real-world processing, staff, or time constraints.

Lastly, another group of animators, modelers, and programmers takes over, uniting aesthetic opinion and crafting the final characters, objects, and backgrounds that will ultimately appear on millions of screens worldwide.

Of course, this breakdown is an extreme oversimplification of an intricate and time-consuming process; fortunately, the many designers interviewed for this book will describe in greater detail how the process was applied to specific titles.

And now, without further ado, let the games begin!

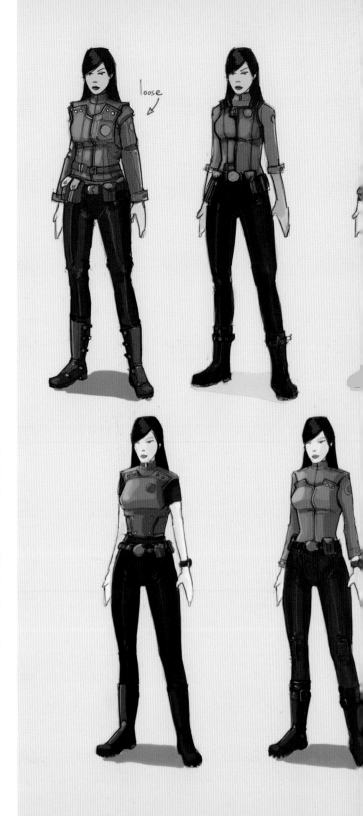

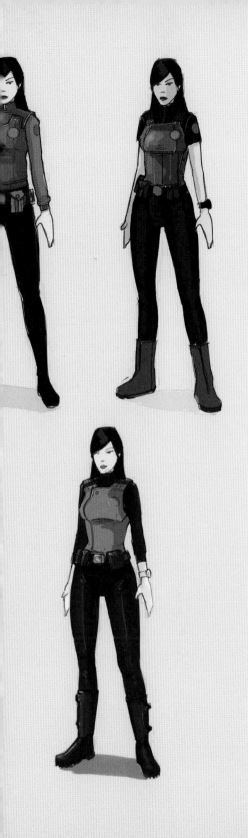

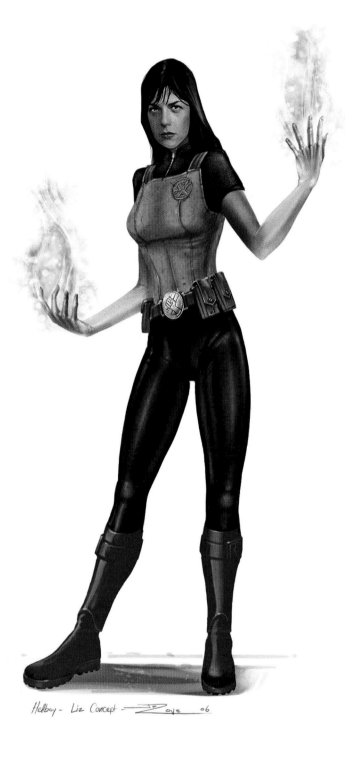

LEFT AND ABOVE: Examples of concept art by Stuart MacKenzie of Krome. From *Hellboy: Science of Evil*.

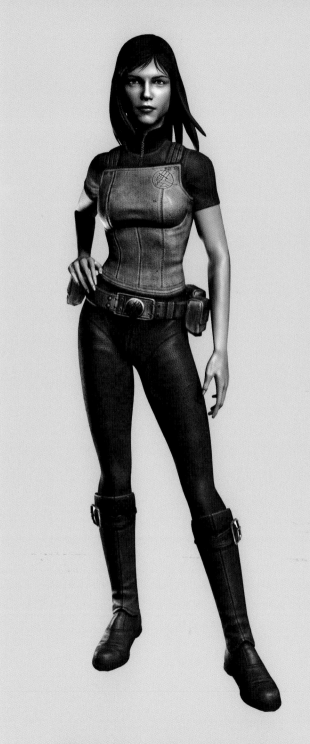

ABOVE: Modelers and texture artists adapt MacKenzie's concept work for in-game translation.

Ace Combat 6: Fires of Liberation

PUBLISHER: NAMCO BANDAI
DEVELOPER: NAMCO BANDAI

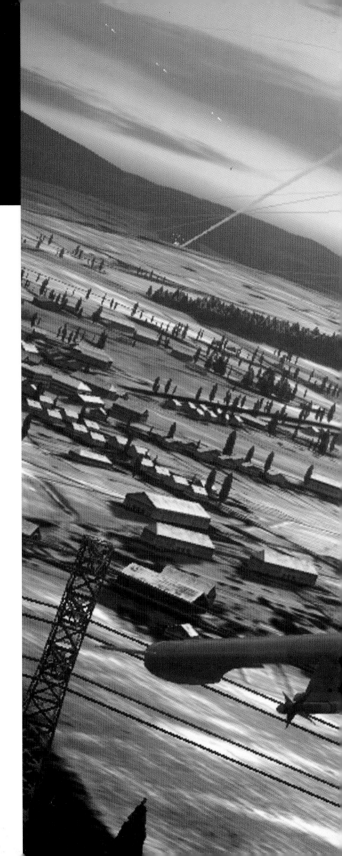

In its efforts to create the most realistic flight-action game ever offered, Namco Bandai licensed fifteen top aircraft from such companies as Boeing and Northrop Grumman. Getting these highly detailed, phenomenally realistic aircraft to work in concert with their environment was Art Director Masata Kanno's biggest challenge: "You could say the artistic theme behind *Ace Combat 6* is 'extraordinary action in a photo-realistic war zone,'" he said. "However, simply porting that philosophy onto the game screen isn't enough to bring it to life. The *Ace Combat 6* world is what gives us the ability to realize this vision with distinctive vistas, color palettes, and exaggerated effects, which are elements of my creative input. *Ace Combat* is also a world in which imaginary aircraft exist alongside real-world aircraft, so we have to abide by a sort of self-imposed rule structure to ensure that the two types coexist side-by-side without breaking the atmosphere."

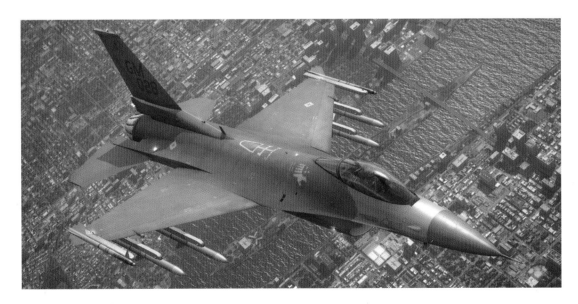

ABOVE: An F-16 Fighting Falcon soars majestically above a thriving metropolis. The detail of the city, even at this distance, is breathtaking.

RIGHT: The A-10 Warthog, set against a backdrop of a massive enemy encampment, is immaculately rendered, down to the last rivet.

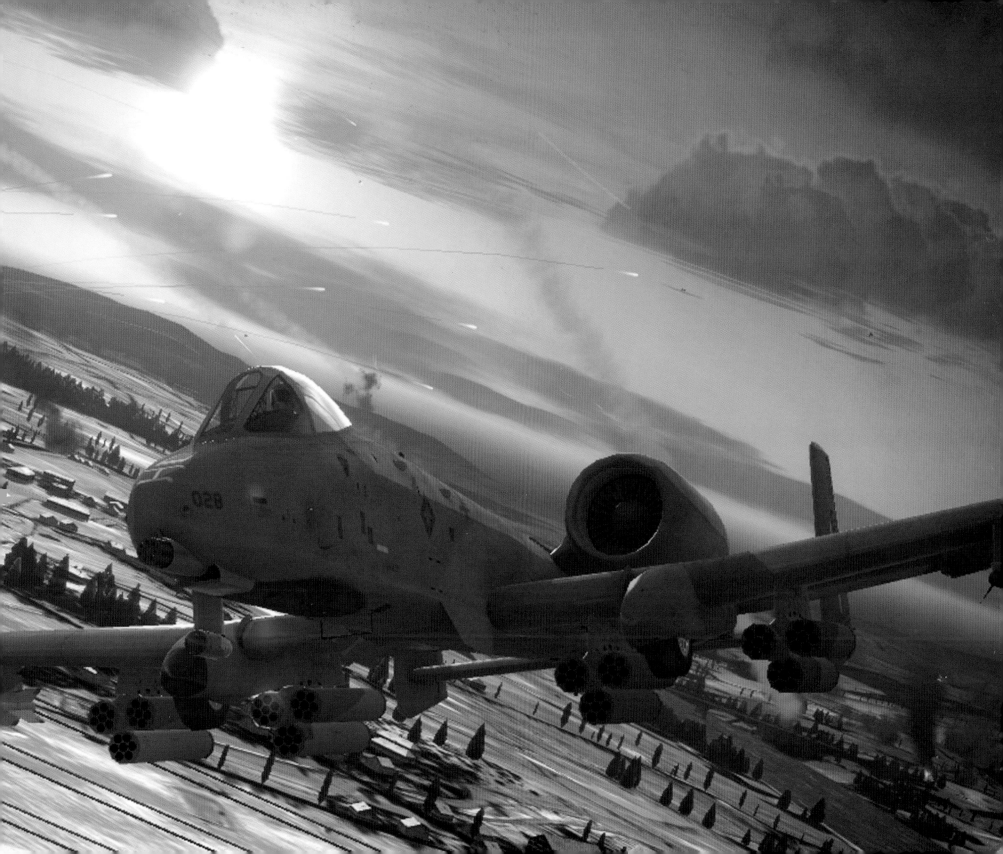

Age of Conan

PUBLISHER: EIDOS
DEVELOPER: FUNCOM

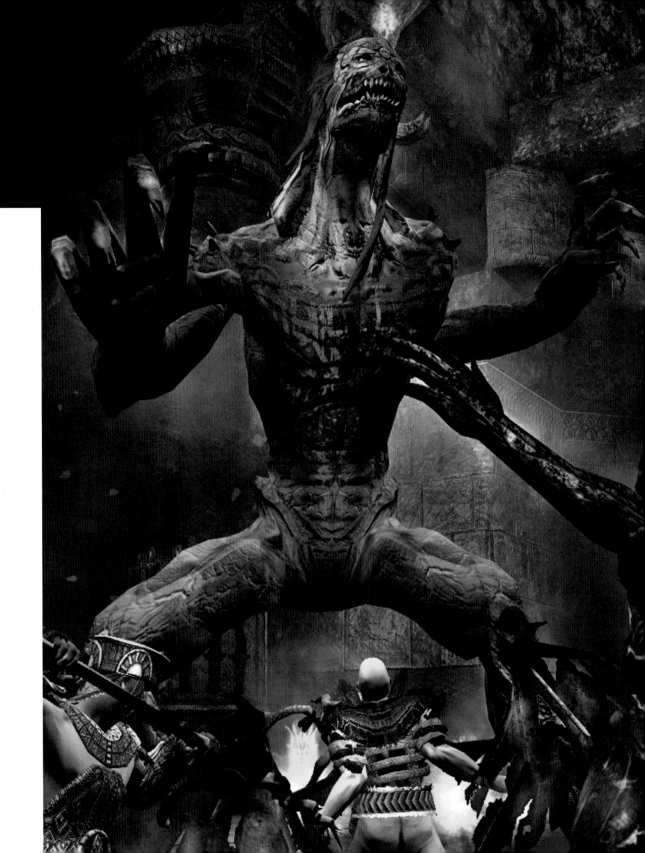

This game is not for the faint of heart. *Age of Conan: Hyborian Adventures* is the first Massively Multiplayer Online game (MMO) to earn a rating of Mature. Given that you'll spend much of the game slaying foes and wiping vile, viscous fluids from your sword, this classification seems entirely warranted.

Visually, the game is unrelentingly moody—almost baleful. The world of Conan is harsh and unforgiving, a forbidding landscape peopled with nefarious characters who would do you harm. Although the landscape is one of great beauty, it's also filled with spectacular decay. Game director Gaute Godager spoke with IGN.com about his dark vision: "The thing that sets Conan apart as an online world is our setting in the dark, lush, ancient, haunted, and lustful world of [author] Robert E. Howard. More than 70 years of novels, comics, and other creative material have built a very powerful and unique fantasy setting where gods are crueler, night is darker, and life is much more violent than what you have seen before."

RIGHT: Particularly impressive in *Age of Conan* is the scale of the action. Here, the battle is joined by a nightmare beast some 25 feet tall.

20

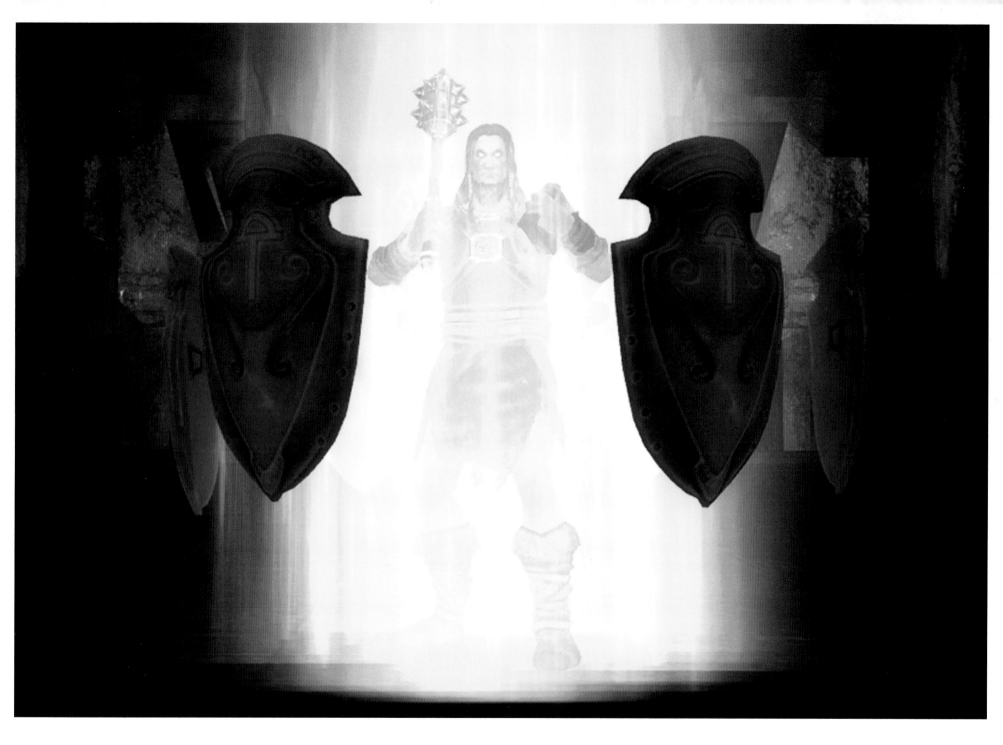

ABOVE: The game manages an entertaining balance of the medieval and the mythic. Traditional weaponry is used alongside the arcane and the occult.

HUGE BATTLE

Featured here is an evocative piece of concept art from Eidos Creative Director Karl Stewart. Filled with gloriously grotesque heaps of gore and errant dismembered appendages, the scene is unapologetically violent. Also interesting is Stewart's use of first-person perspective, which serves to bring viewers directly into the fray. Not only are players forced to survey the terror and carnage of the battlefield, they must also contend with the off-putting notion of hacking deeply into an unknown adversary's tender neck. Gross. And awesome.

But for anyone familiar with the fantasy stories of Robert E. Howard, the scene isn't unfamiliar. Howard's vision for the world of the brawny barbarian was filled with treachery, dark magic, and innumerable perils. Working within such a well-established universe was not only fraught with challenges but also, apparently, a source of great inspiration for Stewart.

ABOVE RIGHT: A pen-and-pencil sketch outlines basic shapes, characters, and perspective.

BELOW RIGHT: A more comprehensive sketch incorporates scale, new characters, and scenery.

OPPOSITE PAGE: Final image: *Huge Battle*, by Karl Stewart, Charlie Clark, Didrik Tollefson, and Concept Arts.

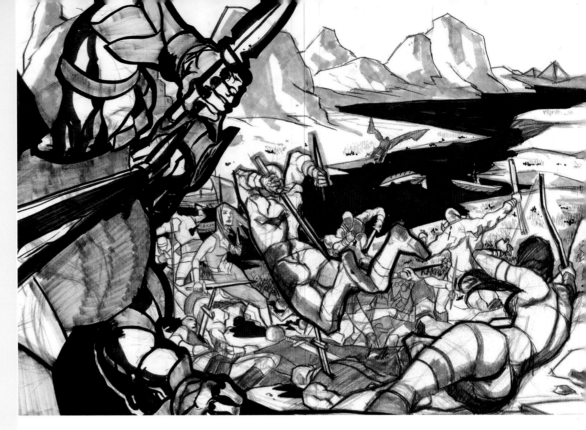

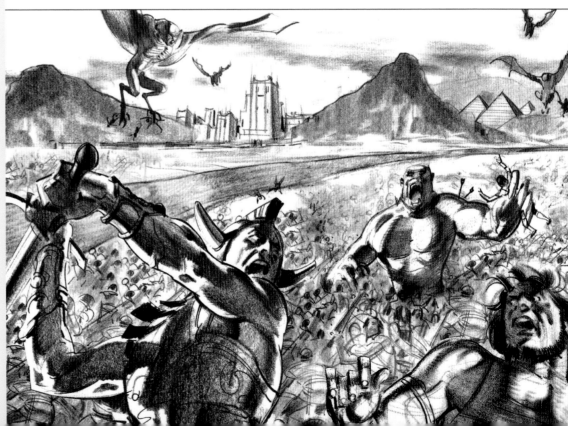

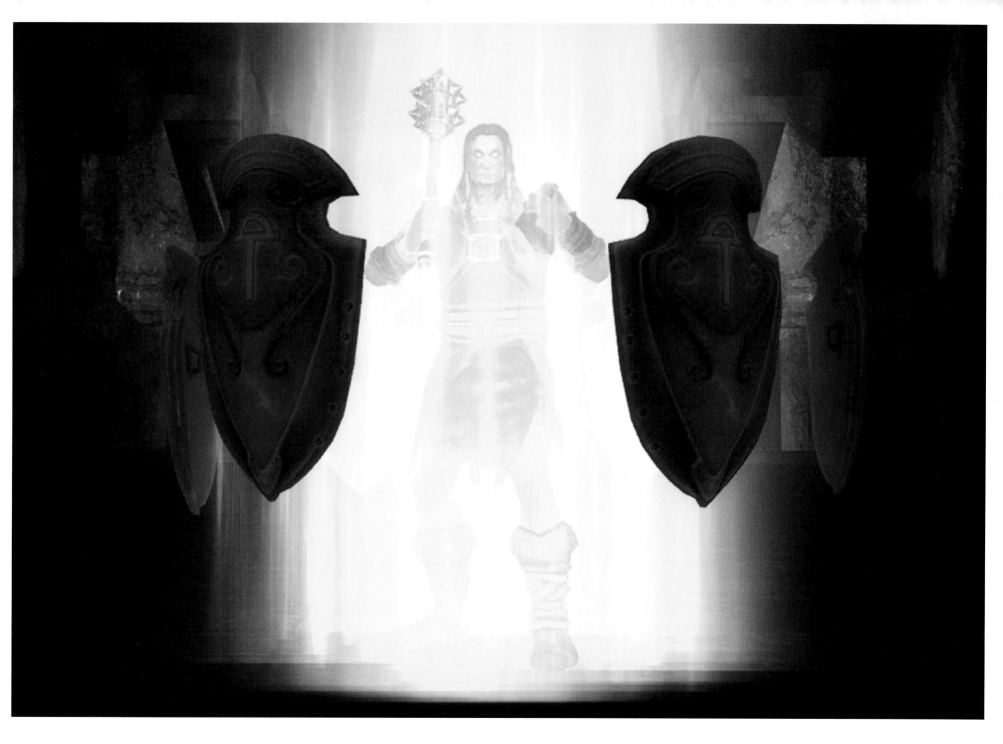

ABOVE: The game manages an entertaining balance of the medieval and the mythic. Traditional weaponry is used alongside the arcane and the occult.

HUGE BATTLE

Featured here is an evocative piece of concept art from Eidos Creative Director Karl Stewart. Filled with gloriously grotesque heaps of gore and errant dismembered appendages, the scene is unapologetically violent. Also interesting is Stewart's use of first-person perspective, which serves to bring viewers directly into the fray. Not only are players forced to survey the terror and carnage of the battlefield, they must also contend with the off-putting notion of hacking deeply into an unknown adversary's tender neck. Gross. And awesome.

But for anyone familiar with the fantasy stories of Robert E. Howard, the scene isn't unfamiliar. Howard's vision for the world of the brawny barbarian was filled with treachery, dark magic, and innumerable perils. Working within such a well-established universe was not only fraught with challenges but also, apparently, a source of great inspiration for Stewart.

ABOVE RIGHT: A pen-and-pencil sketch outlines basic shapes, characters, and perspective.

BELOW RIGHT: A more comprehensive sketch incorporates scale, new characters, and scenery.

OPPOSITE PAGE: Final image: *Huge Battle*, **by Karl Stewart, Charlie Clark, Didrik Tollefson, and Concept Arts.**

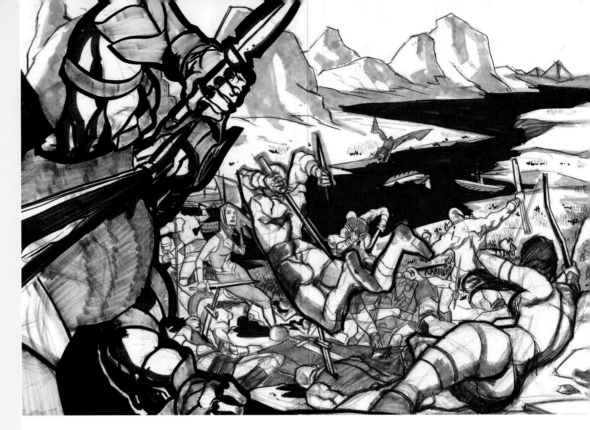

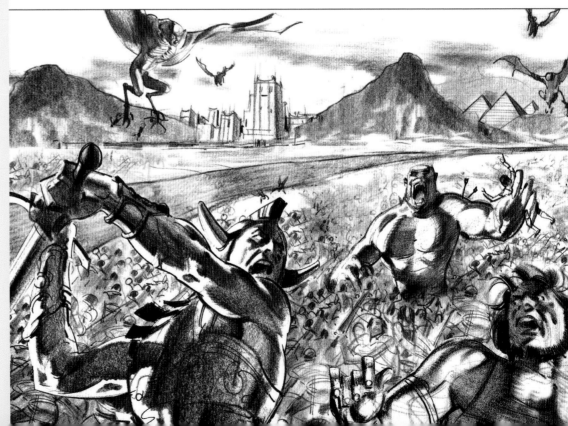

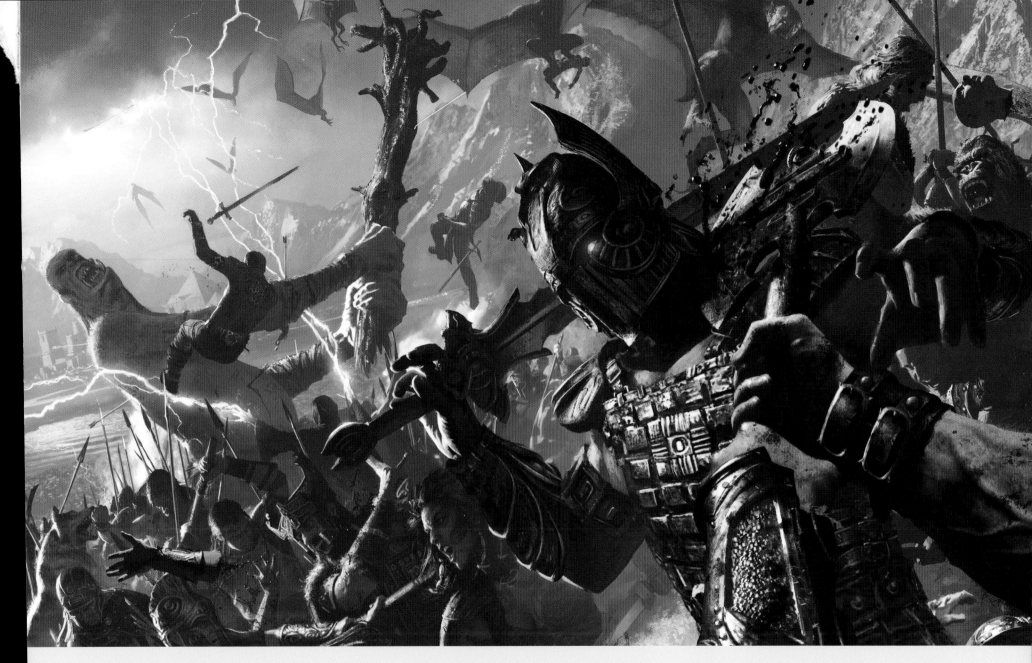

Godager further revealed that "the inspiration for this piece came from reading countless comic and books on Conan and also looking at the old-school artists of the Conan lore, including the great Frazetta and Buscema. We tried to stay as close as possible to the original direction of Robert E. Howard. Therefore, in order to truly get into the mood, I went through a finely tuned two-stage process. First I spent months studying all things Conan, from the comics to the films to the art style, immersing myself in his Hyborian world. After all that, I proceeded to find a spate of dark bars, got very, very drunk, started numerous drunken brawls, and, after nursing many bruises and banging hangovers, I felt I had truly immersed myself in the world of Conan. It was time to begin!"

Conan would be proud.

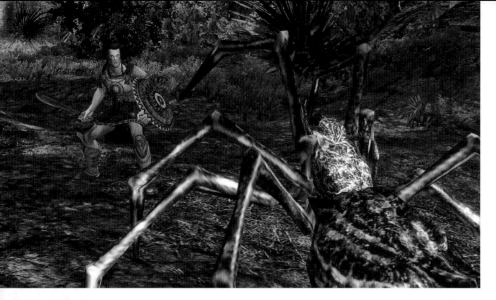

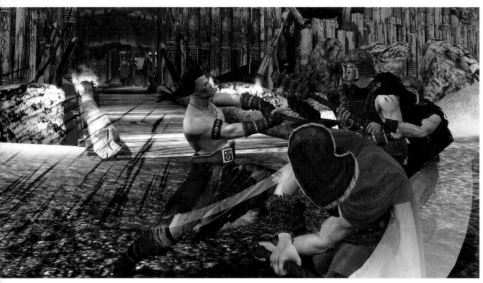

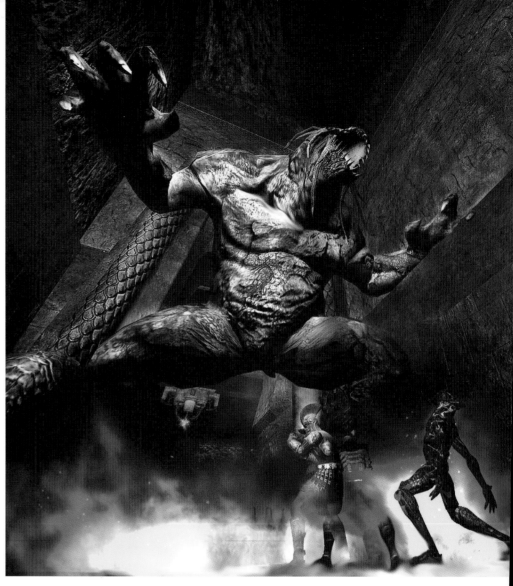

ABOVE LEFT: In *Age of Conan*, even the wildlife is out to get you. Bloodthirsty spiders are among the tamer encounters you can expect.

BELOW LEFT: The in-game carnage is both epic and vicious. Your encounters with other denizens of the world frequently conclude in wild showers of blood and intestine.

ABOVE RIGHT: Boss-level battles require teamwork and strategy. One example: Run like hell.

OPPOSITE PAGE: Again, scale is key to the drama. In this scene, the player passes through open flames to battle another gruesome giant.

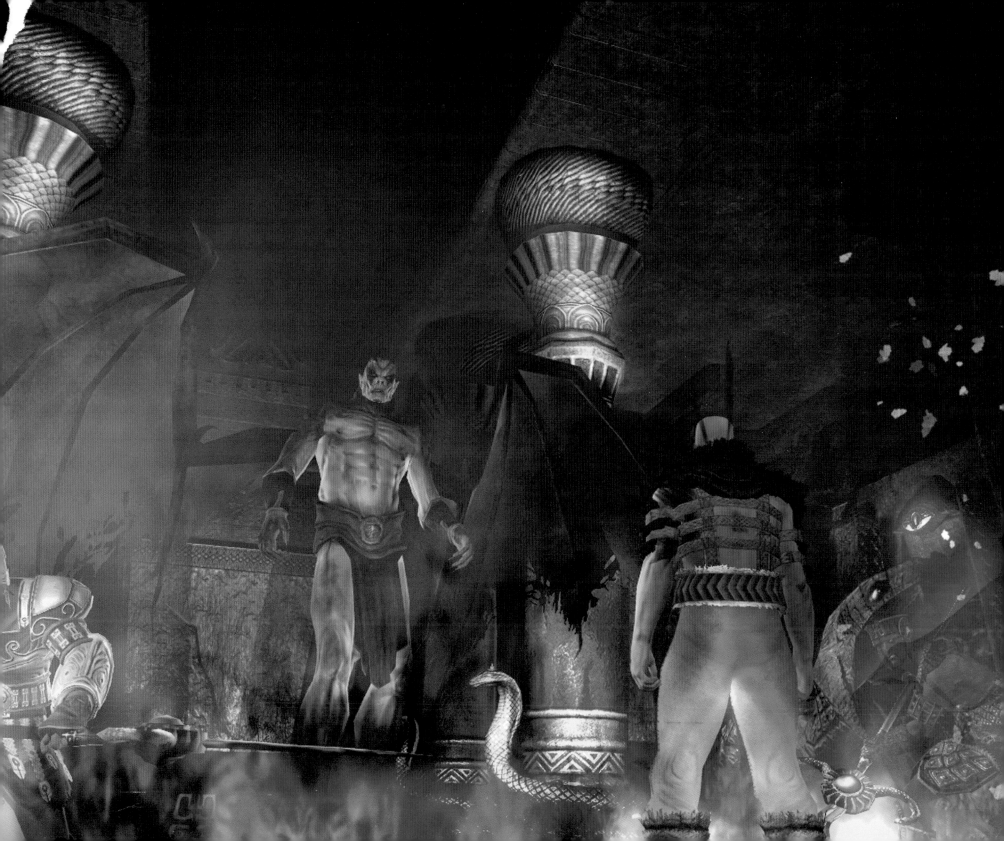

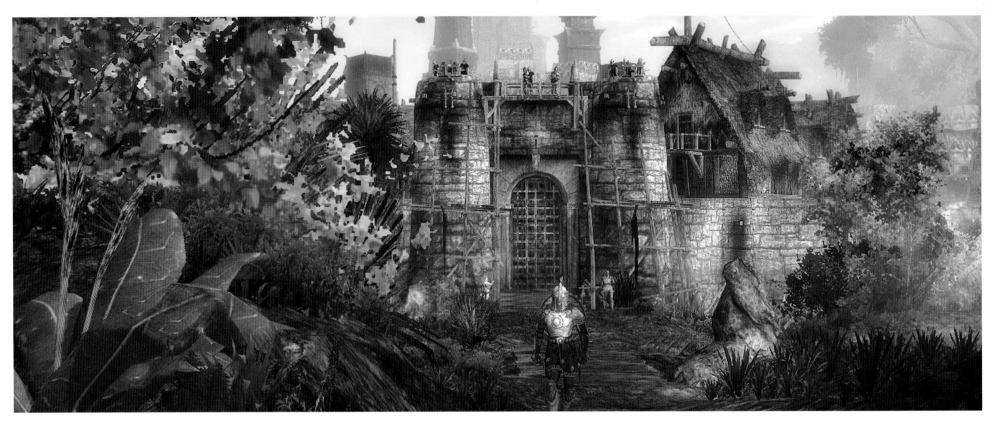

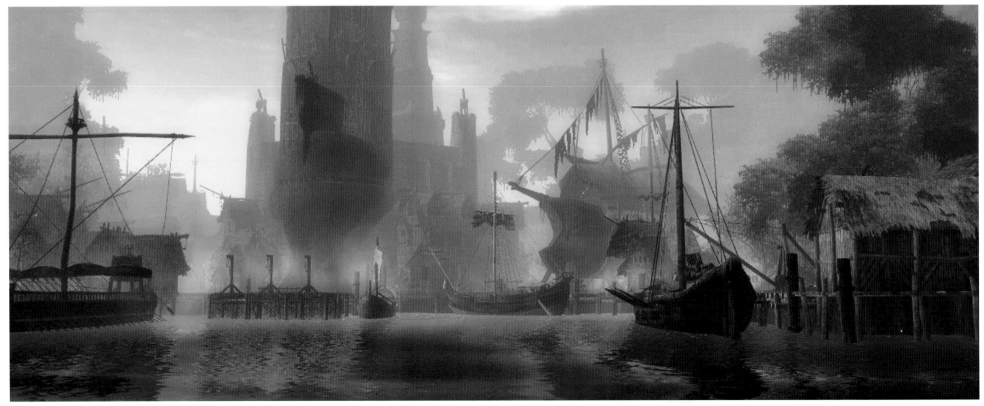

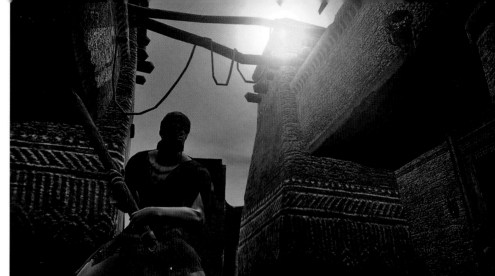

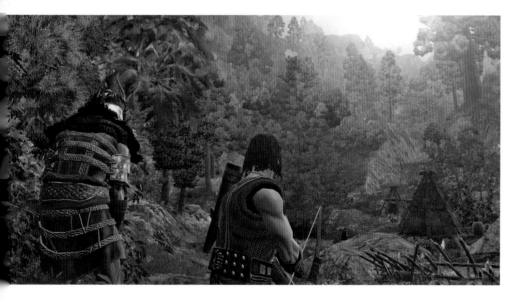

OPPOSITE PAGE ABOVE: Though much of the game takes place in the verdant countryside, many of the most memorable set pieces are in humanity's demesne. These locales often recall medieval France and Britain.

OPPOSITE PAGE BELOW: As in our world, human activity in Aquilonia is concentrated around ports and canals, giving artists the opportunity to develop series of amazingly vivid water scenes.

ABOVE LEFT: There is a palpable feeling of decay in *Age of Conan*, as though a great age has just passed, and humanity has succumbed to its baser instincts.

BELOW LEFT: The forest scenery is overgrown in an almost menacing way, suggesting that humanity has not yet mastered the natural world. In fact, nature seems almost willfully intent on mastering humanity.

ABOVE RIGHT: Artists solidly accomplished the use of light and shadow to craft scenes that imply danger and foreboding.

BELOW RIGHT: Bustling townships pepper the countryside, intricately conceived bastions of commerce and industry.

Battlestations: Midway

DEVELOPER: EIDOS HUNGARY

PUBLISHER: EIDOS

The superior design aesthetic of *Battlestations: Midway* is built on two artistic cornerstones: scale and realism. In the game, players take control of entire fleets of American or Japanese ships and planes and battle through most of World War II's Asiatic Pacific Theater. In addition to assiduously modeling each plane and ship down to the last rivet, developers set new standards for accuracy by realistically rendering internal structures as well. According to Eidos Hungary chief Klaude Thomas, this attention to detail meant that instead of simply applying a certain number of "hits" to sink an enemy cruiser, players must think more strategically, firing at individual ship compartments to induce massive internal flooding. Scale was also important to designers, since the vast oceans and islands of Asia (rather than the relatively diminutive naval fleets of two warring nations) were the dominant visual features of the conflict. Said Thomas, "The first thing to consider is the scale of the Pacific Ocean. We've done a lot of work to make the sea and islands look great and to provide appropriately vast areas to fight over, on, or under."

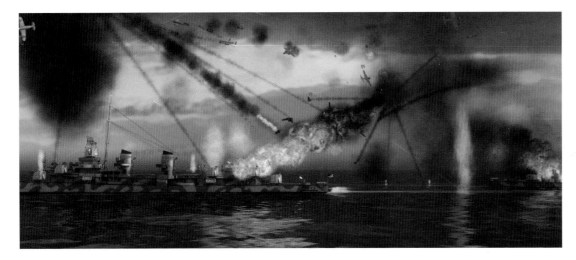

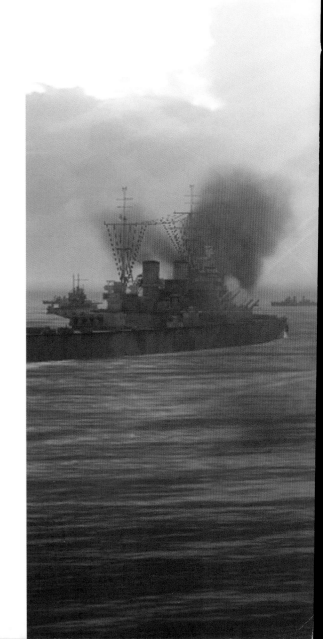

ABOVE: The action in *Battlestations: Midway* is ferocious and immediate, with dozens of ships and aircraft participating at any moment.

RIGHT: Eidos designers spent much time realistically rendering the game's vehicles, including the formidable Yorktown-class carrier fleet.

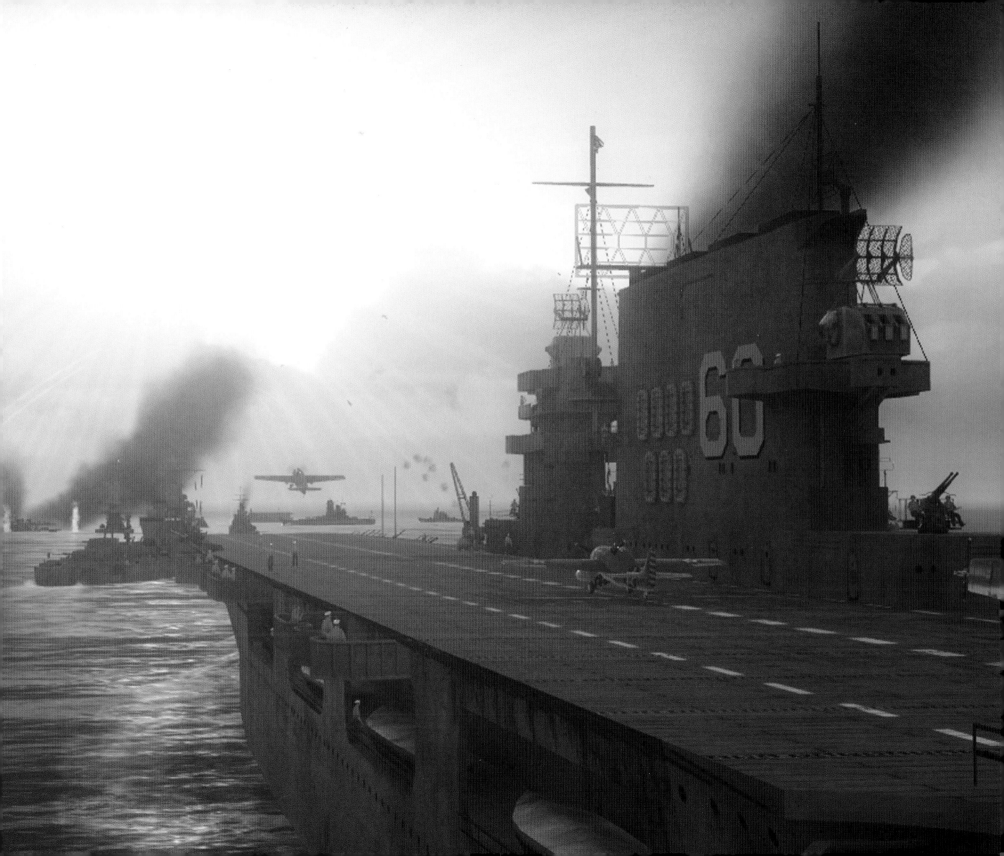

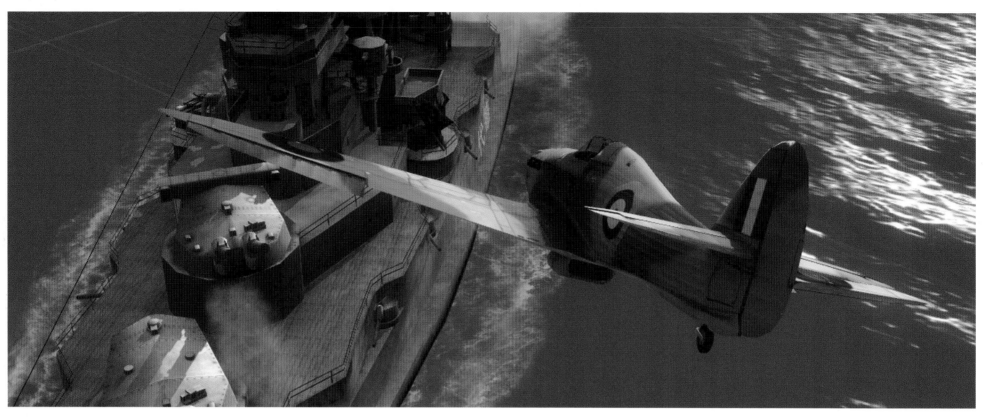
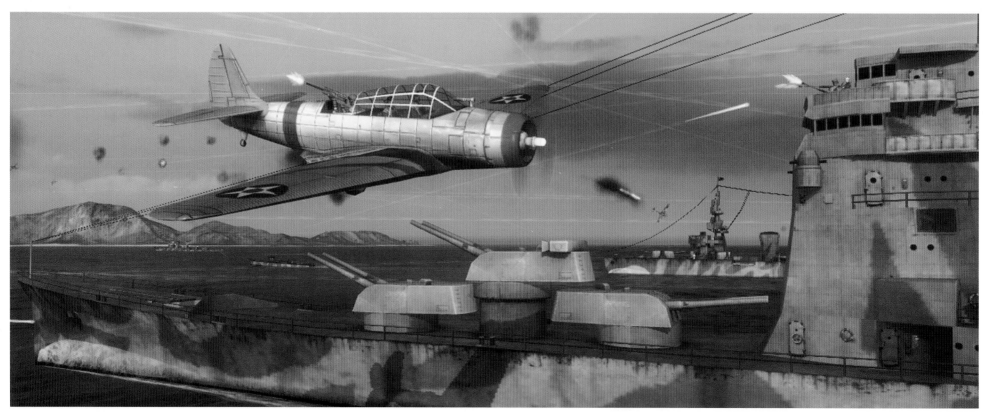

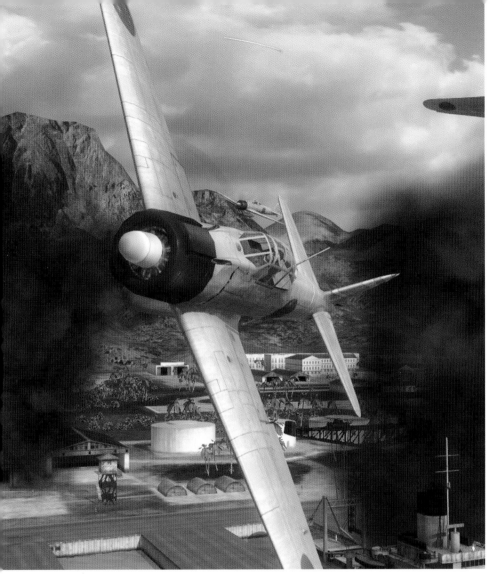

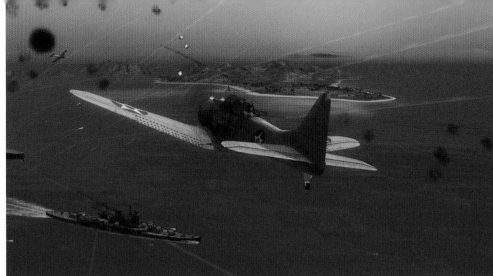

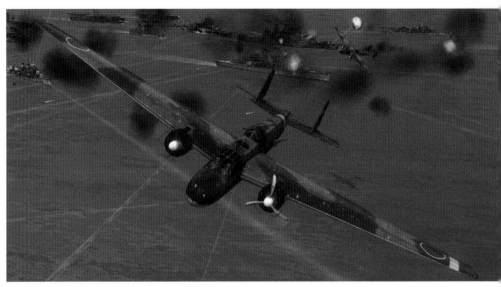

OPPOSITE PAGE ABOVE: Making an attack run in *Battlestations: Midway* is a viscerally thrilling experience. The Eidos team's conspicuous attention to detail means that even up close and at great speed, enemy ships and planes appear staggeringly real.

OPPOSITE PAGE BELOW: Despite creating an interface for controlling whole fleets in battle, developers also ensured that close-quarters combat was realistic and intense.

ABOVE LEFT: *Battlestations: Midway* isn't all triumph and glory. In the interest of historical realism, the war in the Pacific starts just as it did in real life, with the devastating attack on Pearl Harbor.

ABOVE RIGHT: The smoke-charred glass of a cockpit lends verisimilitude to this first-person perspective.

BELOW RIGHT: Developers were careful to maintain a realistic scale in each of the battle sequences, and the game's sophisticated physics engine is able to accurately render the chaos of combat.

Beautiful Katamari

PUBLISHER: NAMCO BANDAI

DEVELOPER: NAMCO BANDAI

Beautiful Katamari is weird. Not *bad* weird; if anything, it's one of the most compelling and original titles released in years. In the game, players control a gradually expanding—and extraordinarily sticky—ball known as a *katamari*. As you roll through homes, towns, cities, and eventually entire countries, gamers accumulate everyday objects that stick to the gluey ball. When the katamari reaches sufficient size, players can use it to replace missing celestial objects in the night sky. Uh-huh.

The bizarre concept came from a young designer at Namco Bandai named Keita Takahashi, whose simple, but not simplistic, vision has captured the attention of millions. Takahashi spoke with Gamasutra.com about how he persuaded Namco Bandai execs to get on board with his far-out idea: "I don't think it's anything special. I just write down my ideas on paper, present it to them, and if they don't understand, I say, 'Well, you'll understand if I make it.' Then I make part of it, and they understand. But I don't really have any kind of marketing plan when I put this stuff together, I just propose what I think might be fun or exciting. I don't really have a good knowledge of what will sell. All I can do is make it and see what happens."

Takahashi has mentioned in several media outlets that he doesn't plan to stay in video gaming. In fact, he already has a new career in mind: designing playgrounds. He described his ideal as "one that's soft, and with lots of big blocky shapes, and a place where [kids] can't really get hurt . . . where kids can roll around and be free. But it's probably okay if they occasionally get hurt, too." Uh-huh.

RIGHT: The straightforward design scheme for *Beautiful Katamari* involves plenty of light, primary colors; a simplistic interaction interface; and an adorable, if bizarre-looking, protagonist.

The Prince

B Get Off

ABOVE: Nothing in *Beautiful Katamari* quite fits under the heading of "normal." Even world-view screens have a sort of preternatural whimsy that is unlike anything else in gaming.

BELOW LEFT: As the size of your katamari grows, so does the game's complexity.

BELOW RIGHT: As you continue to accumulate objects, your katamari eventually grows large enough to digest whole cities and towns.

10m35cm3mm
10,000km

309m26cm1mm
10,000km

Blacksite: Area 51

PUBLISHER: MIDWAY
DEVELOPER: MIDWAY STUDIOS AUSTIN

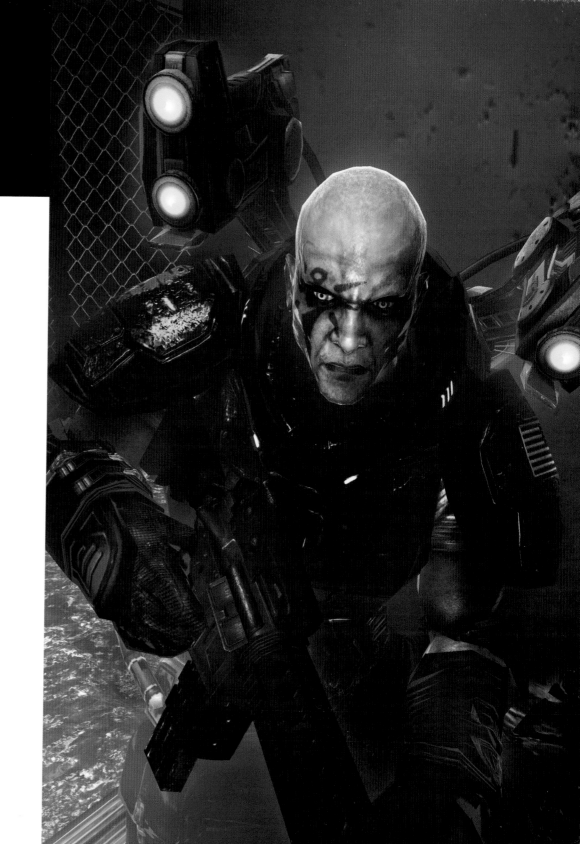

Following on the heels of the phenomenally successful arcade title *Area 51, Blacksite* pits gamers against unfathomable enemies from beyond the skin of the Earth, with the infamous government installation Area 51 serving as the backdrop. Midway Studios Austin chief Harvey Smith explained in an interview with Firingsquad.com that one of the development team's primary goals was to craft a visually involving game equipped with a host of cool environments.

"I developed an interest in using very grounded, small-town settings for the game," Smith said. "I also wanted to include some political allegory related to what we're afraid of in today's world. But maybe more than anything I had some personal goals to accomplish: I wanted to achieve a certain level of polish in terms of how the game looks, sounds, and feels. I've always admired games with great aesthetics, solid frame-rates, smooth movement, and combat controls—just that general feeling of polish. I want to master that standard and apply it to all the games I work on going forward."

RIGHT: An oppressive sort of darkness pervades much of *Blacksite: Area 51*. Artists managed to incorporate a sense of creeping menace into all characters—friend and foe alike.

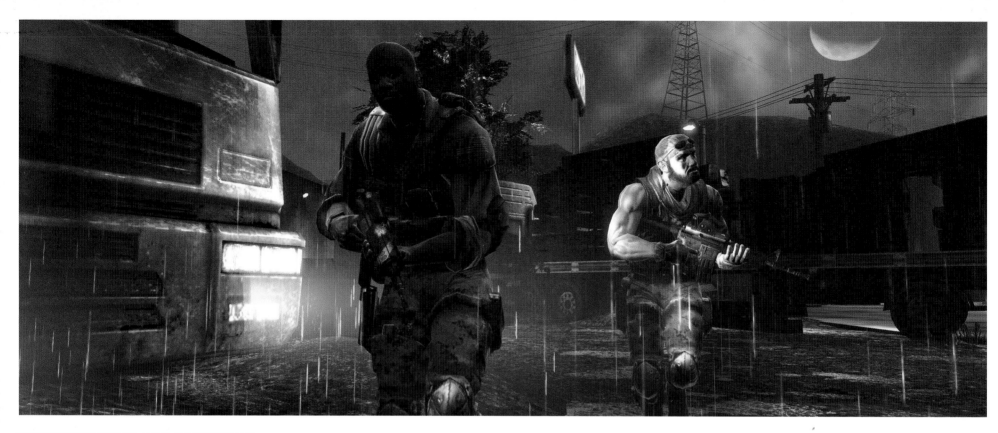

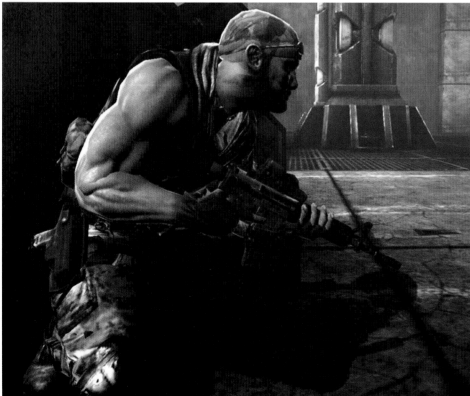

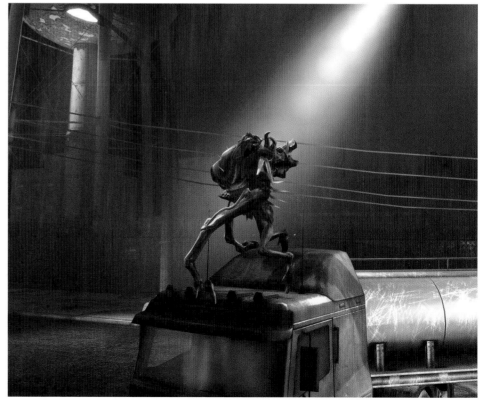

Blacksite: Area 51

PUBLISHER: MIDWAY
DEVELOPER: MIDWAY STUDIOS AUSTIN

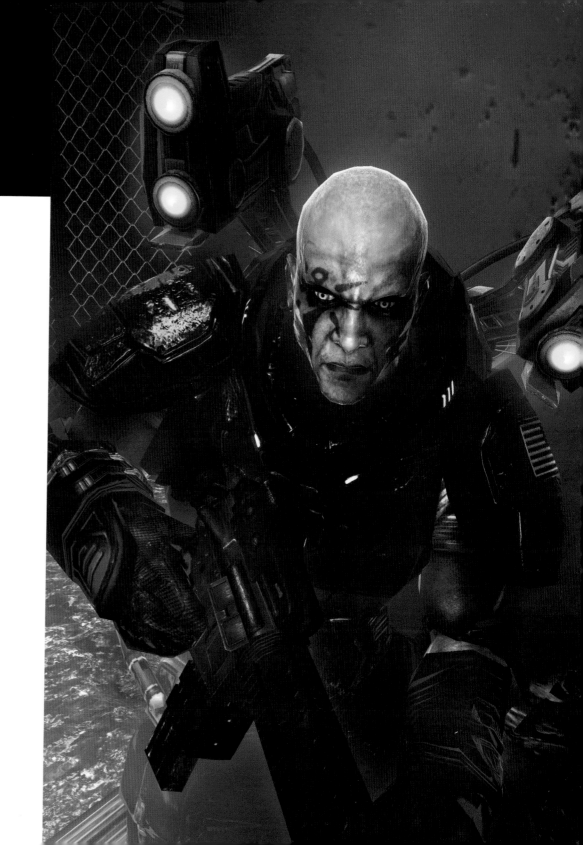

Following on the heels of the phenomenally successful arcade title *Area 51, Blacksite* pits gamers against unfathomable enemies from beyond the skin of the Earth, with the infamous government installation Area 51 serving as the backdrop. Midway Studios Austin chief Harvey Smith explained in an interview with Firingsquad.com that one of the development team's primary goals was to craft a visually involving game equipped with a host of cool environments.

"I developed an interest in using very grounded, small-town settings for the game," Smith said. "I also wanted to include some political allegory related to what we're afraid of in today's world. But maybe more than anything I had some personal goals to accomplish: I wanted to achieve a certain level of polish in terms of how the game looks, sounds, and feels. I've always admired games with great aesthetics, solid frame-rates, smooth movement, and combat controls—just that general feeling of polish. I want to master that standard and apply it to all the games I work on going forward."

RIGHT: An oppressive sort of darkness pervades much of *Blacksite: Area 51*. Artists managed to incorporate a sense of creeping menace into all characters—friend and foe alike.

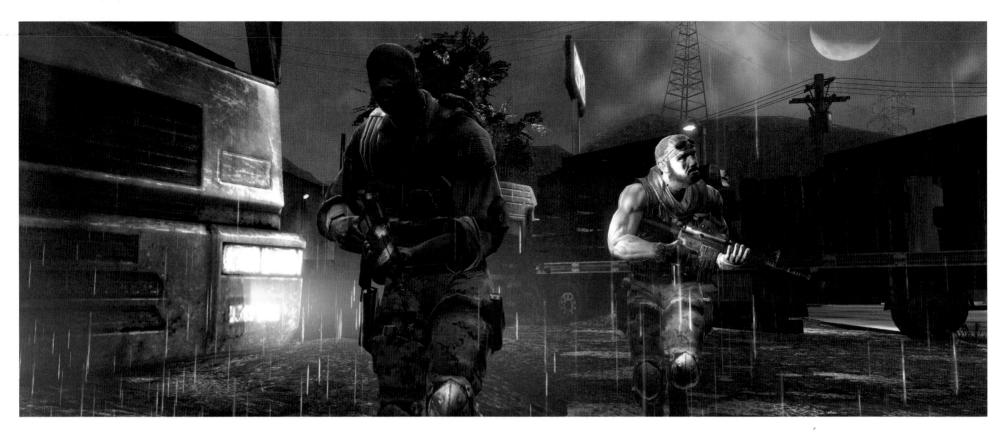

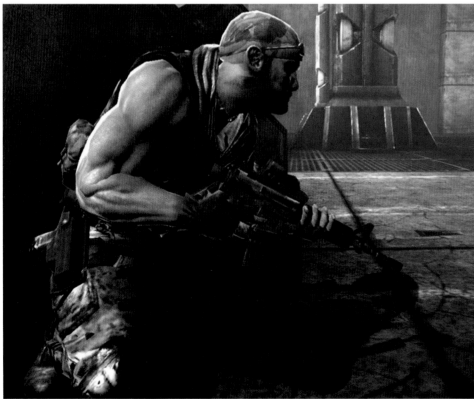

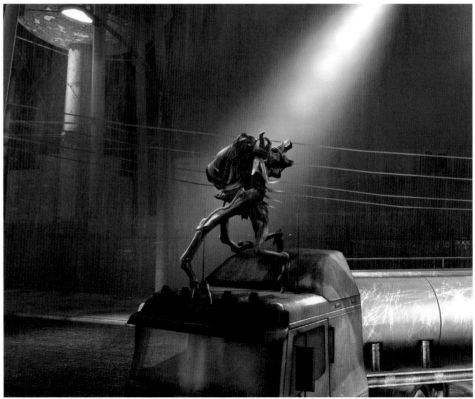

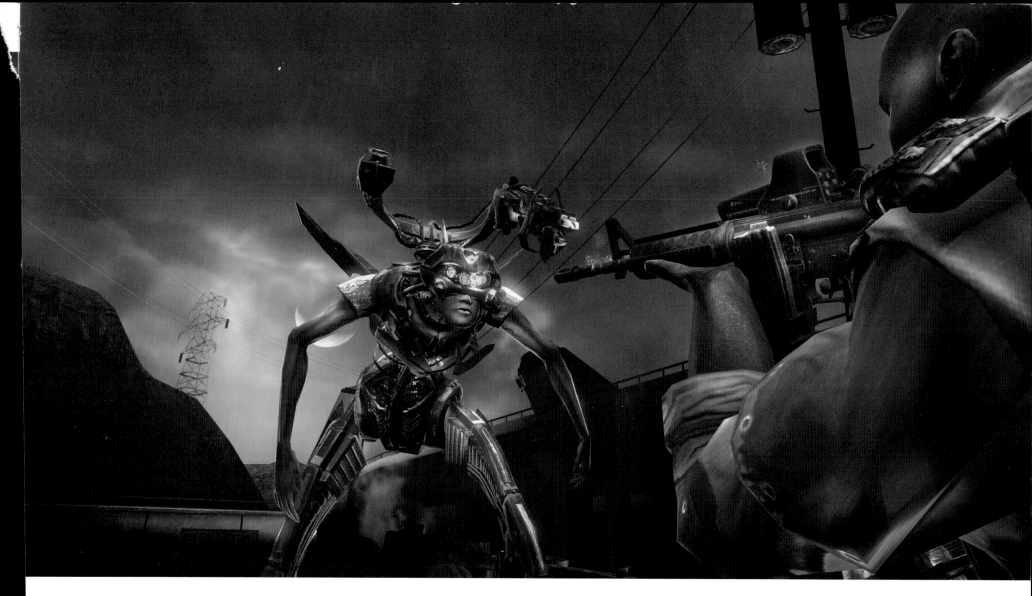

OPPOSITE PAGE ABOVE: At night, the landscape is illuminated only by a waning moon and paltry ambient light. It is a forbidding environment in which evil lurks in every shadowed corner.

OPPOSITE PAGE BELOW LEFT: Though often cast in a weak, pallid glow, the game's protagonists are expertly rendered, down to the last sinew.

OPPOSITE PAGE BELOW RIGHT: Part of the thrill of *Blacksite* is the way marauding grotesqueries are interposed with familiar elements of everyday life—like this sinister fellow and a common 18-wheeler truck.

ABOVE: Character design was emphasized during the game's development, and the result is a cast of villainy that is conspicuously malevolent as well as utterly unique.

Call of Duty 4: Modern Warfare

PUBLISHER: ACTIVISION

DEVELOPER: INFINITY WARD

The story of *Call of Duty 4* is typical gaming fare: A pair of fanatical madmen with vast resources and manpower threatens the sovereignty of the world's free nations. Your unit must stop these lunatics and their cronies before the conflict boils over and imperils global democracy. Visually, the game is remarkably realistic, with shadow, light, and weather effects among the best in the genre. But the true majesty of the *Call of Duty* franchise, and of *Modern Warfare* in particular, is the intensity of the action. Infinity Ward president Grant Collier noted that the design team was focused on accurately re-creating combat's visual chaos. "We try to create that living, breathing battlefield," Collier said. "It's not just the fight between you and one guy—there's all this other shit going on around you. You'll see jets flying through the sky; you might see things exploding in the distance or a rocket truck launching rockets, maybe planes crashing and tanks battling it out. . . . It's a combination of all those things that really make it. And the immersion level. We want it to be as authentic as possible, and we want it to be as realistic as possible."

RIGHT: *Call of Duty* takes place in a series of modern combat environments, and each is rendered in meticulous detail. From corrugated metal flooring to the imposing architectural edifices of a contemporary warship, the settings are infused with an urgent sense of realism, adding to the inherent drama of combat.

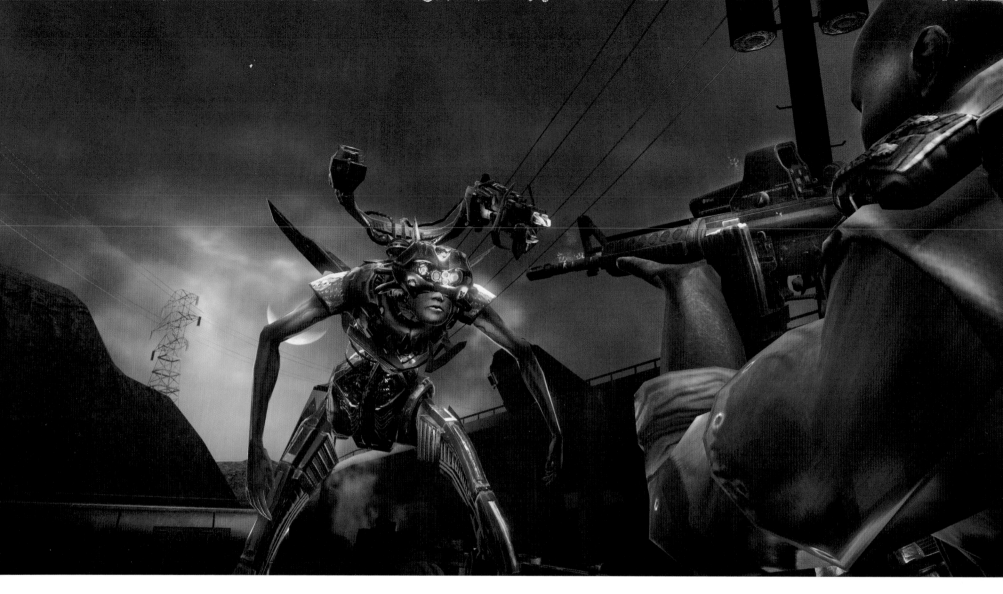

OPPOSITE PAGE ABOVE: At night, the landscape is illuminated only by a waning moon and paltry ambient light. It is a forbidding environment in which evil lurks in every shadowed corner.

OPPOSITE PAGE BELOW LEFT: Though often cast in a weak, pallid glow, the game's protagonists are expertly rendered, down to the last sinew.

OPPOSITE PAGE BELOW RIGHT: Part of the thrill of *Blacksite* is the way marauding grotesqueries are interposed with familiar elements of everyday life—like this sinister fellow and a common 18-wheeler truck.

ABOVE: Character design was emphasized during the game's development, and the result is a cast of villainy that is conspicuously malevolent as well as utterly unique.

Call of Duty 4: Modern Warfare

PUBLISHER: ACTIVISION
DEVELOPER: INFINITY WARD

The story of *Call of Duty 4* is typical gaming fare: A pair of fanatical madmen with vast resources and manpower threatens the sovereignty of the world's free nations. Your unit must stop these lunatics and their cronies before the conflict boils over and imperils global democracy. Visually, the game is remarkably realistic, with shadow, light, and weather effects among the best in the genre. But the true majesty of the *Call of Duty* franchise, and of *Modern Warfare* in particular, is the intensity of the action. Infinity Ward president Grant Collier noted that the design team was focused on accurately re-creating combat's visual chaos. "We try to create that living, breathing battlefield," Collier said. "It's not just the fight between you and one guy— there's all this other shit going on around you. You'll see jets flying through the sky; you might see things exploding in the distance or a rocket truck launching rockets, maybe planes crashing and tanks battling it out. . . . It's a combination of all those things that really make it. And the immersion level. We want it to be as authentic as possible, and we want it to be as realistic as possible."

RIGHT: *Call of Duty* takes place in a series of modern combat environments, and each is rendered in meticulous detail. From corrugated metal flooring to the imposing architectural edifices of a contemporary warship, the settings are infused with an urgent sense of realism, adding to the inherent drama of combat.

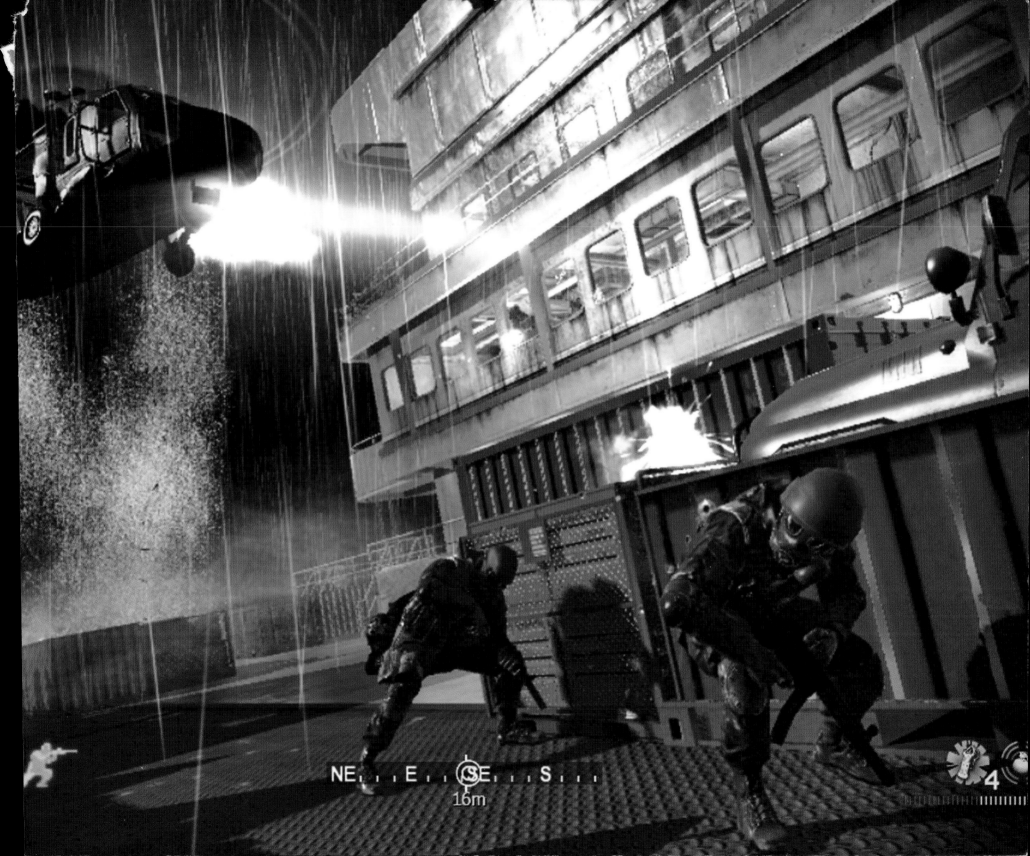

NE E SE S
16m

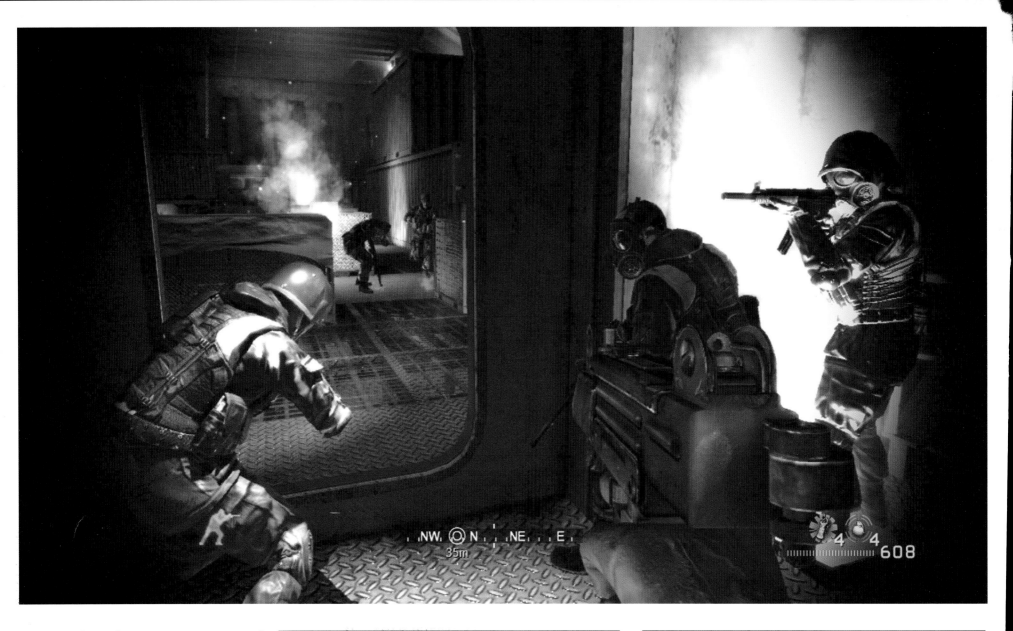

ABOVE: Interior environments are another area in which *Call of Duty* shines. Confined spaces and cramped corridors predominate, concentrating the action into tight combat zones.

BELOW LEFT: Weather effects serve almost as another character, concealing you and your enemies.

BELOW RIGHT: Long-distance attacks also play an important in-game role, but, near or far, the resultant pyrotechnics appear startlingly real.

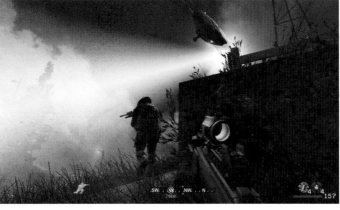

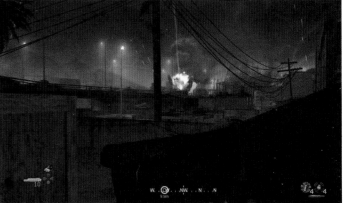

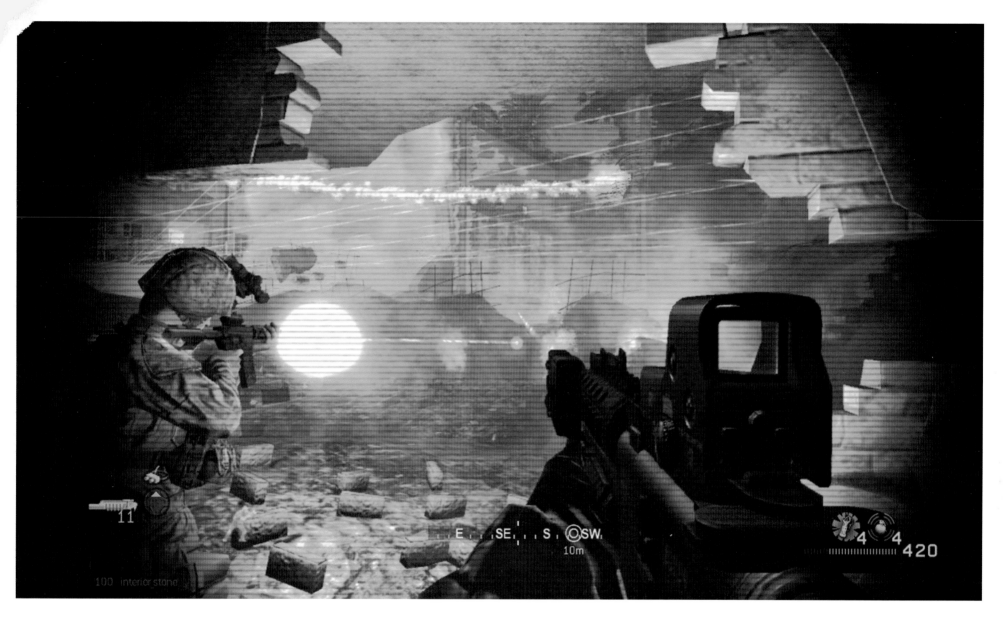

11

100 interior stone

E SE S SW
10m

4 4
420

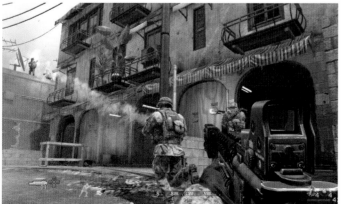

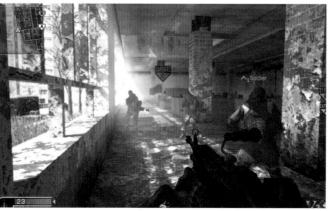

ABOVE: Night vision enhances realism. Any on-screen light sources—usually explosions and gunfire—are greatly amplified, augmenting the natural spectacle of battle.

BELOW LEFT: The game's urban environments are particularly well designed; war-ravaged metropolises with ample hiding places for enemy combatants.

BELOW RIGHT: Devastated by decades of war and neglect, interior environments reflect the ugliness of contemporary conflict.

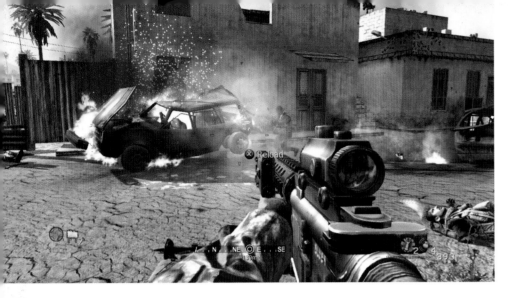

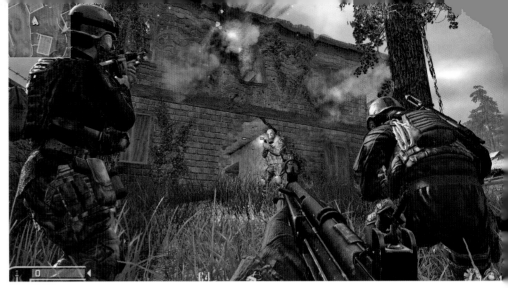

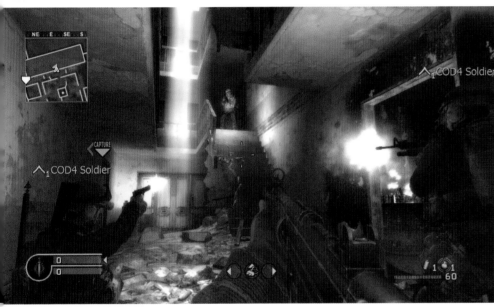

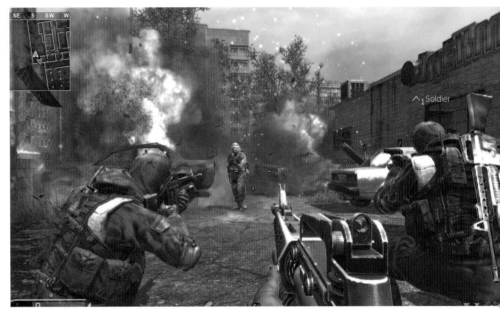

ABOVE LEFT: Despite the rampant destruction evident in many of *Call of Duty*'s environments, it's clear you're fighting in a living city, replete with burning cars, collapsing buildings, and an obscenely active insurgency.

BELOW LEFT: Squad-based combat is an important aspect of most modern war games. Activision and Infinity Ward have taken the con- cept further, however, crafting vividly realized fellow soldiers with independent personalities and unique appearances.

ABOVE RIGHT: Your mission in *COD* takes you across much of Europe and the Middle East, so that in addition to urban combat, you must con- tend with the unpredictability of fighting in forests, swamps, and wide-open grasslands.

BELOW RIGHT: Perhaps the best-loved aspect of the game is the frenzied pace of the action. Explosions surround you on all sides, as snipers take careful aim at your squad and battle-hard- ened enemies charge your defenses in a fit of feverish bloodlust.

FIFA '08

PUBLISHER: EA SPORTS
DEVELOPER: EA SPORTS

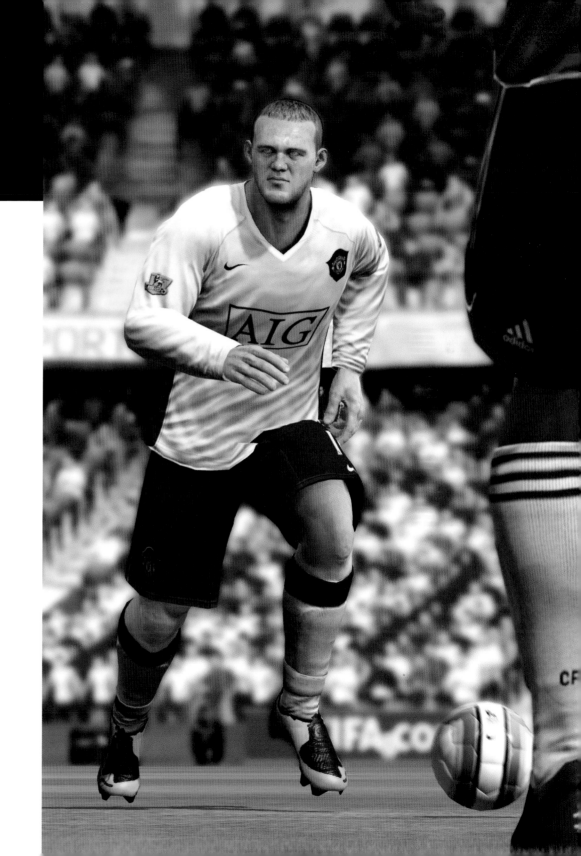

The FIFA series, from EA Sports, is a painstakingly realistic soccer franchise that features likenesses of thousands of professional players from international teams. "Making [the players'] in-game counterparts is not an easy job," explains art director Matt Jones. "Some players have an incredibly high profile on a worldwide level, so the perception of what they look like is widespread. It can be challenging to create a likeness that matches that perception."

In many cases, designers rely on existing photo archives to develop a player's digital counterpart. But the *FIFA '08* team used a more advanced process for illustrating Ronaldinho, one of the biggest soccer stars in the world. The player was invited into their studios, and makeup artists applied a host of tiny dots to his face. Next he was photographed and filmed, and the images fed into a computer. Programmers used the dots to map the contours and muscles of his face and to build the foundation for an accurate, three-dimensional re-creation.

For all of its high stakes and insane deadlines, the process of creating *FIFA '08* isn't without a lighter side. Jones explains, "The last hairstyle to be tweaked each year is David Beckham's because it always changes during the project."

RIGHT: Wayne Rooney, one of the most popular players in soccer today, is captured in immaculate detail, from his trademark furrowed brow to his windblown jersey.

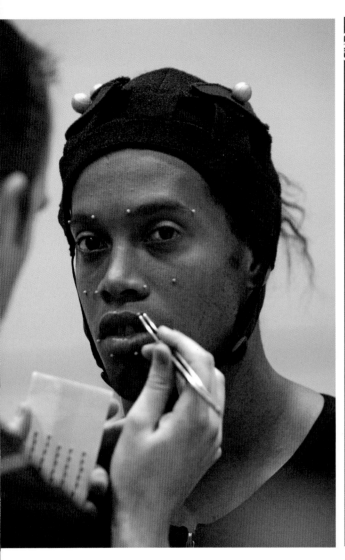

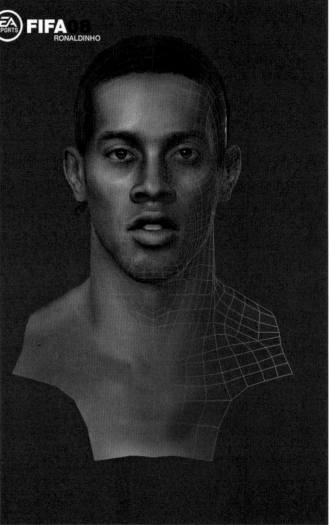

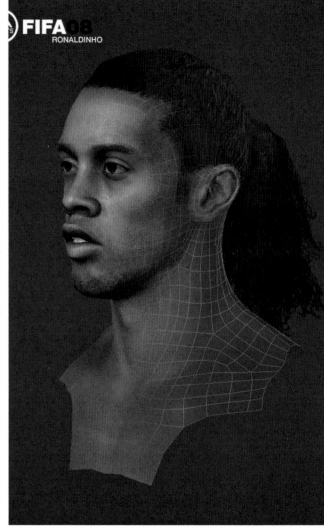

Ronaldinho, one of the sport's most popular players, has tiny computer-mapping dots placed onto his face so that it can be mapped in three dimensions.

With the map complete, artists can use the data to create an accurate reproduction of Ronaldinho's face.

A side view of the process.

OPPOSITE PAGE: Final image: Ronaldinho Xbox 360 In-Game Capture, art directed by Matt Jones.

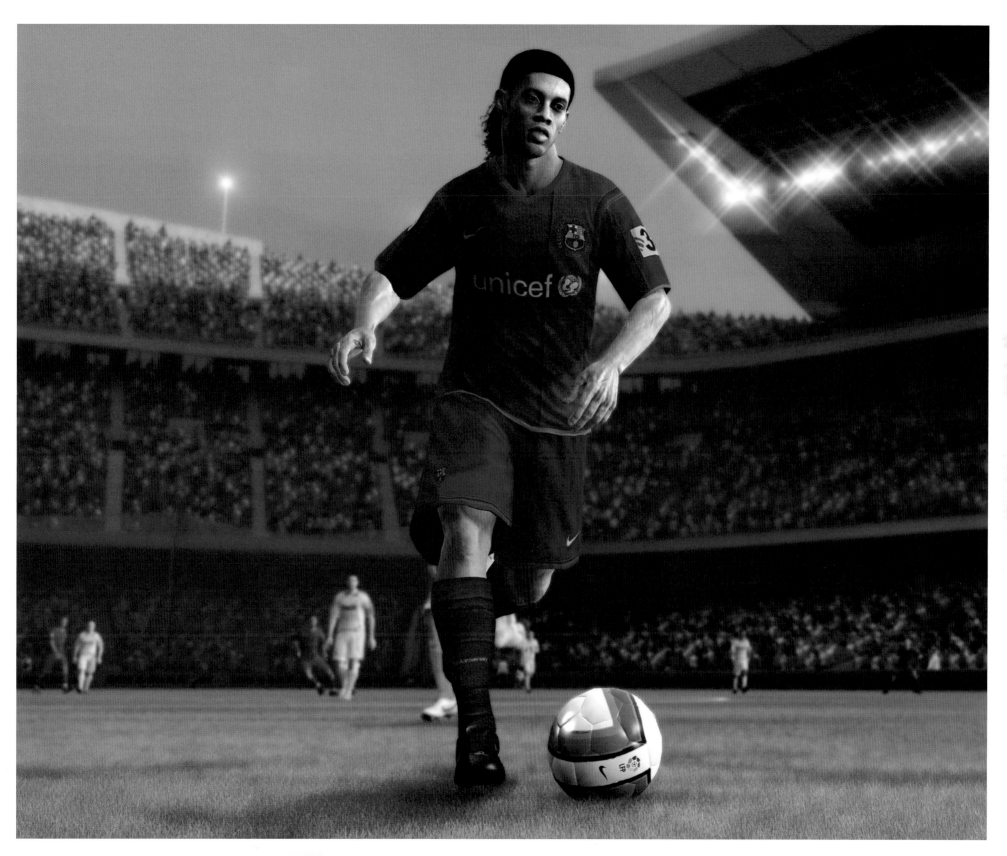

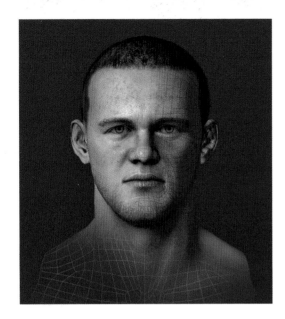

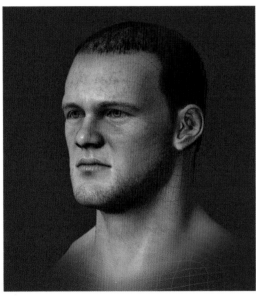

ABOVE: After accumulating a massive amount of visual data, artists begin to build a map of Rooney's face, adding color, shading, texture—even sweat.

RIGHT: Capturing Rooney's face is only the first part of a multistage process. Artists and programmers later incorporate lighting and weather effects, background stadium structure, an energetic crowd, and, perhaps most important, the rest of Rooney's body.

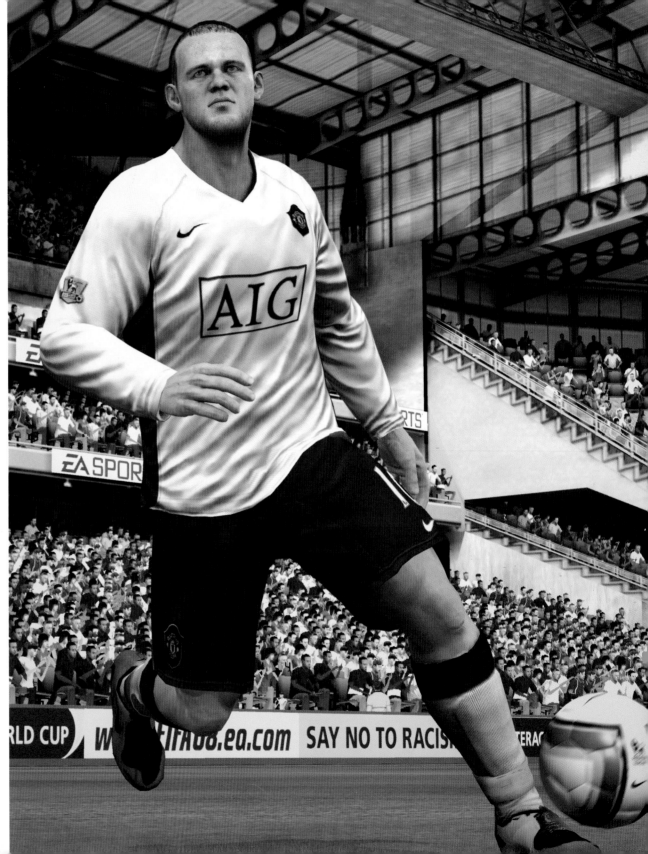

Half-Life 2

DEVELOPER: VALVE
PUBLISHER: ELECTRONIC ARTS

Upon its release in 1998, the original *Half-Life* was showered with near-universal acclaim, earning some 50 game-of-the-year awards from media outlets worldwide and hailed as the best game of all time by *PC Gamer* magazine. *Half-Life 2* picks up an indeterminate number of years after the original and pits Dr. Gordon Freeman against a host of enemies intent on occupying planet Earth. The overall art direction and individual set pieces and characters are beautifully rendered, though much of the game's appeal derives from its sophisticated physics engine. The innovative gravity gun, for example, allows gamers to interact with (and destroy) their environments with unprecedented thoroughness. Visually the game is dark and moody, but in an ominous way that suggests a sense of foreboding rather than generalized gloominess. Designers also excelled at integrating the known and the unknown. With highly alien technology stomping around in the woods and valleys of our own backyards, the game offers a terrific mix of the fearsome and the familiar.

RIGHT: The Hunter is one of the most common—and menacing—enemies in the *Half-Life* universe. It is an utterly alien beast, with dangerously hooked claws and a face that only its mother could love.

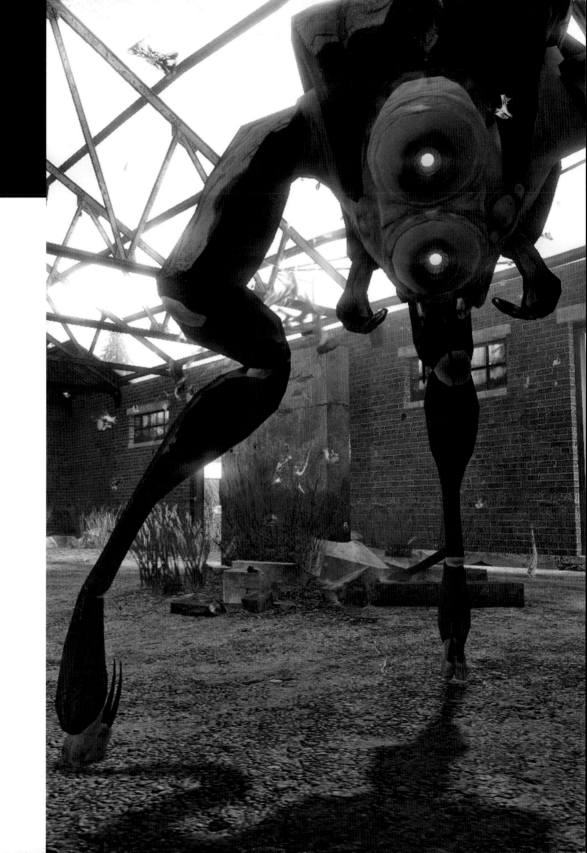

THE HUNTER

Valve artist Ted Backman was charged with designing one of the game's most notorious and ubiquitous enemies: the Hunter. Backman's work on the character began with a comprehensive study of form. "For the figure, I wanted an expressive focal area around the player's eye level and a good arrangement of light and dark areas across the form. I knew ahead of time what the basic form of the hunter would be, but I spent a lot of time working on different proportions, leg types, and facial arrangements. On this design, I probably spent most of the time doing small thumbnails."

Once the technical forms were established, Backman began working on the beast's locomotion and functionality. "The process for this design started with functional requirements," he said. "The Hunters were required to look large, imposing, and alien. They needed to move much more quickly than the soldiers, so they could keep pace with a player in a vehicle while remaining small enough to enter through doorways and pursue the player indoors." Working with Painter IX during the concept process and XSI and Mudbox for the modeling, Backman utilized the near-infinite variety of the natural world for inspiration. "I try to reference nature as much as possible," he said. "I was inspired by threat displays of mantis shrimp, the carapaces of tiger beetles, and the raptorial limbs

RIGHT: Baker's initial concept sketches establish the character's basic form and facial features.

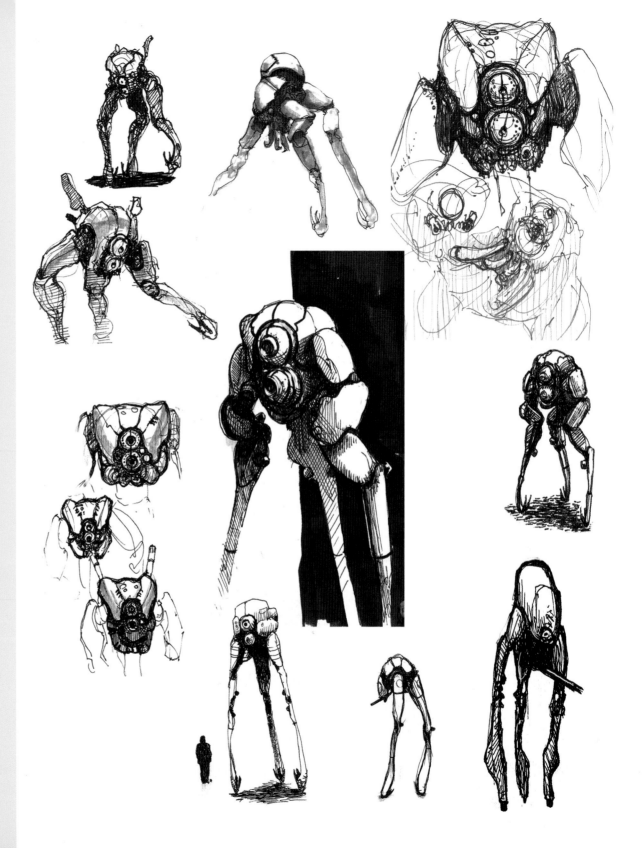

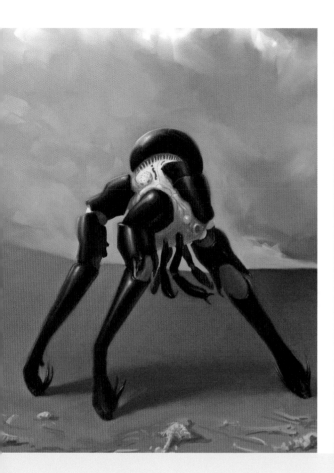

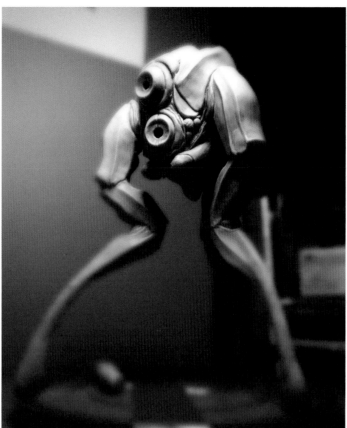

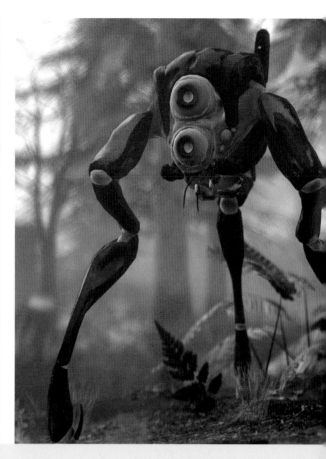

of mantids. I also looked a lot at the surfaces of scorpions and how the contours reinforced the structure of the exoskeleton."

Above all, Backman seemed determined to make the beast look and act like a genuine, living creature. "I wanted the Hunter to look like something new, not something that fit deep inside any well-established aesthetic. Expressiveness was also one of my primary concerns. I didn't want the Hunter to be anthropomorphic, but I did want it to be emotive." That emotion is well defined and carries with it a lesson to other artists: The heart of a piece is in the prep work.

ABOVE LEFT: A full-scale painting further elaborates the creature's form and color.

ABOVE CENTER: A 3-D model defines volume and finalizes shape.

ABOVE RIGHT: Final image: *The Hunter*, by Ted Backman.

NEXT PAGE: An in-game shot of the Hunter on the prowl, its alien eyes fixed unflinchingly on you. It's clear that the partially flooded warehouse is about to be filled with some serious gunfire—and possibly various pieces of your body.

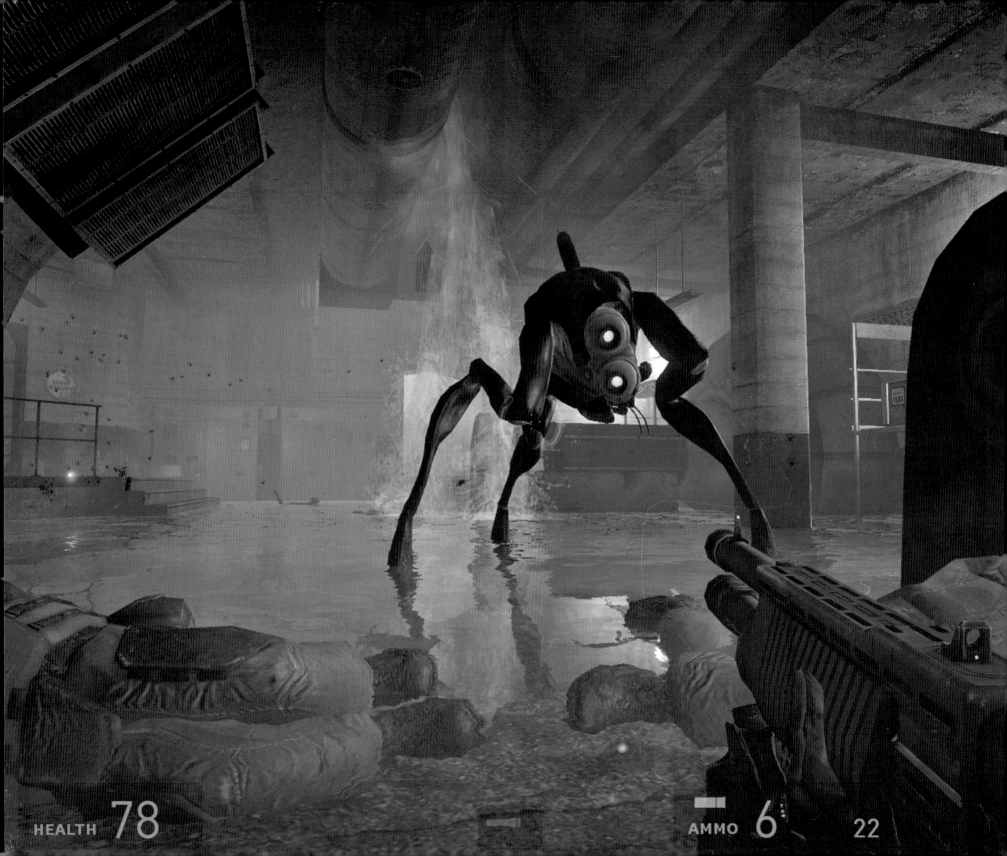

HEALTH 78

AMMO 6 22

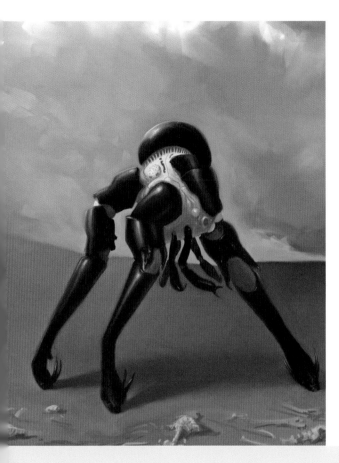

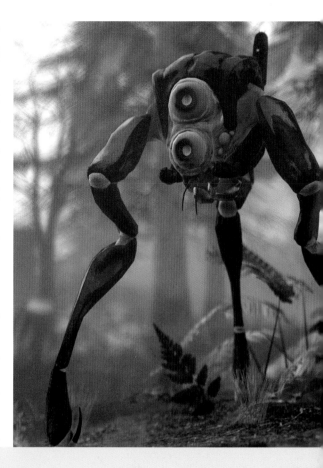

of mantids. I also looked a lot at the surfaces of scorpions and how the contours reinforced the structure of the exoskeleton."

Above all, Backman seemed determined to make the beast look and act like a genuine, living creature. "I wanted the Hunter to look like something new, not something that fit deep inside any well-established aesthetic. Expressiveness was also one of my primary concerns. I didn't want the Hunter to be anthropomorphic, but I did want it to be emotive." That emotion is well defined and carries with it a lesson to other artists: The heart of a piece is in the prep work.

ABOVE LEFT: A full-scale painting further elaborates the creature's form and color.

ABOVE CENTER: A 3-D model defines volume and finalizes shape.

ABOVE RIGHT: Final image: *The Hunter*, by Ted Backman.

NEXT PAGE: An in-game shot of the Hunter on the prowl, its alien eyes fixed unflinchingly on you. It's clear that the partially flooded warehouse is about to be filled with some serious gunfire—and possibly various pieces of your body.

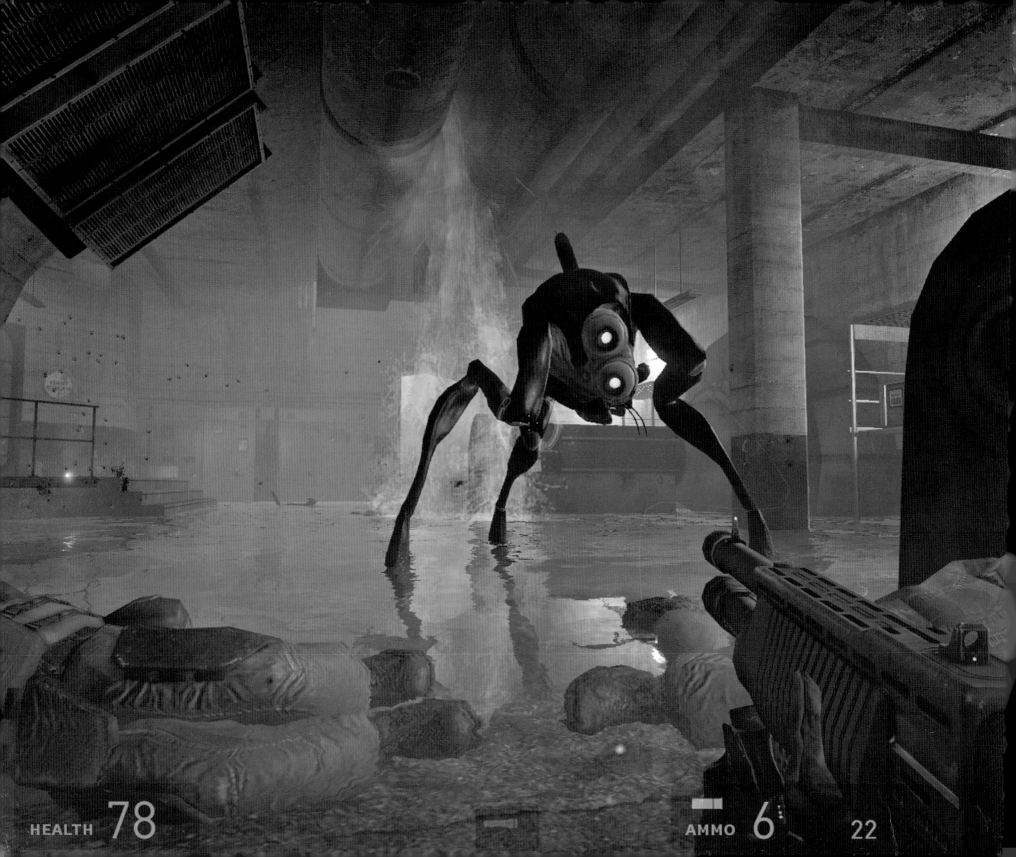

HEALTH 78

AMMO 6 22

CITY 17

This haunting image by Valve's Jeremy Bennett appears early in *Episode 2*. "This event sets the scene for the game," he explained. "The sense of foreboding and unease created here permeates the entire game. At this point we are not fully aware of the danger lurking or what form it may take, so this event acts as a very direct signal that all is not right in the world. The vista needed to feel huge and apocalyptic, with any feelings of hope or salvation threatened by extinction. Several studies were created. [We tried] variations that experimented with color temperature and contrast to ensure we came close to the desired effect."

Working in Photoshop, Bennett completed work on *City 17* in record time. A fact that, he said, works to its benefit. "The main painting took a couple hours," said Bennett. "It's fairly quick, as you can see, and does employ some photographic elements. I personally feel it works due to the lack of time spent on it, which maybe helped convey a certain amount of frenetic energy needed in the piece. . . . We knew roughly how large the vista needed to be and what information it should convey. We were looking for a focal point from which the portal storm would emanate to make the storm feel believable and therefore threatening. The vista was broken down into four layers of cards sitting in front of the skybox, which gave us the opportunity to introduce artificial fog to help convey depth and parallax to complete the illusion of a sweeping vista."

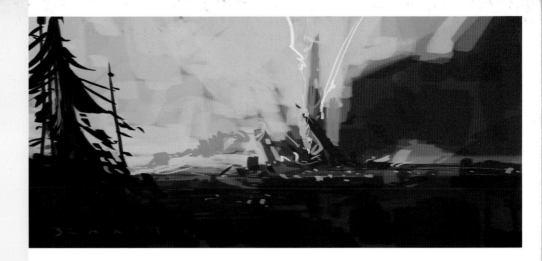

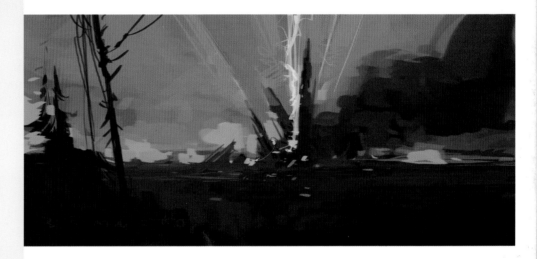

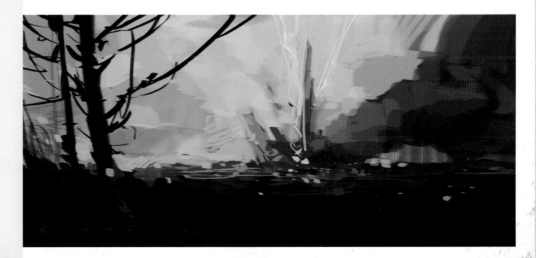

RIGHT: Initial paintings outline color, scale, and perspective.

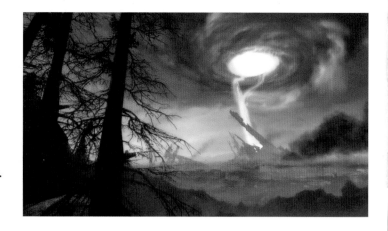

RIGHT: A second pass incorporates a dramatic cyclone.

BELOW: Final image: *City 17*, by Jeremy Bennett.

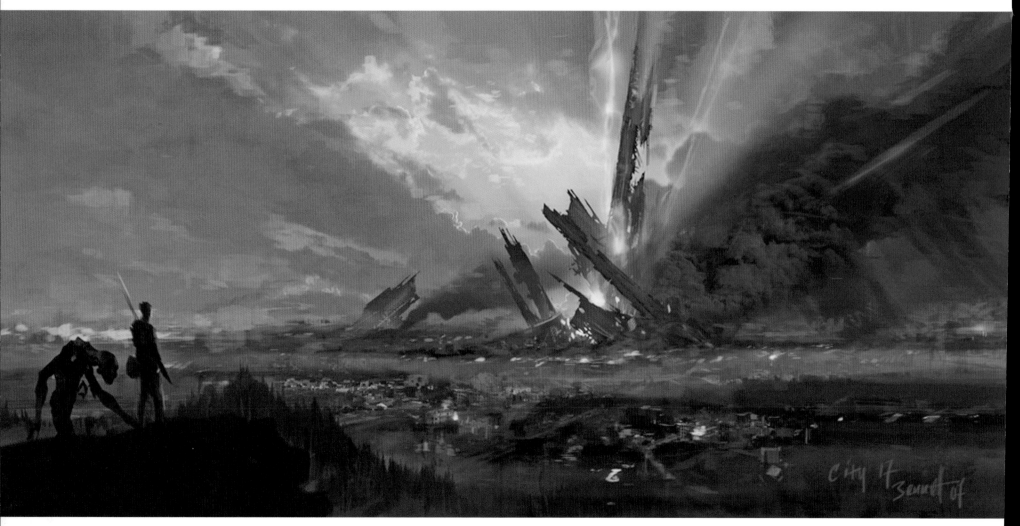

CITY 17

This haunting image by Valve's Jeremy Bennett appears early in *Episode 2*. "This event sets the scene for the game," he explained. "The sense of foreboding and unease created here permeates the entire game. At this point we are not fully aware of the danger lurking or what form it may take, so this event acts as a very direct signal that all is not right in the world. The vista needed to feel huge and apocalyptic, with any feelings of hope or salvation threatened by extinction. Several studies were created. [We tried] variations that experimented with color temperature and contrast to ensure we came close to the desired effect."

Working in Photoshop, Bennett completed work on *City 17* in record time. A fact that, he said, works to its benefit. "The main painting took a couple hours," said Bennett. "It's fairly quick, as you can see, and does employ some photographic elements. I personally feel it works due to the lack of time spent on it, which maybe helped convey a certain amount of frenetic energy needed in the piece. . . . We knew roughly how large the vista needed to be and what information it should convey. We were looking for a focal point from which the portal storm would emanate to make the storm feel believable and therefore threatening. The vista was broken down into four layers of cards sitting in front of the skybox, which gave us the opportunity to introduce artificial fog to help convey depth and parallax to complete the illusion of a sweeping vista."

RIGHT: Initial paintings outline color, scale, and perspective.

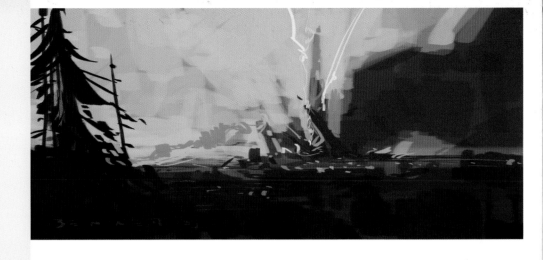

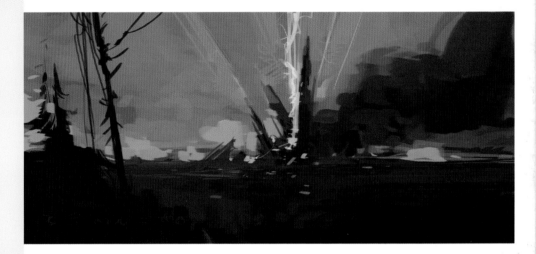

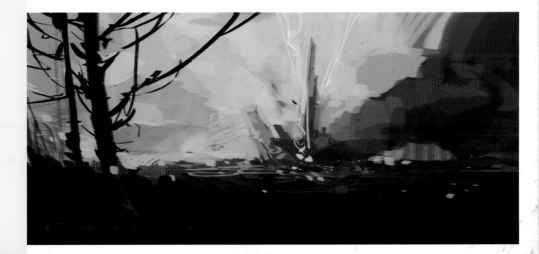

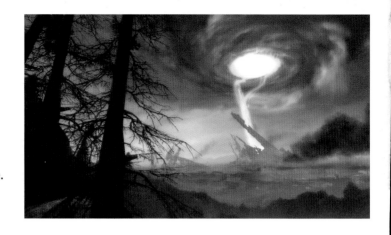

RIGHT: A second pass incorporates a dramatic cyclone.

BELOW: Final image: *City 17*, by Jeremy Bennett.

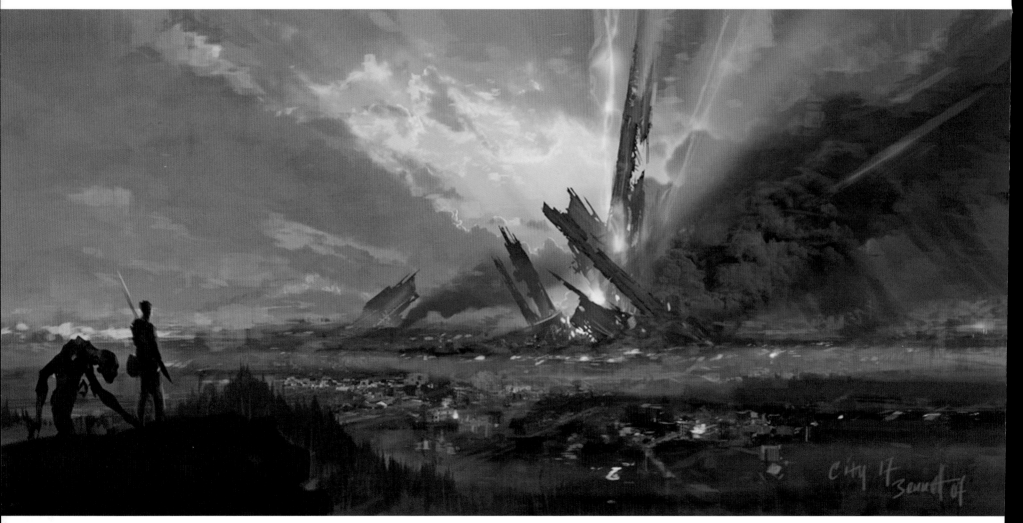

Hellboy

DEVELOPER: KROME STUDIOS
PUBLISHER: KONAMI

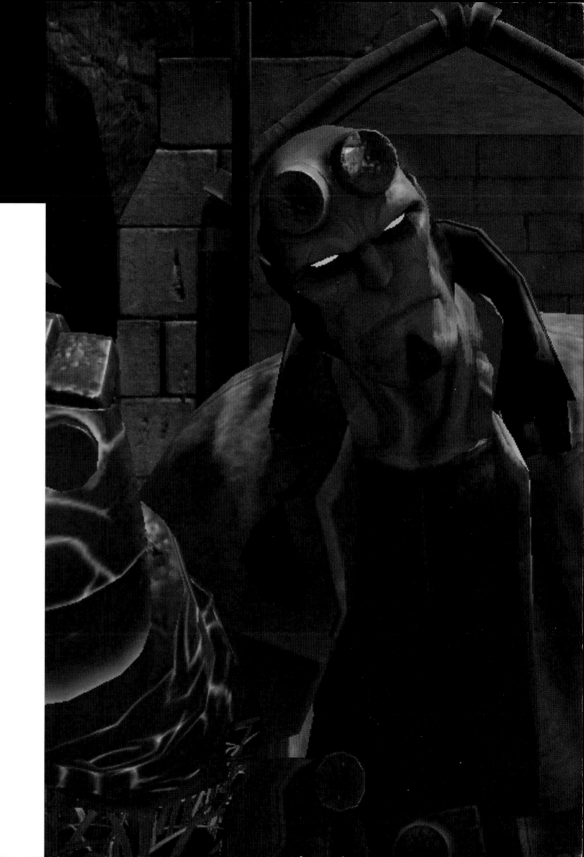

The task of turning a beloved comic icon into an interactive superstar is never easy. Developers of Hellboy were obligated to please a demanding gaming public as well as a devoted fan base of the many comics and graphic novels from Dark Horse Comics. Nevertheless, the teams at Konami and Krome have managed to appease both camps. The game is a feast for the eyes (and the thumbs). Designers have managed to create a truly complete other world—one that melds the foreign and the familiar, the funny and the frightening. Every scene is filled with ominous shadows, moody lighting, and a host of terrible enemies both terrestrial and otherworldly. In an interview with IGN.com, lead designer Chris Palu talked about his team's visual goals: "It's really important for the Hellboy mythos and its world that you really feel like you're in another place. It's one of the things that the next-gen consoles allow us to do. We want to put the player in a place where they really feel like they're a part of the 'Other,' where they're in these fantastic worlds."

RIGHT: With bright-red skin, filed horns, and a tail, Hellboy casts an imposing figure. Krome artists were tasked with creating an accurate in-game representation of a character beloved by millions worldwide.

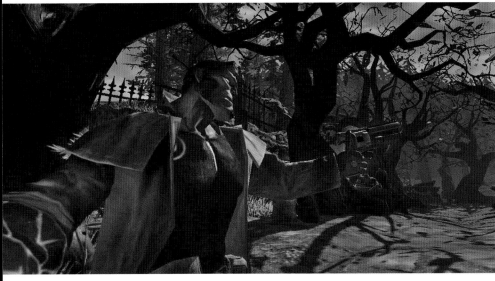

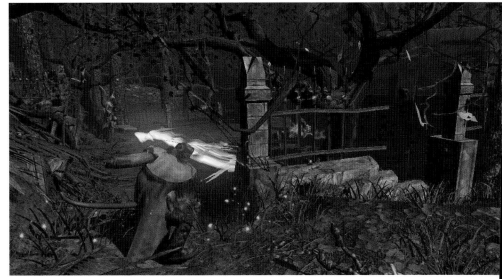

ABOVE LEFT: With such rich source material, *Hellboy* features a fantastic array of monstrous and misshapen villainy.

BELOW LEFT: Lead designer Chris Palu spoke about creating a sense of the "Other," a world of ominous shadow and otherworldly ambience.

ABOVE RIGHT: With fully destructible environments, Hellboy literally tears up the scenery, charging through enemies (and walls) like a hot knife through Nazi-flavored gelatin.

BELOW RIGHT: Hellboy's pursuit of the forces of darkness takes him all over the world, from verdant Old World forests to creepy czarist villages.

OPPOSITE PAGE: Hellboy takes on the formidable Frog Fiend in the bowels of some dank, mystical cave.

Hellboy

DEVELOPER: KROME STUDIOS
PUBLISHER: KONAMI

The task of turning a beloved comic icon into an interactive superstar is never easy. Developers of Hellboy were obligated to please a demanding gaming public as well as a devoted fan base of the many comics and graphic novels from Dark Horse Comics. Nevertheless, the teams at Konami and Krome have managed to appease both camps. The game is a feast for the eyes (and the thumbs). Designers have managed to create a truly complete other world—one that melds the foreign and the familiar, the funny and the frightening. Every scene is filled with ominous shadows, moody lighting, and a host of terrible enemies both terrestrial and otherworldly. In an interview with IGN.com, lead designer Chris Palu talked about his team's visual goals: "It's really important for the Hellboy mythos and its world that you really feel like you're in another place. It's one of the things that the next-gen consoles allow us to do. We want to put the player in a place where they really feel like they're a part of the 'Other,' where they're in these fantastic worlds."

RIGHT: With bright-red skin, filed horns, and a tail, Hellboy casts an imposing figure. Krome artists were tasked with creating an accurate in-game representation of a character beloved by millions worldwide.

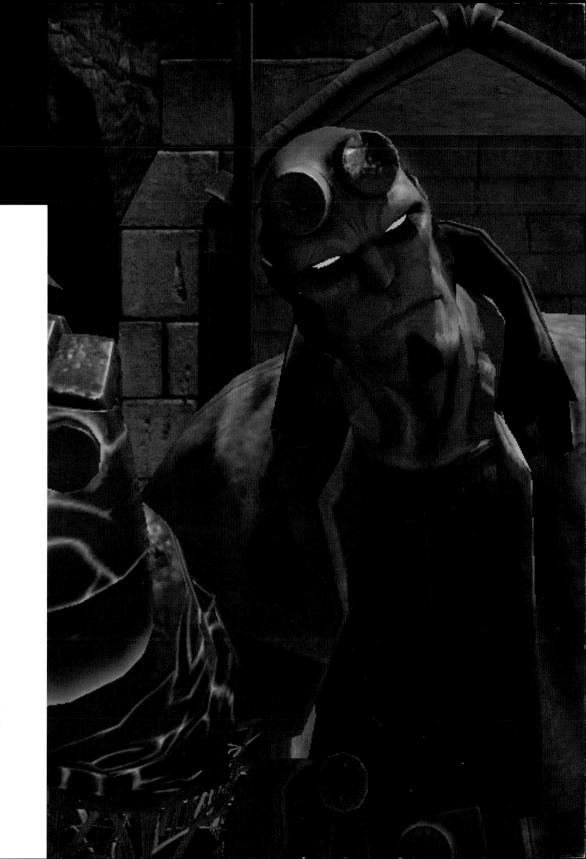

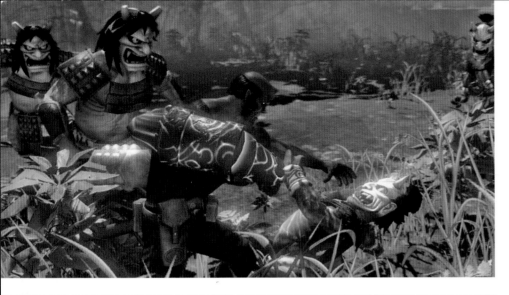

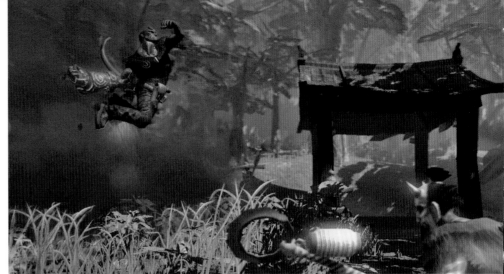

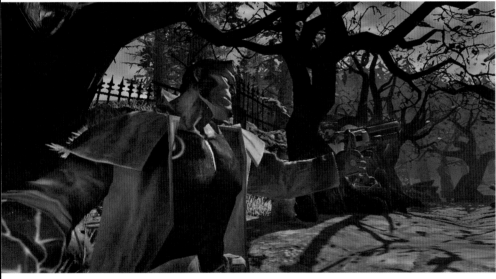

ABOVE LEFT: With such rich source material, *Hellboy* features a fantastic array of monstrous and misshapen villainy.

BELOW LEFT: Lead designer Chris Palu spoke about creating a sense of the "Other," a world of ominous shadow and otherworldly ambience.

ABOVE RIGHT: With fully destructible environments, Hellboy literally tears up the scenery, charging through enemies (and walls) like a hot knife through Nazi-flavored gelatin.

BELOW RIGHT: Hellboy's pursuit of the forces of darkness takes him all over the world, from verdant Old World forests to creepy czarist villages.

OPPOSITE PAGE: Hellboy takes on the formidable Frog Fiend in the bowels of some dank, mystical cave.

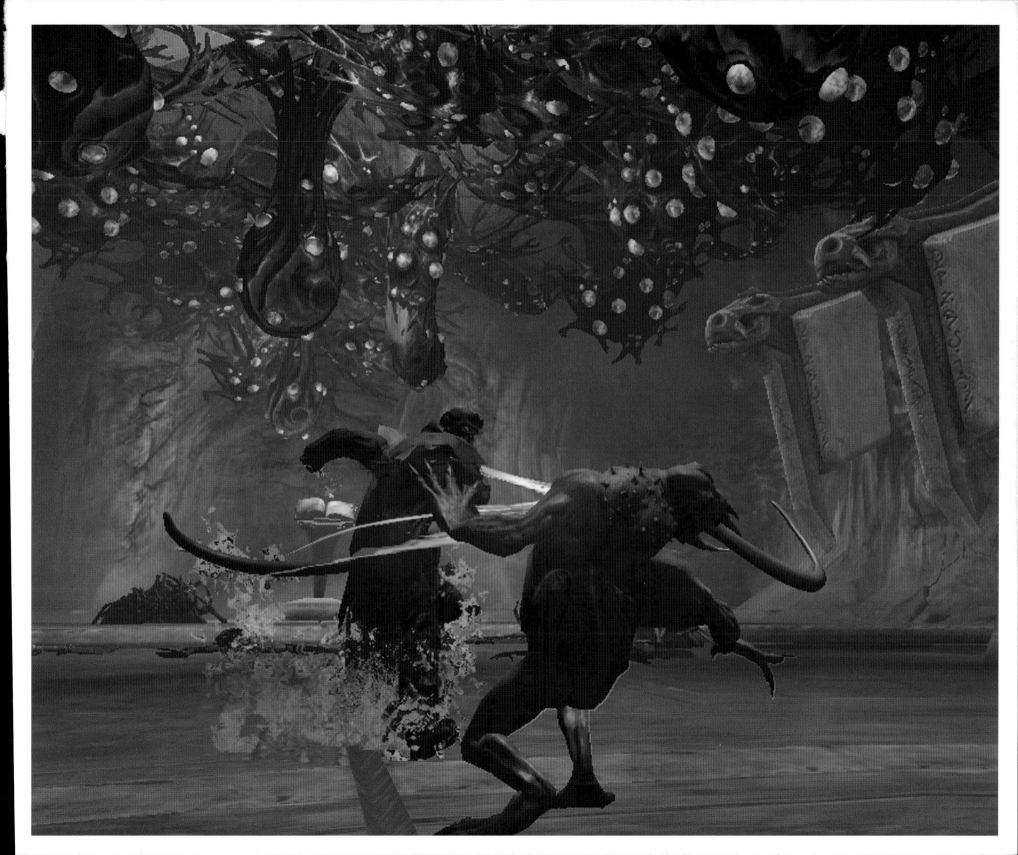

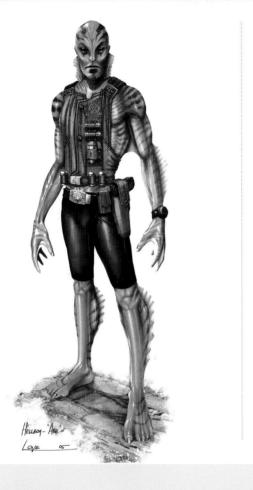

Hellboy "Abe"
Love 05

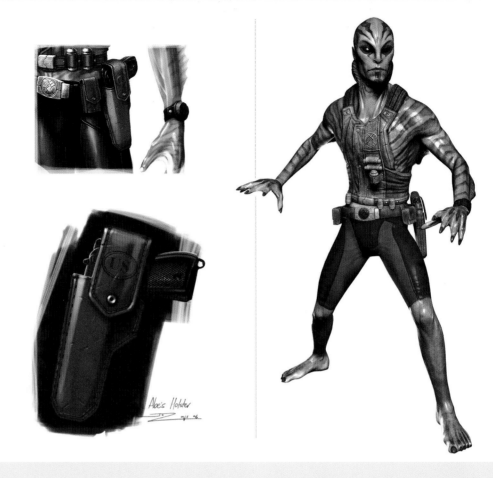

Abe's Holster

ABE SAPIEN

Krome artist Stuart MacKenzie walked us through the process of bringing to life Abe Sapien, one of the game's key protagonists. "The inspiration for the art was born from a mix of Mike Mignola's Hellboy universe as well as mystical, historical, and creepy places around the globe," he said. "At the beginning of the project, Krome and Konami sent a three-man team to Europe for some inspiration and location scouting. The team was made up of our publisher, our designer, and myself. Literally thousands of photos were taken so that we could use them for reference later, back at the studio. Visiting run-down villages and seeing some truly creepy architec-

ture, castles, and forests along the Carpathian Mountains was all we needed to feel that spooky mood, not to mention some hair-raising situations we found ourselves in while out in the middle of nowhere."

After producing tons of concept art, an initial design brief, and a small demo game, MacKenzie presented the direction to Mike Mignola, the creator of Hellboy. Also present in the meeting were Mike Richardson, the founder of Dark Horse Comics, and Guillermo Del Toro (producer of the *Hellboy* movies). "As you can imagine, it's pretty important to impress these guys, as they are highly creative and it's their baby you are working with. This day was easily the

ABOVE LEFT: An early model of the character lays out basic size, shape, volume, and personality.

ABOVE CENTER: A series of detail drawings helps late-stage modelers create more faithful 3-D renderings.

ABOVE RIGHT: Final Abe Sapien model, ready for insertion in the game.

highlight of my career to date; they were all so happy with what we were doing and were extremely impressed with the quality of the design and concept art. Being told that we had nailed the character design was a huge weight off our shoulders."

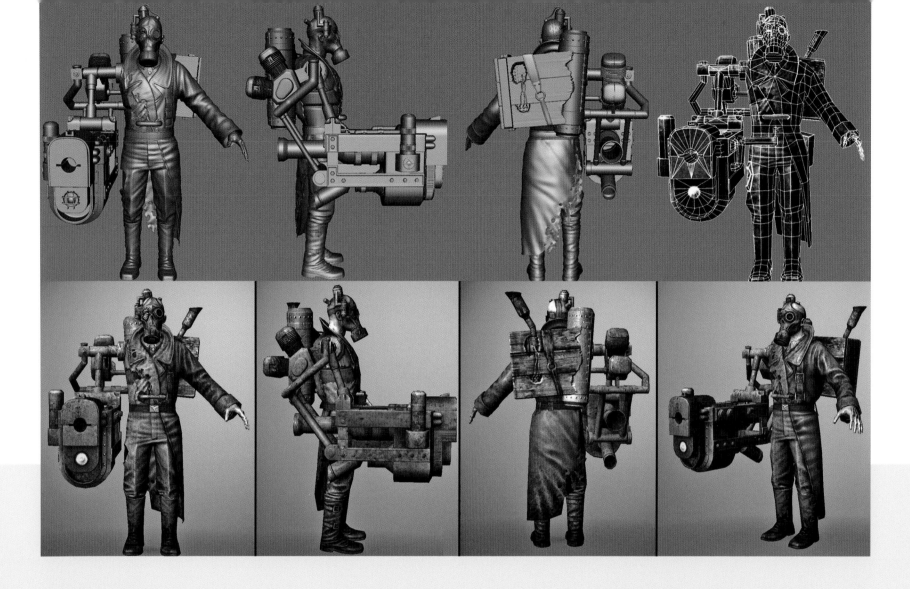

SAND KRIEGER

Krome artist Stuart MacKenzie discussed the evolution of this character, from the first sketches to sophisticated 3-D renderings complete with volume and texture. Solid concept art was the first step; the next was creating detailed concepts and model sheets. According to MacKenzie, all this prep work is essential. He told us, "I strongly believe that for the art team on any project, good concept is the artistic backbone to a visually appealing game. A good piece of concept should inspire the other project members, and it helps meld the team together." Once again, project executives, including Hellboy creator Mike Mignola and producer Guillermo Del Toro, had final sign-off on the designs. Once the directions were approved, the final in-game artwork was produced.

ABOVE TOP: From Stuart MacKenzie's original concept drawing, a detailed 3-D model is created.

ABOVE BOTTOM: Lighting, texture, and details are added in preparation for the character's transition into an in-game asset.

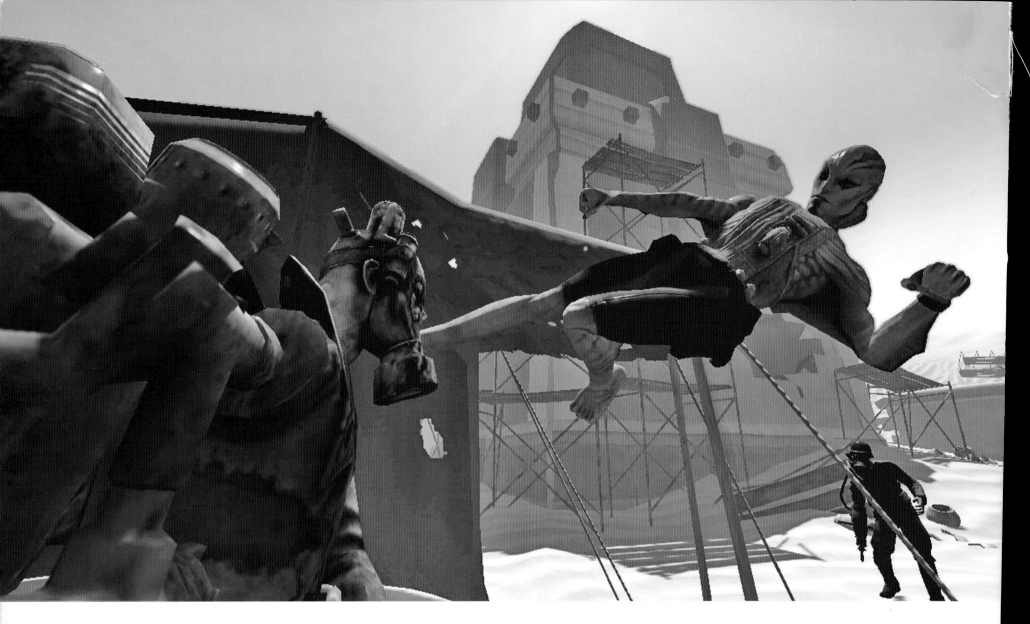

ABOVE: After months of concept and modeling work, Abe Sapien is inserted into the game. That so much detail is retained in the in-game model is a testament to the talent of the modelers and texture artists.

RIGHT: Model, texture, lighting, and background come together as the Sand Krieger is finally inserted into the game.

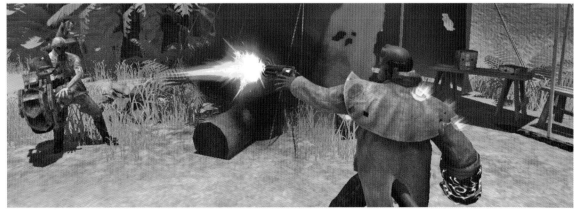

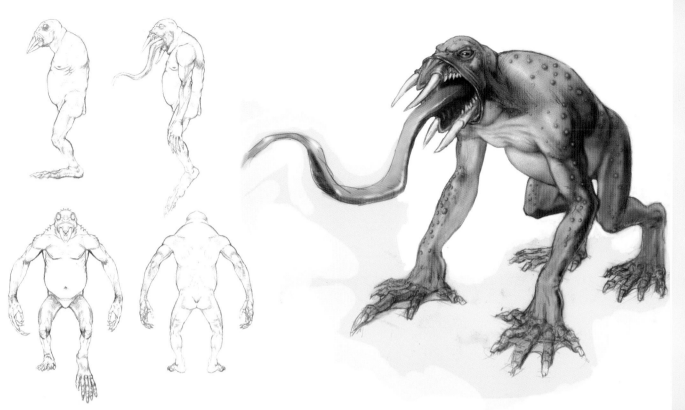

FROG FIEND

FAR LEFT: Early concept sketches define the shape and proportion of the Frog Fiend.

LEFT: A final colorized sketch incorporates a reptilian skin tone and hints at the beast's quadruped tendencies.

BELOW: An in-game capture of the Frog Fiend. Krome modelers managed to capture all the gruesome menace of the original concept sketches.

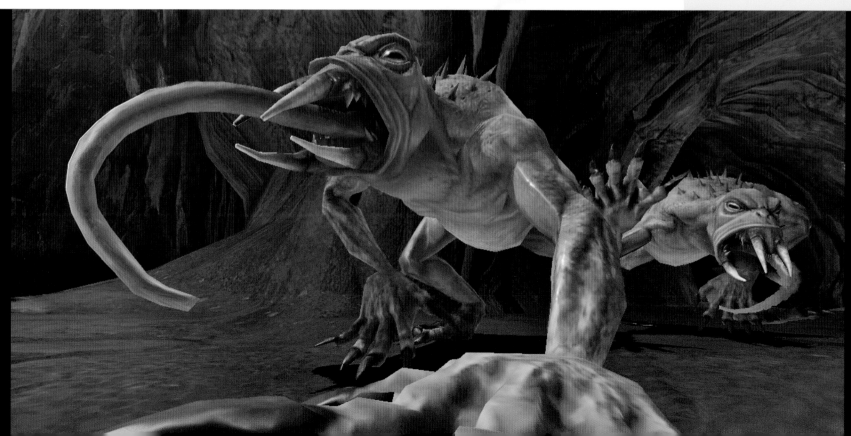

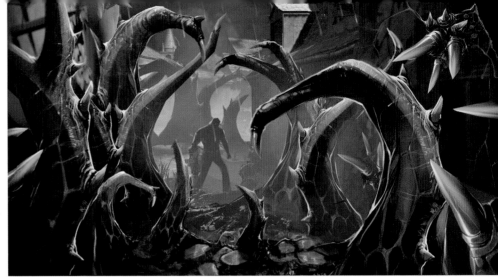

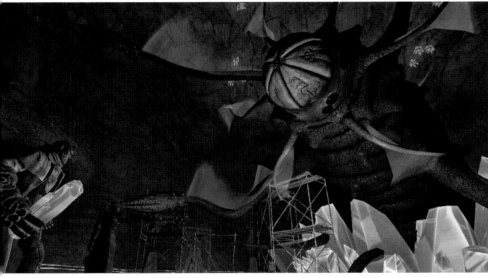

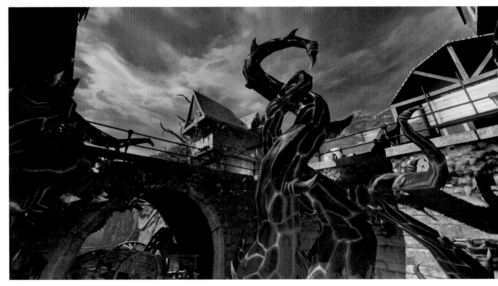

ABOVE LEFT: A concept illustration outlines a horrific plantlike beast known as the Demon Worm, its writhing tentacles poised with malicious intent.

BELOW LEFT: The Demon Worm as it appears in the game. Notice how the modeler, while staying true to the original sketch, has thickened the midsection, incorporating a sense of strength missing from the initial pass.

ABOVE RIGHT: Another concept sketch lays out a haunted, diseased forest; a corrupt root system seems to be almost willfully devouring a small village.

BELOW RIGHT: An in-game rendering of the same forest. The glowing red fissures on the plant life have been amplified and set against an ominous, stormy green sky.

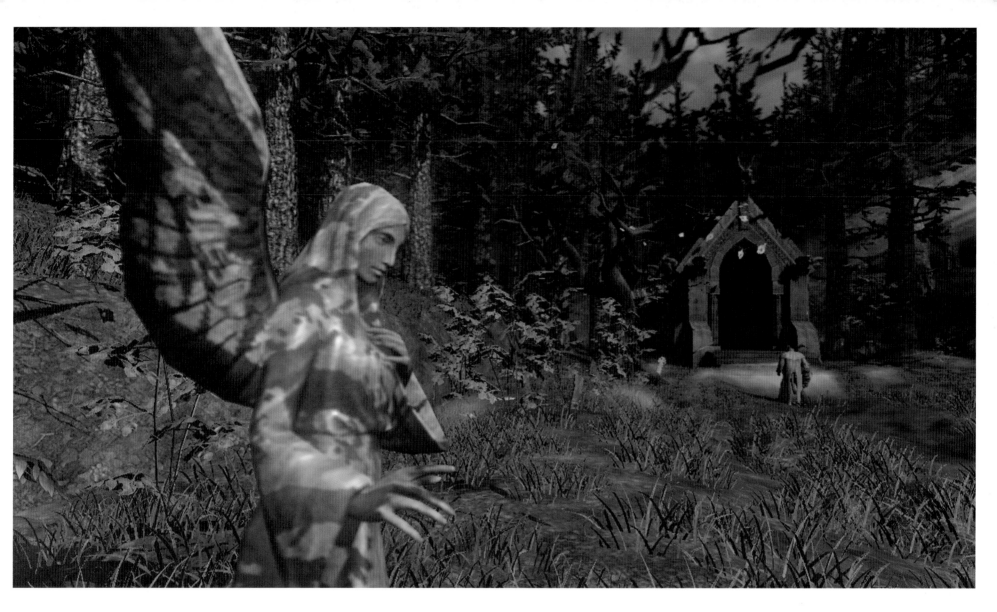

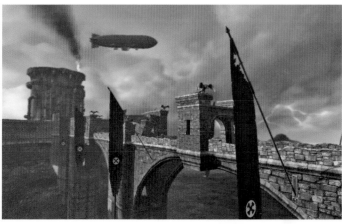

ABOVE: *Hellboy: Science of Evil* is all about atmosphere. Gothic religious iconography serves to contrast and underscore the game's thematic material.

LEFT: The design team's trip to Eastern Europe paid huge dividends from an artistic standpoint. Strong stone architecture designed for purely utilitarian purpose recalls a certain red-hued protagonist.

Hellgate: London

DEVELOPER: FLAGSHIP STUDIOS
PUBLISHER: ELECTRONIC ARTS

This dark and atmospheric thriller is steeped in biblical lore and European history. The story takes place in the near future, after a diabolical army of demons has invaded London, renewing a centuries-old struggle of good versus evil. Fortunately, the ever-enigmatic Freemasons designed the London subway system to be resistant to demonic influence. And so it is from the Underground that you valiantly set out, armed with weapons both ancient and modern.

Visually *Hellgate* is an appealing mix of arcane and contemporary elements. Soldiers clad in ancient Templar armor wage war amid present-day London; modern soldiers combat their foes with medieval weaponry. It makes for a unique aesthetic chemistry that pervades much of the action. The game feels rather like an epic dark fantasy set against a backdrop of modern civilization—a little like the *Harry Potter* movies, but with a lot more gore.

RIGHT: Emmera Ephram, a key character in *Hellgate: London*, is shrouded in enough raw energy to power the eastern seaboard. The artist has done a phenomenal job of wedding the elemental vigor of the natural world with a completely realized, realistic character.

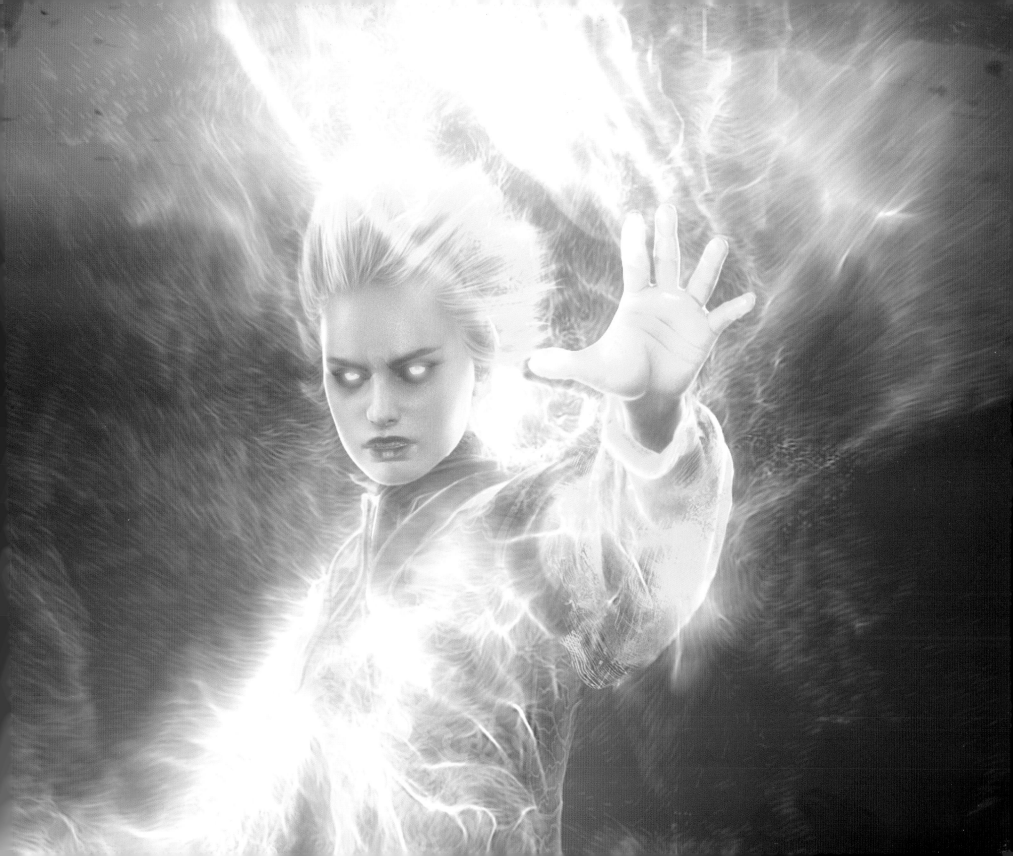

ABOVE: An early sketch of the Sydonai demon, establishing basic shape and silhouette.

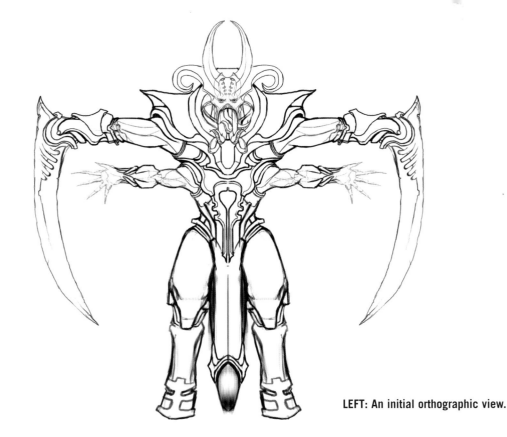

LEFT: An initial orthographic view.

SYDONAI

Here we see the evolution of Sydonai, the game's final villain. As a character, Sydonai is key to the *Hellgate* storyline. Designed initially in Photoshop CS2, with 3-D modeling in Zbrush and Autodesk 3ds Max, the final concept took artist Lee Dotson four days to finish. "My goal with Sydonai was to come up with a monster that didn't fall back on the 'fire, spikes, and skulls' philosophy of creature design," he said. "Of course, I wound up falling back on some archetypically evil design traits established by the always classic Cthulhu. But I feel like Sydonai still manages to be distinct."

Dotson is quick to point out that most of his artistic decisions are informed by a meticulously compiled design scheme: "Typically, any monster, character, or item in *Hellgate: London* begins its life as a variety of Excel spreadsheet entries," he said. "These fields determine game specifics regarding the unit. So, if it's a weapon we're making, is it going to be one-handed or two-handed? Check the sheet. If it's a suit of armor, what type of character faction is going to be wearing the armor? The sheet will say. And, if it's a monster, what's the basic type of behavior that monster is meant to have? Let's ask Excel. What this means is that we put gameplay first. Flagship tries to determine what would be best for *Hellgate: London* from a gameplay perspective and

OPPOSITE PAGE TOP LEFT: Orthographic view with closer attention to detail and texture.

OPPOSITE PAGE BOTTOM LEFT: Shadow, texture, and lighting are added to the sketch.

OPPOSITE PAGE FAR RIGHT: Final details and color are incorporated.

then requires artists to fill in the blanks."

But through it all, Dotson's guiding design dictum was simple. When players finally come upon Sydonai toward the end of the game, he wanted them to think just one thing: "Oh, @#!%! He's going to beat my ass!"

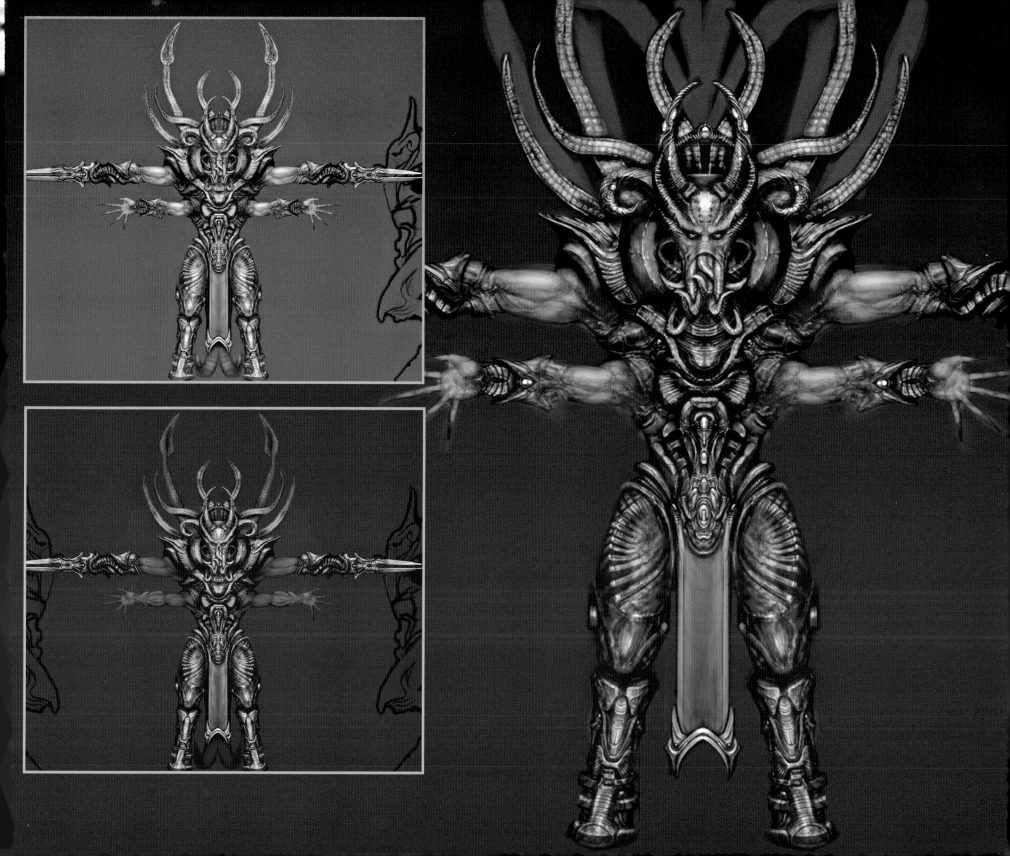

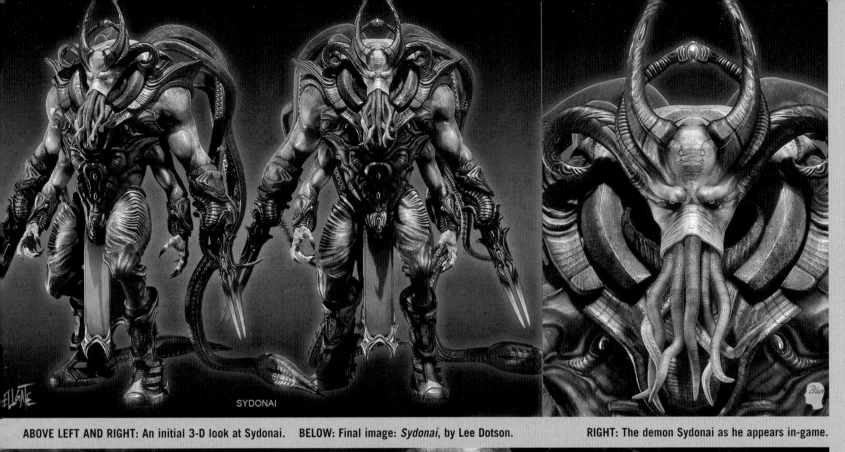

SYDONAI

ABOVE LEFT AND RIGHT: An initial 3-D look at Sydonai. BELOW: Final image: *Sydonai*, by Lee Dotson. RIGHT: The demon Sydonai as he appears in-game.

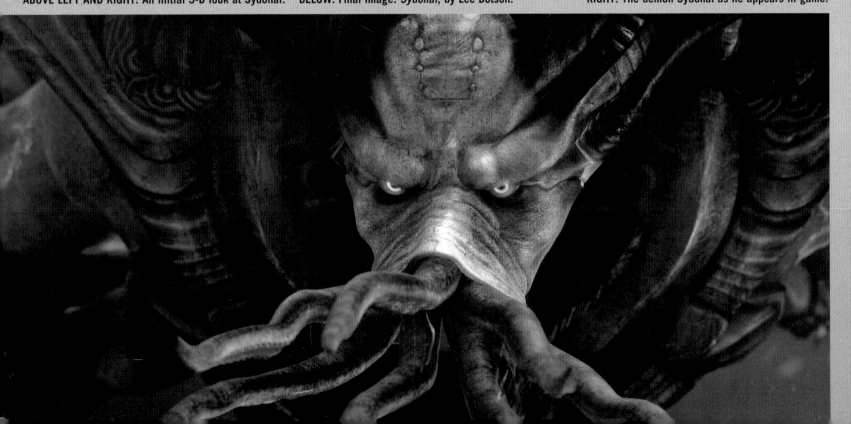

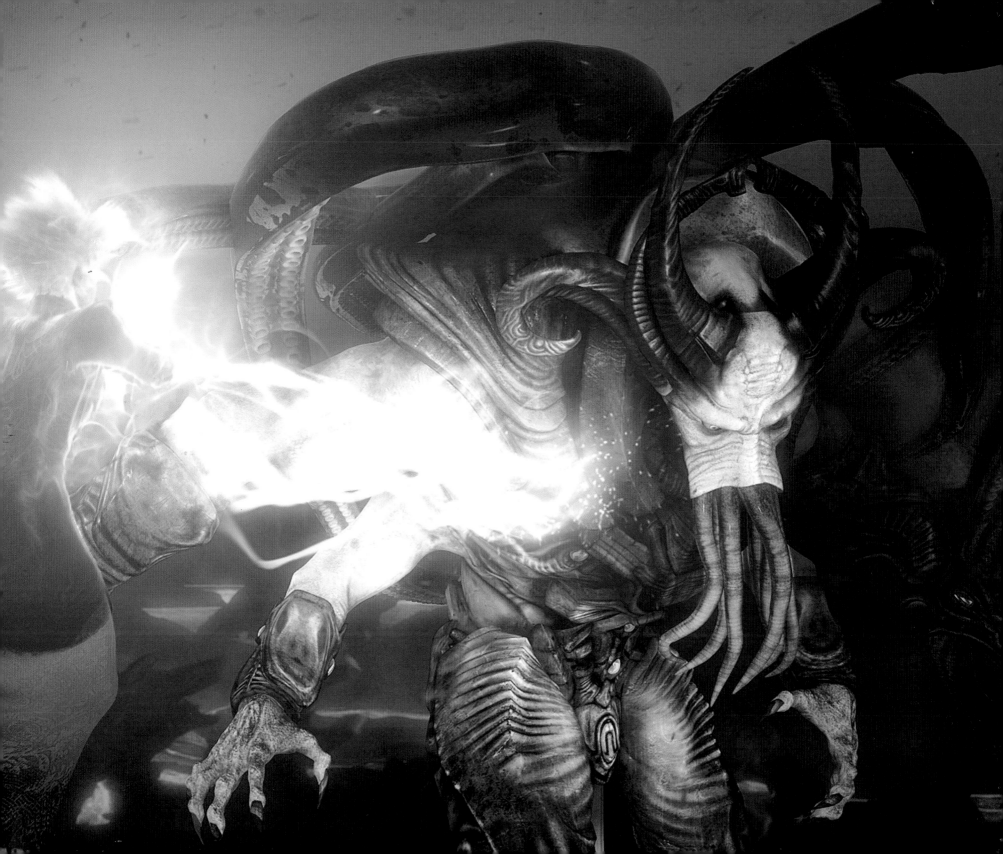

TRUTH ROOM

By utilizing the natural dramatic energy of shadows, the dynamic interplay of darkness and light, and plenty of spider webs (never underestimate the remarkable theatrical prowess of spider webs!), Flagship Studios' Jin Hyung Kim has managed to craft an environment of deep foreboding. He became involved with the design at a pivotal point: The development team had the game fleshed out in broad strokes, and everyone knew generally what they wanted. They just needed an artist like Kim to reflect their ideas back to them on paper.

"Directors usually provide the underlying theme of a piece," said Kim. "With that in mind, I play with different shapes and do some thumbnails to set tone. This is the most exciting step. Sometimes I try to capture or imitate images or mix the core ideas from nature or artificial objects into my piece. It helps me incorporate some interesting shapes, colors, and textures. Saying that, photos are a great reference and help me incorporate realistic details." In the end, Kim's piece is an amalgamation of several incongruent visions of what the game should look like.

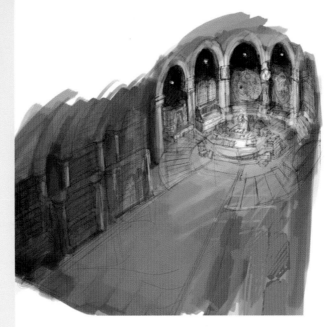

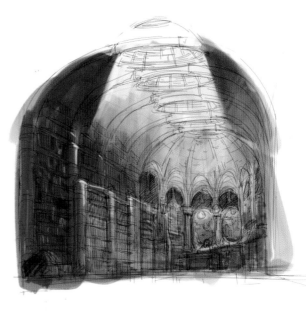

ABOVE: An early sketch lays out the room's dimensions and major architectural features.

ABOVE: Another angle enables Kim to begin a discussion of light and shadow.

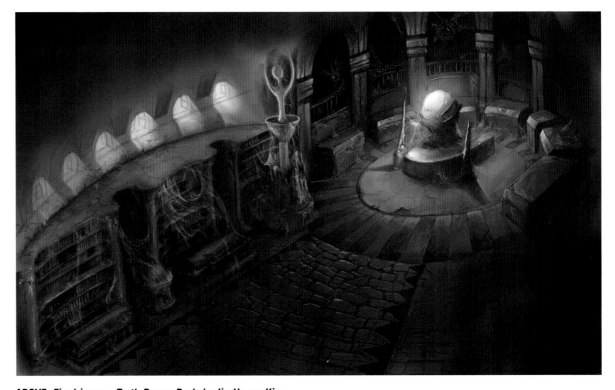

ABOVE: Final image: *Truth Room: Dark*, by Jin Hyung Kim.

FATAL HARDWARE

Creating a wide variety of devastating weapons was a priority for Flagship developers, and the resulting collection of fatal hardware is a point of great pride. The team's goal was to create guns that incorporated all of the game's narrative elements, namely present-day technology combined with a design aesthetic that favors the arcane and the occult. Developers weren't content with the tried-and-true weaponry generally seen in vampire and monster movies. (Crossbows firing bolts of holy water weren't going to cut it.) Thus, designers like Jin Hyung Kim were pressed to think outside the box, a process that resulted in such bizarre creations as the Locust Hive, a specialized firearm that launches a cloud of stinging insects at the target. Other results of his brainstorming are shown here.

RIGHT: On the first pass, Kim works within the established look of the game to sketch a few dozen weapon ideas for each of the factions.

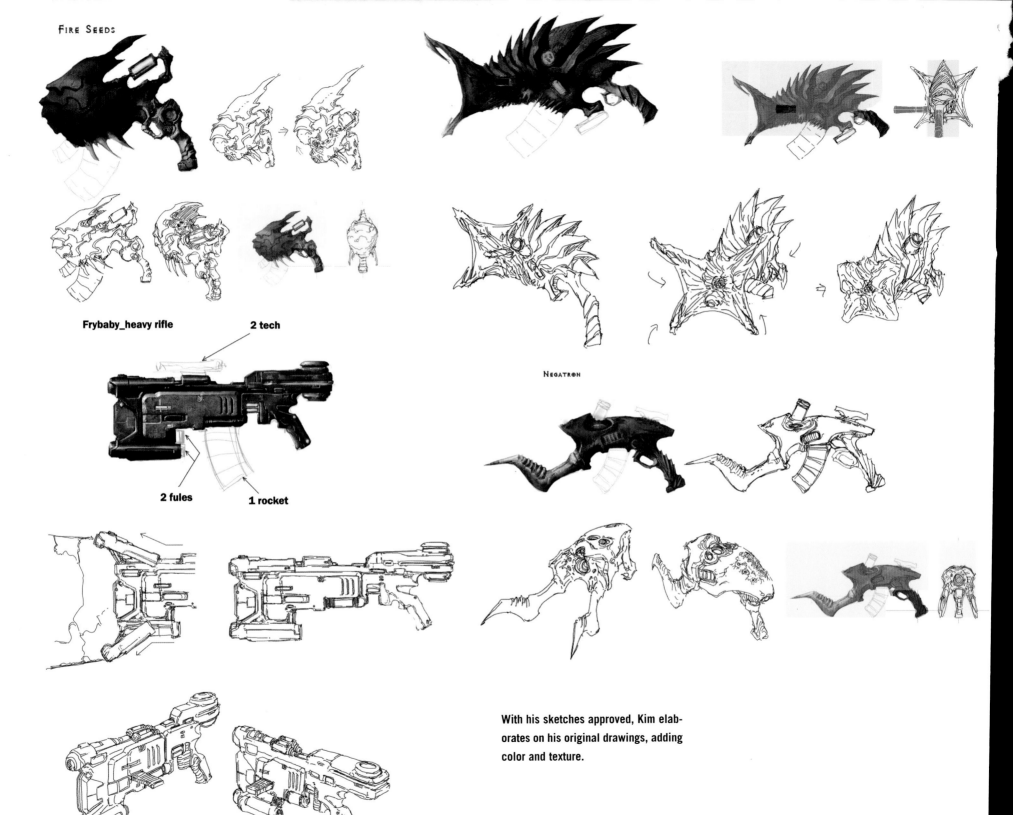

FIRE SEEDS

Frybaby_heavy rifle

2 tech

2 fules

1 rocket

NEGATRON

With his sketches approved, Kim elaborates on his original drawings, adding color and texture.

Thumper_rocket launcher

1 tech

1 fuel

2 rocket

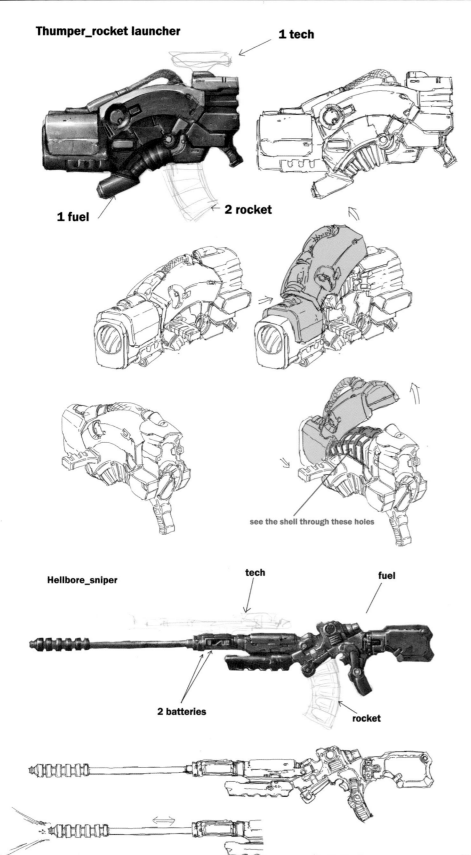

see the shell through these holes

Hellbore_sniper

tech

fuel

2 batteries

rocket

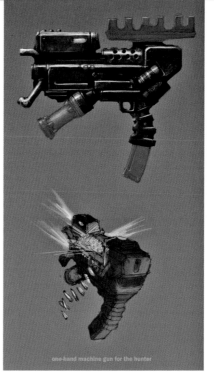

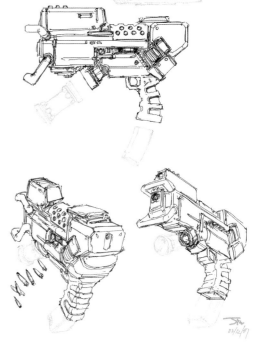

one-hand machine gun for the hunter

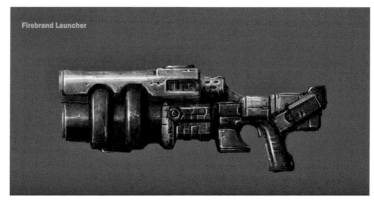

Firebrand Launcher

battery

Tech

x2 fuel

x2 Rocket Clip

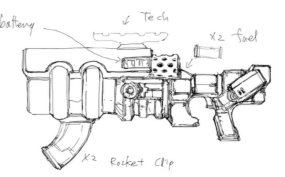

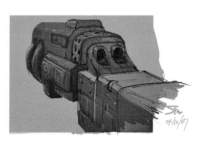

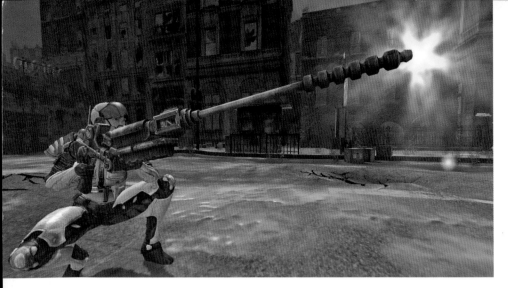

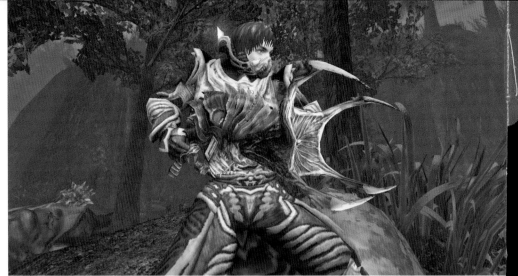

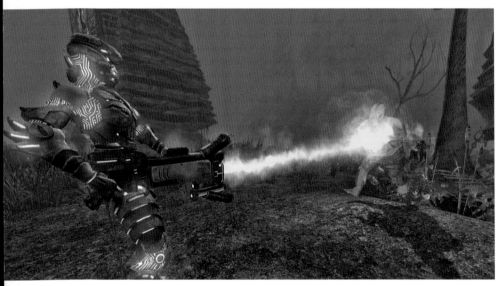

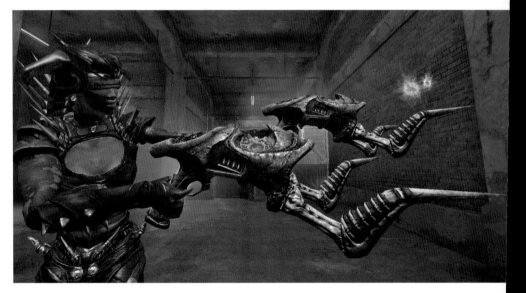

After final approval, Kim's weapons are rendered in three dimensions and put into the game. Here are the final versions of the Hellbore Sniper (above left), Frybaby Heavy Rifle (below left), Singularity Node (above right), Negatron (middle right), and Dual Fireseeds (below right).

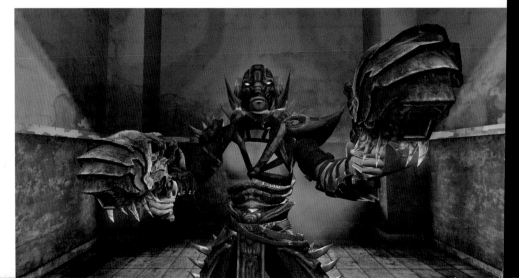

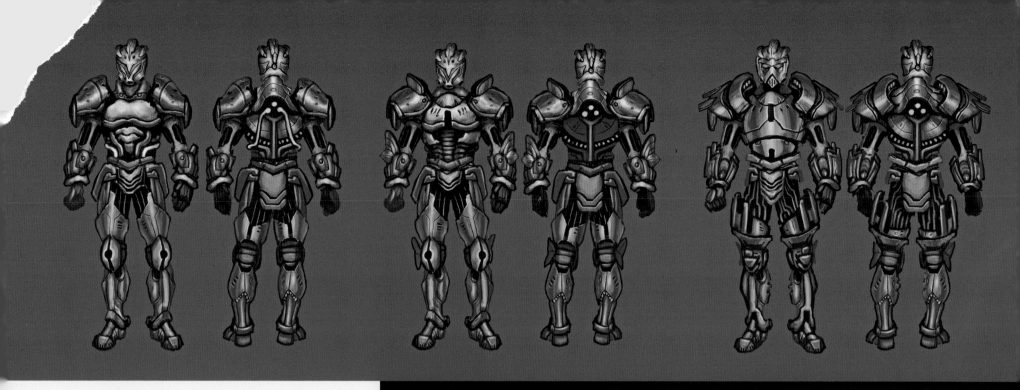

ARMOR

Featured here is one of *Hellgate: London*'s coolest armor configurations, the Templar-Guardian's Heavy Armor, from concept artist Jason Felix. As with any good artist, when beginning work on the piece, Felix tried to set his subject in historical context. "Every time I start a new idea, it's important for me to focus on the overall silhouette and shapes," he said. "Once fortified in direction, it is vital to figure out how each piece actually moves and works. I've spent a lot of time and effort studying how medieval armor is crafted, moves, and functions."

FROM UPPER LEFT TO RIGHT: In his first pass, Felix outlines the essential elements of the armor elements, their shapes and sizes.

A second sketch incorporates new elements, such as pronounced gauntlets and knee protrusions.

Further refinements include the addition of two glowing eyes, which lend the suit a menacing air.

This final sketch incorporates more of the glowing inner light featured in the previous iteration. Religious iconography is also included.

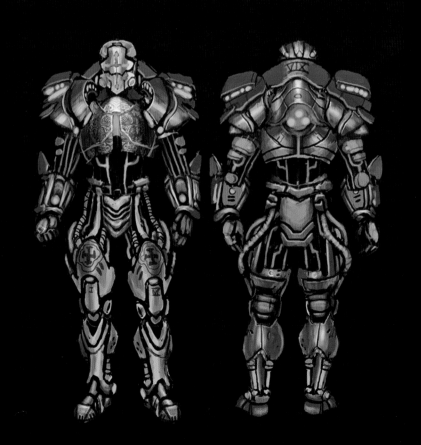

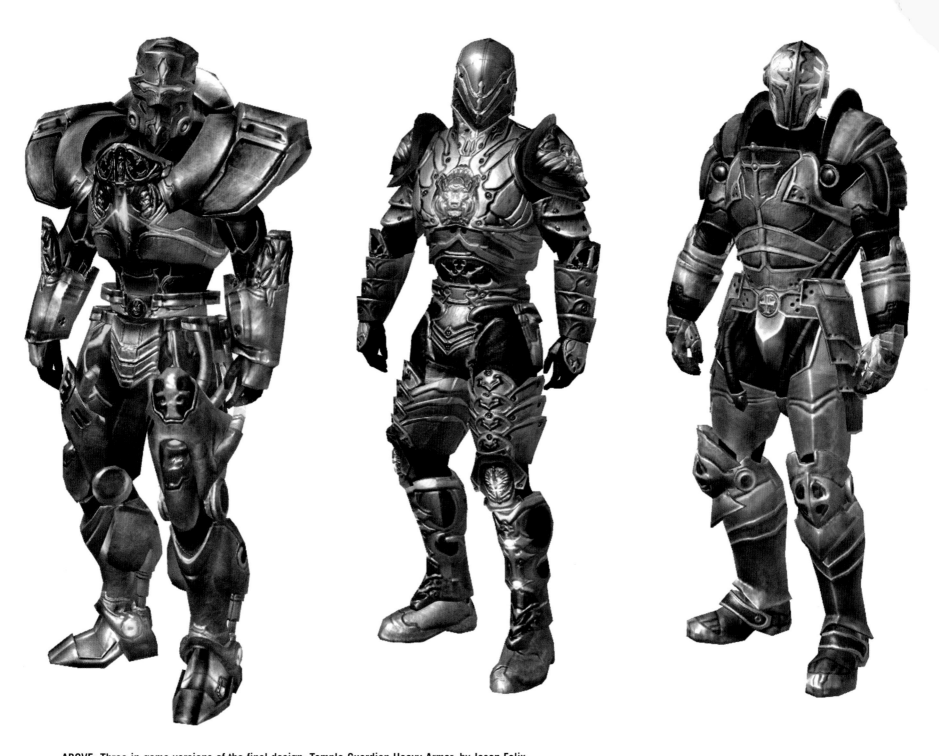

ABOVE: Three in-game versions of the final design: Temple-Guardian Heavy Armor, by Jason Felix.

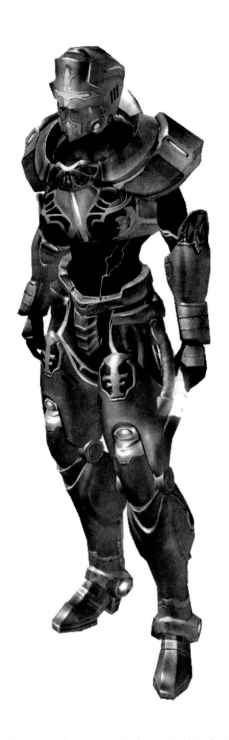
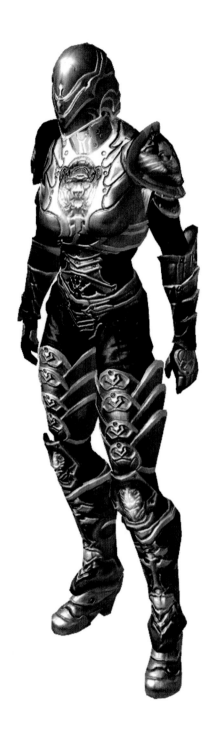
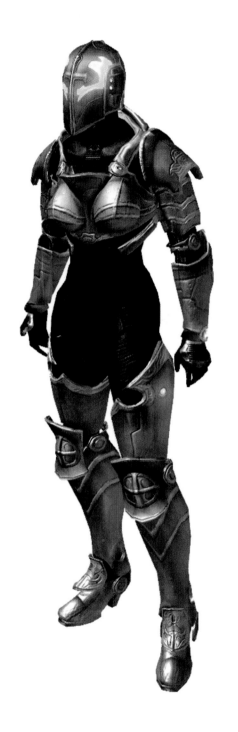

ABOVE: More in-game renderings of Felix's final Temple-Guardian armor.

Kane & Lynch: Dead Men

PUBLISHER: EIDOS

DEVELOPER: IO INTERACTIVE

One of the most highly anticipated shoot-'em-ups in recent memory, *Kane & Lynch: Dead Men* was clearly influenced by the films of Michael Mann, Quentin Tarantino, James Cameron, and any other director who's staged a high-octane shootout in a gritty urban environment. The story revolves around troubled anti-hero Kane and his necessary partnership with Lynch, a delightfully ruthless madman with uncertain motives. Together the mismatched protagonists mete out their gory brand of justice in a desperate attempt to save their own particularly thick necks.

A good part of the fun of *Kane & Lynch* comes from exploring the game's gorgeously rendered environments. Much of the action takes place in an unnamed city filled with massive edifices and imposing interior architecture, and this familiarity lends the game a sense of reality you don't get from battling frogmen on alien spaceships. Plus, there's nothing quite like a furious gun battle 86 stories above street level.

For the game's stellar backgrounds, art director Martin Guldbaek said that the team relied on photo shoots in Los Angeles, attempting to capture that city's gritty metropolitan architecture and innate sense of sprawling urban menace. With basic backgrounds thus defined, artists went to work to further spice them up, infusing each setting with drama and a sense of visceral mayhem in an effort, according to Guldbaek, to craft "locations that matched the characters' moods and perspectives."

RIGHT: The title characters in *Kane & Lynch* aren't your typical heroes. Designers gave both a unique visual presence, dressing them up with the scars, pits, and open wounds consistent with men of questionable moral character.

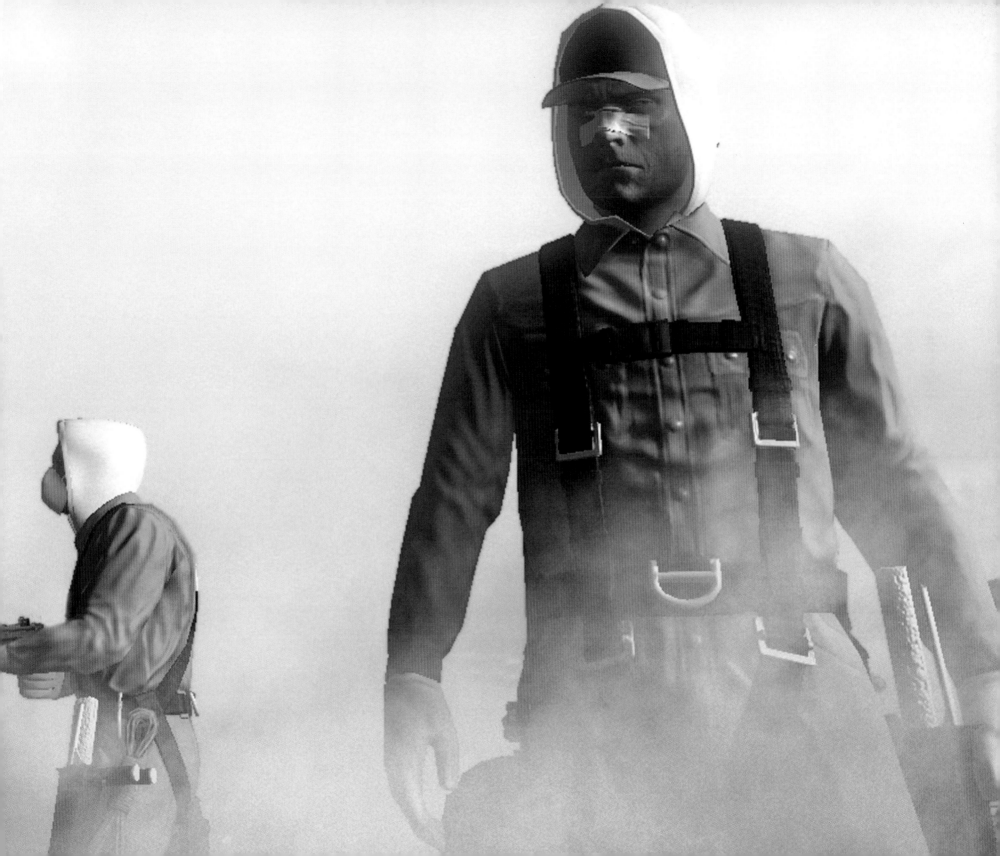

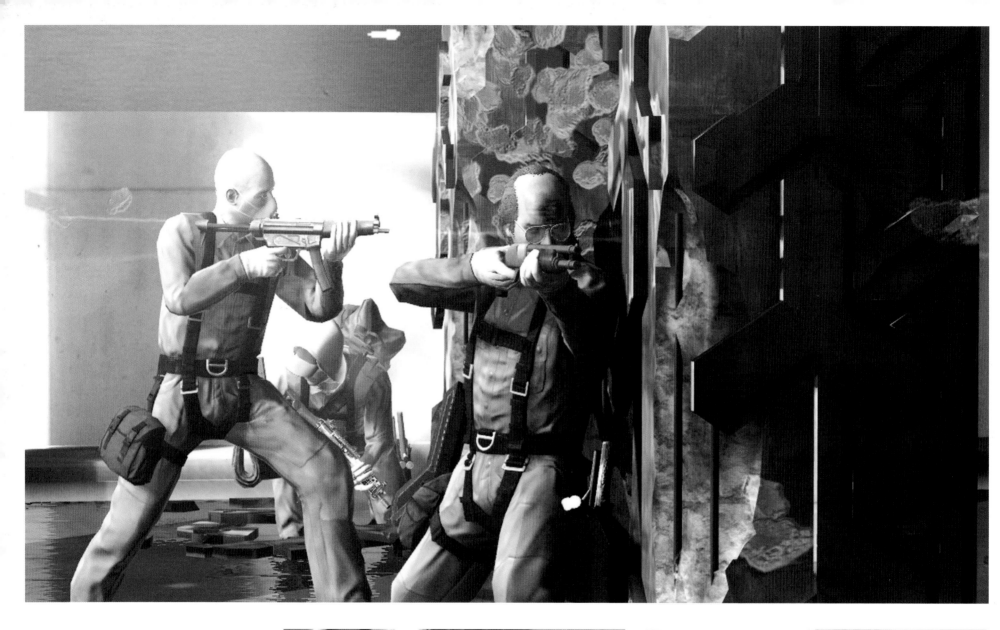

ABOVE: This office environment (see page 80 for more) features numerous destructible elements.

BELOW LEFT: The overhead angle lends this scene a certain sense of drama.

BELOW RIGHT: *Kane & Lynch* developers came under fire for their in-game treatment of peace officers. Police, security guards, and bank officers are dispatched with equal abandon.

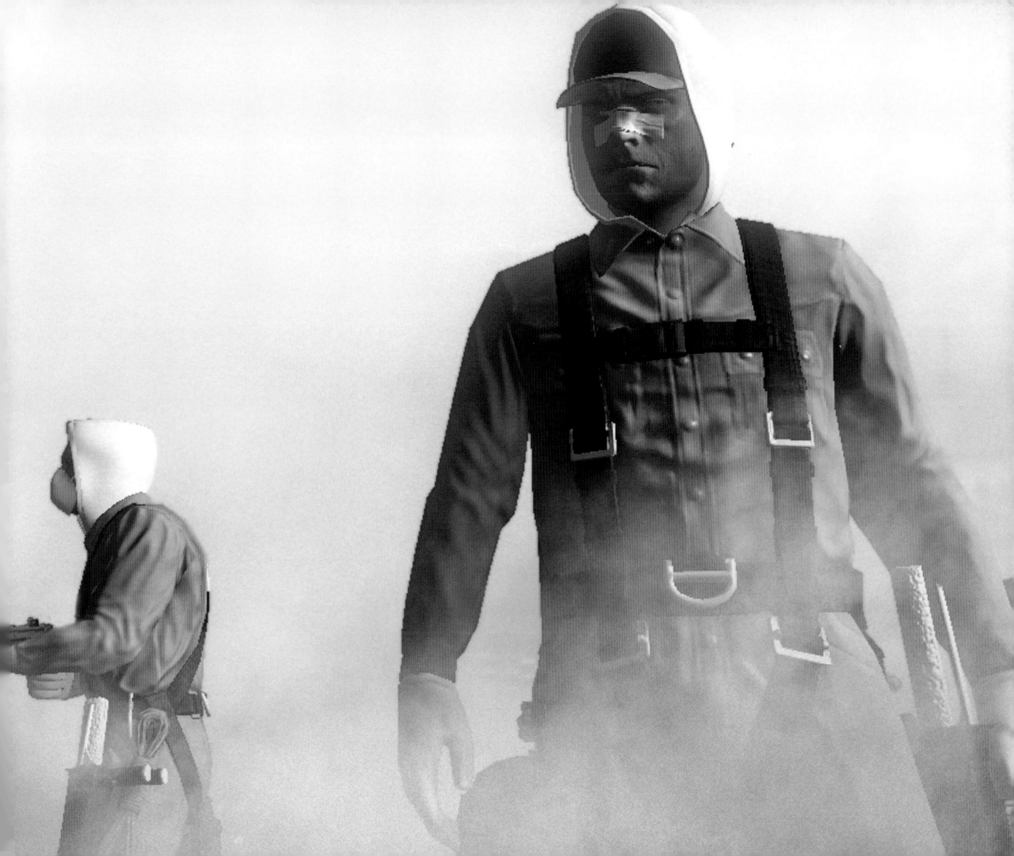

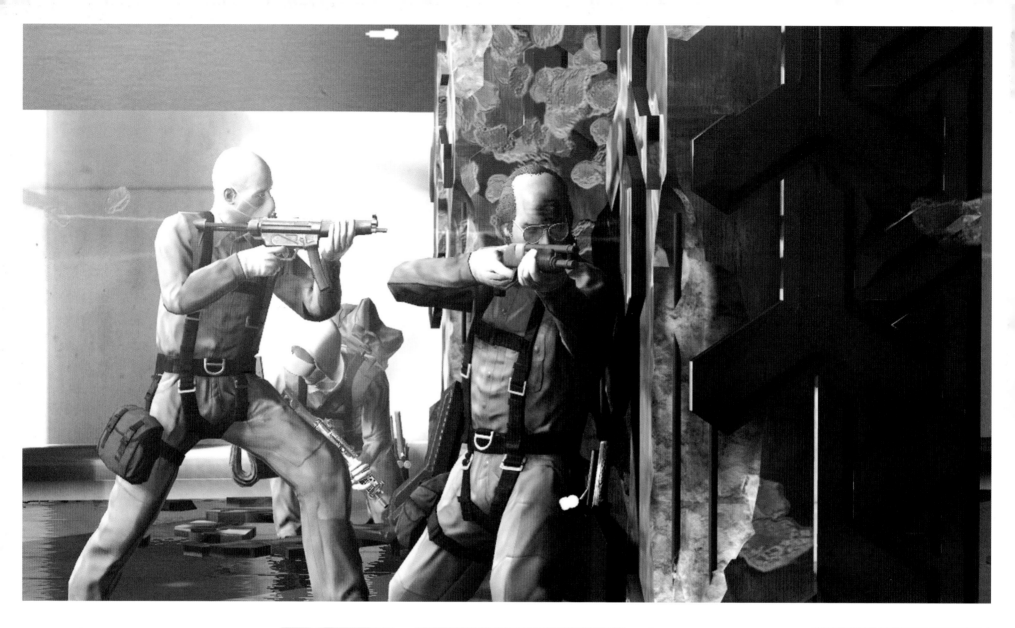

ABOVE: This office environment (see page 80 for more) features numerous destructible elements.

BELOW LEFT: The overhead angle lends this scene a certain sense of drama.

BELOW RIGHT: *Kane & Lynch* developers came under fire for their in-game treatment of peace officers. Police, security guards, and bank officers are dispatched with equal abandon.

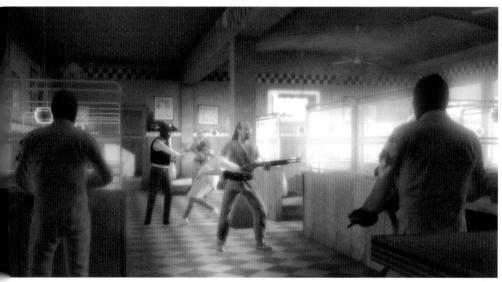

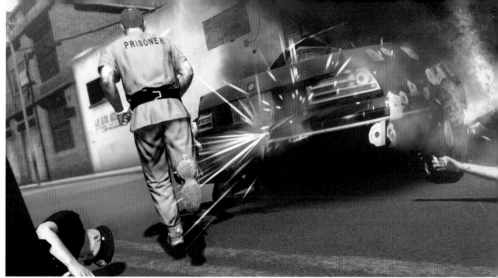

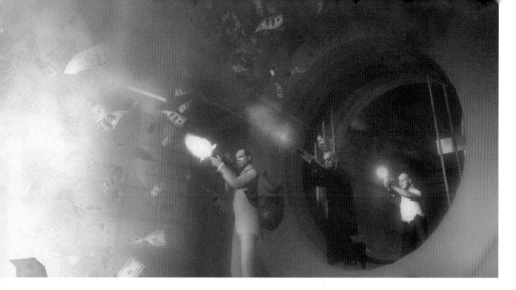

ABOVE LEFT: The game's climactic bank heist is at once spectacular and anarchic.

BELOW LEFT: This doughnut shop features plenty of 1950s design cues. It forms the Tarantino-like setting of a Tarantino-like shootout.

ABOVE RIGHT: From the opening moments of the game, the action is fast and furious. Designers worked hard to prevent the gun battles from devolving into chaos.

BELOW RIGHT: Part of the game's thrill comes from the heavily populated environments, like the nightclub shown here.

OFFICE BUILDING

Rasmus Polson of Io Interactive walked us through the surprisingly complex process of creating an environment like this Tokyo office building, which Kane and Lynch visit midway through the game: "I started out with the 3-D mock-up [done be Israfel "Raffy" Ibainza]," he said. "I found my preferred angle and rendered my background, a [process] that ensures that the architecture and perspective are correct. I then filled out the window area with white and started lighting the room with soft shadows as though it was being lit only by indirect light from the window. That way I get all my neutral light in place first and can make decisions on lamps and sunlight later. I then fill in the walls with padding, glass, and other fixtures.

"From there I proceeded to add details to the pillars that I decided to make the centerpiece of this specific room. Lastly I added the sunlight that falls in though the window. I finished off by correcting bounced light and other tidbits as well as by color correcting different parts of the image."

Inspiration, Polson said, can come from anywhere. "[This space is] a mishmash of Tyrell's office in *Blade Runner* and the Rasta gangster hideout in *Predator 2.* I wanted the office to have an imposing atmosphere and to make it memorable by having these red pillars that break apart when shot at. They also tell us that the owner of the office isn't afraid to boast a little and that he has a taste for the flamboyant. We also tried to reference his background as a warrior by having him collect old samurai armor and paintings. The floor is polished, black, and reflective to give a cold and hard feeling to the room. Warm sunlight is spilling in to counter all this [harshness] while retaining a sense of drama."

ABOVE: An early 3-D model defines the space.

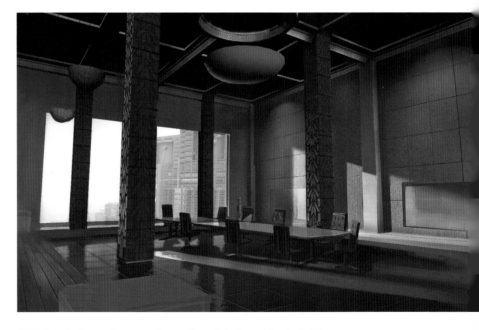

ABOVE: A first pass incorporates surface details and basic lighting.

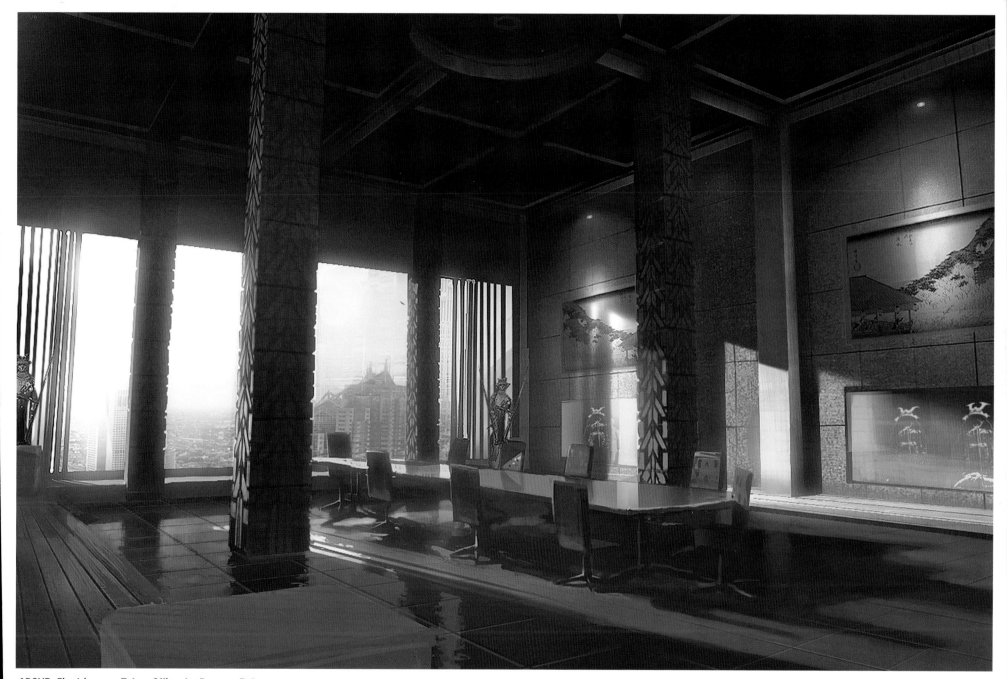

ABOVE: Final image: *Tokyo Office*, by Rasmus Polson.

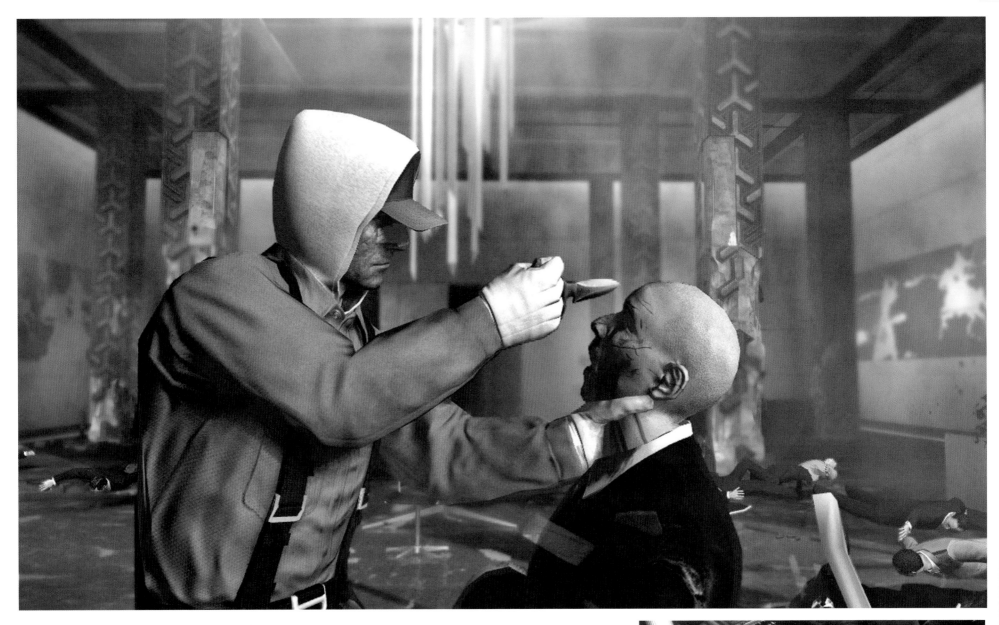

ABOVE: Surrounded by the chaos and destruction of a recent gun battle, there's something extraordinarily chilling about the calmness with which Kane prepares to gore his foe.

RIGHT: The scale of the action is truly cinematic, and the game's artists used more than a few Hollywood tricks (such as this off-kilter camera angle) to further that impression.

OPPOSITE PAGE, ABOVE: This interior stage of the game features copious destructible elements, among them priceless samurai artifacts, structural pillars, and plenty of bad guys.

OPPOSITE PAGE, BELOW: Rather than capturing the action in a standard horizontal wide shot, designers chose a top-down view, greatly intensifying the visual experience.

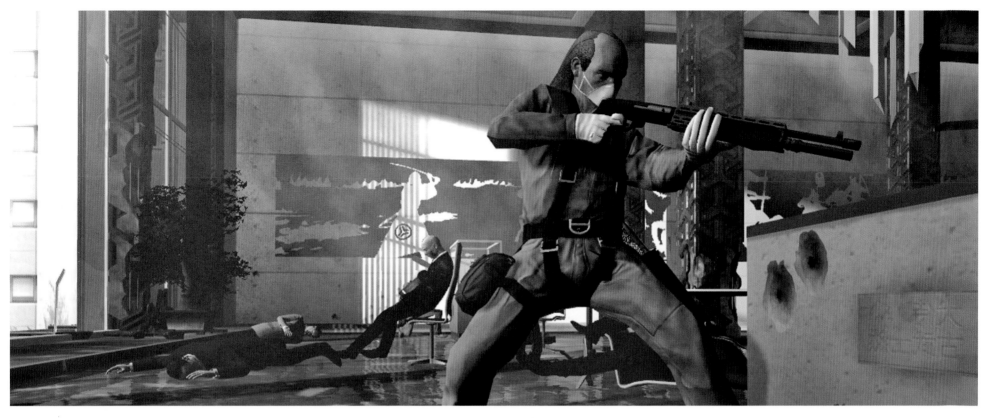

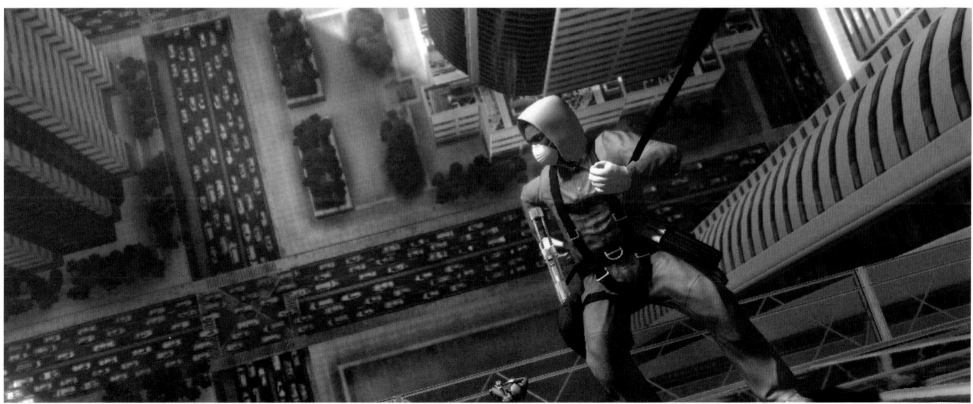

Killzone 2

PUBLISHER: SONY COMPUTER ENTERTAINMENT

DEVELOPER: GUERRILLA GAMES

Surely *Killzone 2* is among the most ballyhooed games of recent years. But in this case, the hype is justified: It's one of the most visually stunning and graphically adept games ever. At an exclusive preview during the E3 gaming conference, the media railed against developers for presenting a *Killzone* trailer that couldn't possibly be representative of in-gameplay. Boy, were they wrong. Utilizing a series of graphics engines and emergent technology that's difficult to pronounce—let alone explain—Guerrilla Games has managed to craft a war game that captures all the violence, terror, and brutality of real combat. Players assume the role of Jan Templar and lead a squad of specialists against the Helghast, a mutated mockery of the human genome. The Helghast are a bloodthirsty brood of warmongering maniacs descended from humanity and bent upon its destruction. Armed with a delightful array of highly effective weaponry, you and your squad set out to meet blind aggression with, well, even more blind aggression.

RIGHT: A perfect example of the look and feel of *Killzone 2*: It's a dark, gritty shooter that's immediately involving, thanks to a combination of realistically rendered environments, characters, weaponry, and effects.

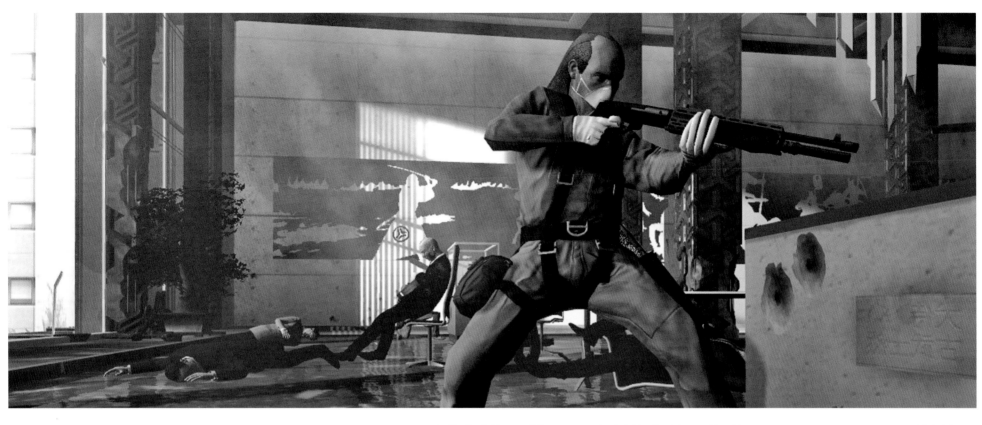

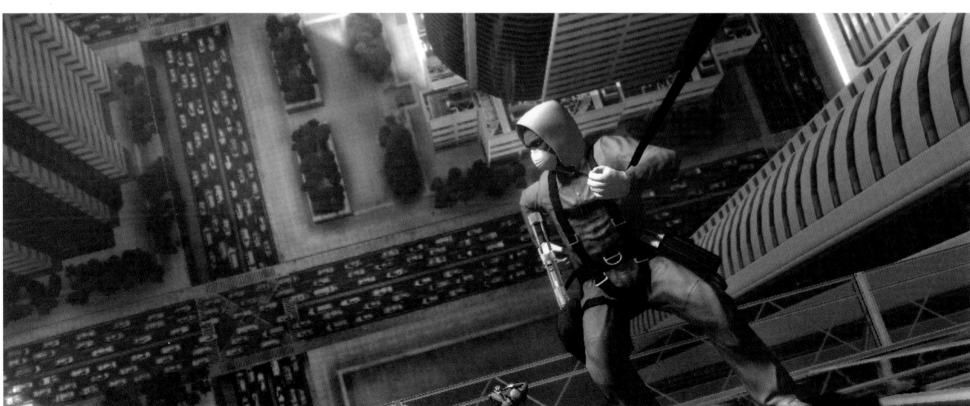

Killzone 2

PUBLISHER: SONY COMPUTER ENTERTAINMENT
DEVELOPER: GUERRILLA GAMES

Surely *Killzone 2* is among the most ballyhooed games of recent years. But in this case, the hype is justified: It's one of the most visually stunning and graphically adept games ever. At an exclusive preview during the E3 gaming conference, the media railed against developers for presenting a *Killzone* trailer that couldn't possibly be representative of in-gameplay. Boy, were they wrong. Utilizing a series of graphics engines and emergent technology that's difficult to pronounce—let alone explain—Guerrilla Games has managed to craft a war game that captures all the violence, terror, and brutality of real combat. Players assume the role of Jan Templar and lead a squad of specialists against the Helghast, a mutated mockery of the human genome. The Helghast are a bloodthirsty brood of warmongering maniacs descended from humanity and bent upon its destruction. Armed with a delightful array of highly effective weaponry, you and your squad set out to meet blind aggression with, well, even more blind aggression.

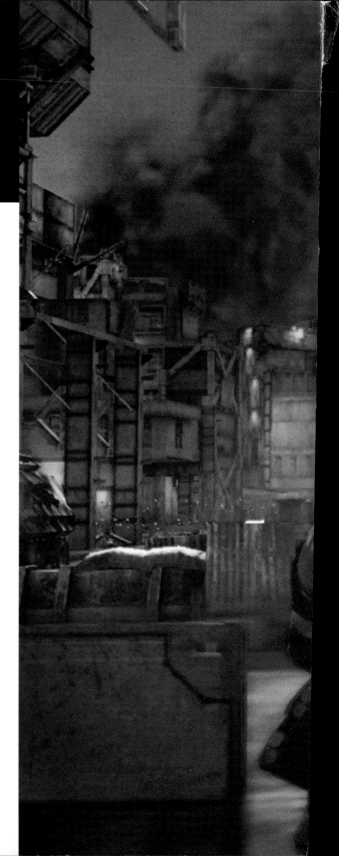

RIGHT: A perfect example of the look and feel of *Killzone 2*: It's a dark, gritty shooter that's immediately involving, thanks to a combination of realistically rendered environments, characters, weaponry, and effects.

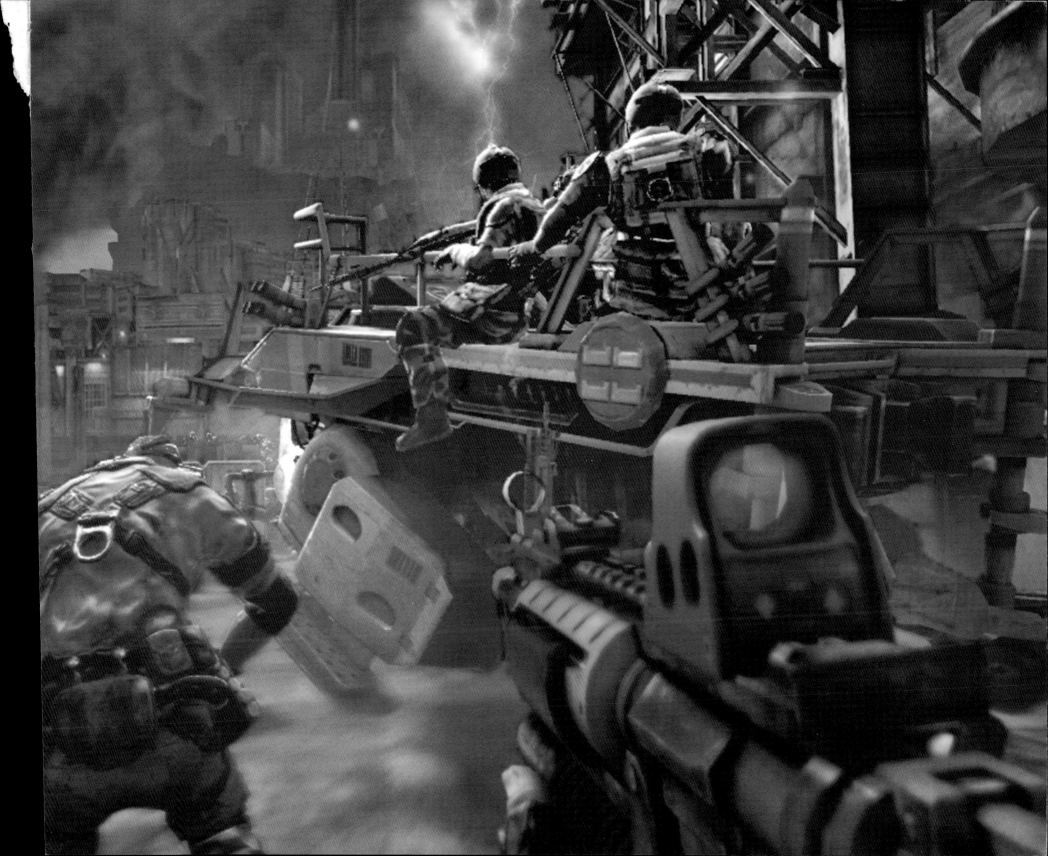

KZ2 CORRIDOR

This environment presented an interesting challenge for Guerrilla Games artist Miguel Angel Martinez. Instead of creating an image from scratch, he was charged with fixing a set piece that had already been rendered within the game. "The idea was to open one of the corridors a little more, so it would feel less claustrophobic," Martinez explained. "They selected a screenshot that highlighted the problem, and I simply started painting over it. The first thing I did was to remove the overhanging structures and shorten the surrounding walls. Next I added brighter colors and highlights to the buildings in the background to provide the player with a clear visual objective. I also used the opportunity to research and introduce new elements, like the shapes of the towers in the distance." Though the final image is of a decidedly modern environment, Martinez initially looked to the past for ideas. "It was largely inspired by stories and depictions of the Crusades," he said. "The characters in the foreground are trying to storm the foreign-looking towers in the distance, but they're thwarted by an equally foreign-looking enemy army."

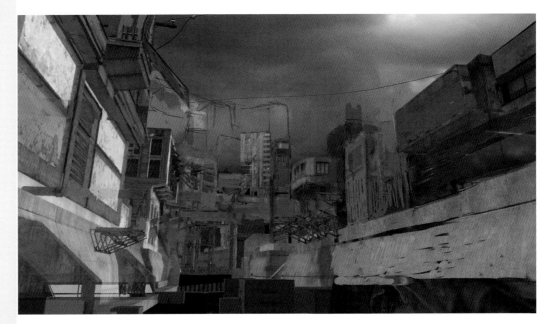

ABOVE: An in-game environment is provided to Miguel Angel Martinez for improvement. He begins by penciling in new elements and painting over others.

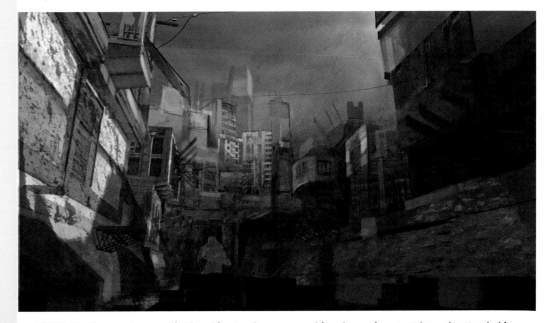

ABOVE: Martinez performs a bit of architectural surgery, making the environment less claustrophobic.

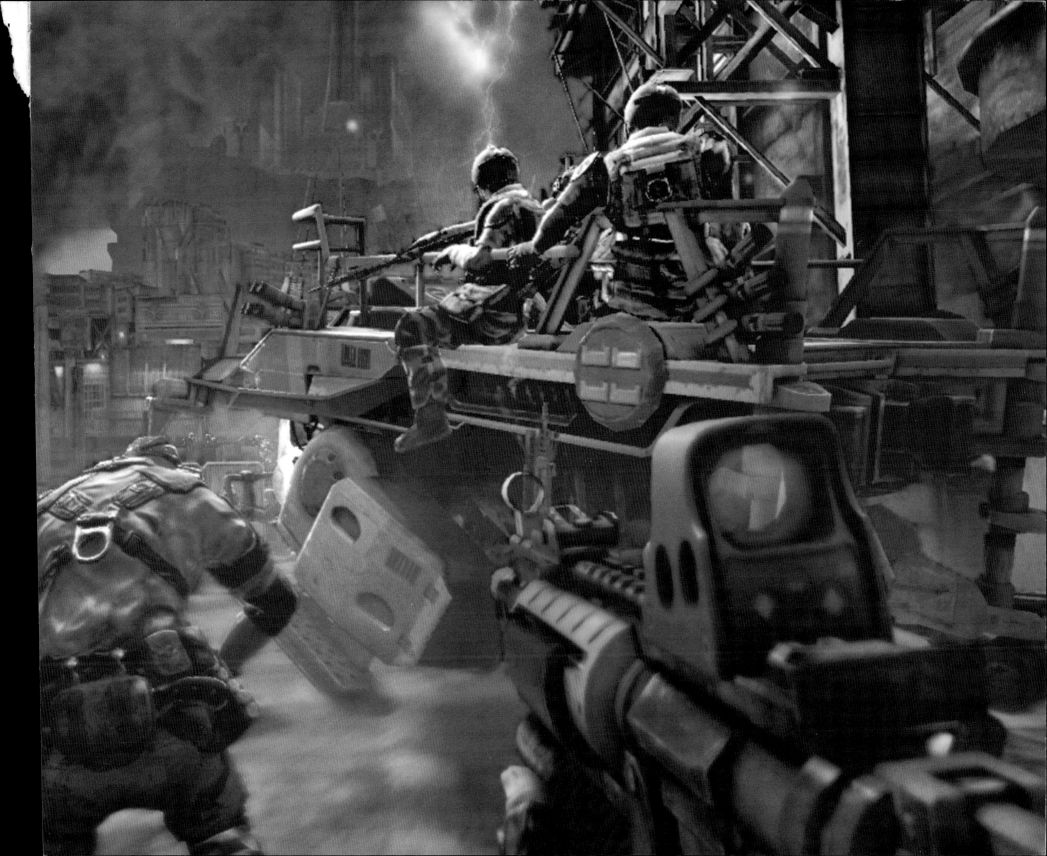

KZ2 CORRIDOR

This environment presented an interesting challenge for Guerrilla Games artist Miguel Angel Martinez. Instead of creating an image from scratch, he was charged with fixing a set piece that had already been rendered within the game. "The idea was to open one of the corridors a little more, so it would feel less claustrophobic," Martinez explained. "They selected a screenshot that highlighted the problem, and I simply started painting over it. The first thing I did was to remove the overhanging structures and shorten the surrounding walls. Next I added brighter colors and highlights to the buildings in the background to provide the player with a clear visual objective. I also used the opportunity to research and introduce new elements, like the shapes of the towers in the distance." Though the final image is of a decidedly modern environment, Martinez initially looked to the past for ideas. "It was largely inspired by stories and depictions of the Crusades," he said. "The characters in the foreground are trying to storm the foreign-looking towers in the distance, but they're thwarted by an equally foreign-looking enemy army."

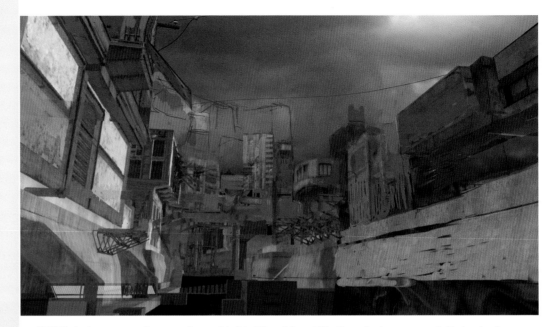

ABOVE: An in-game environment is provided to Miguel Angel Martinez for improvement. He begins by penciling in new elements and painting over others.

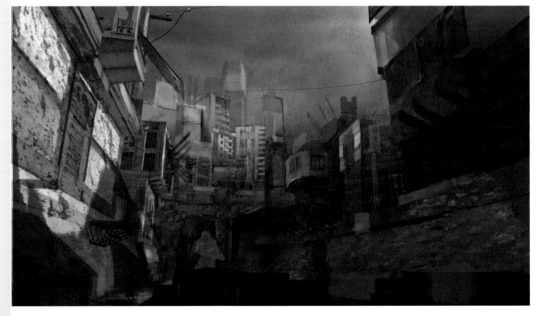

ABOVE: Martinez performs a bit of architectural surgery, making the environment less claustrophobic.

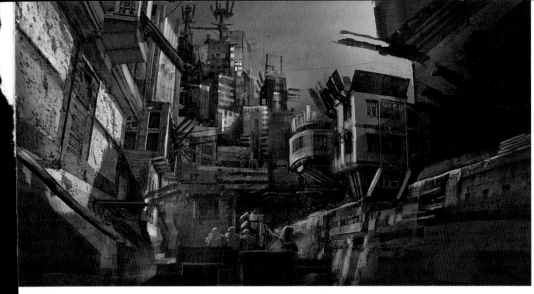

LEFT: Detailing, lighting, and enemy soldiers are incorporated.

BELOW: Final image: *KZ2 Corridor*, by Miguel Angel Martinez.

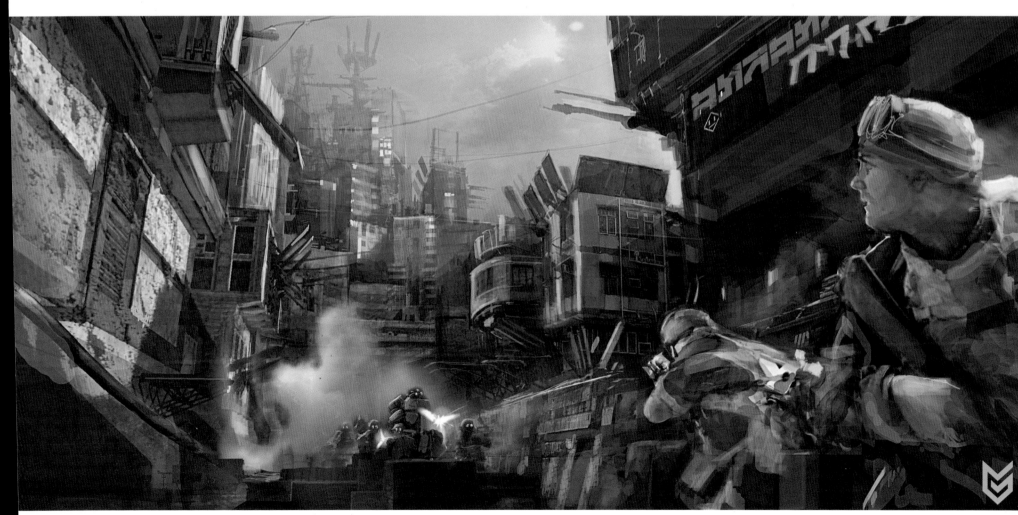

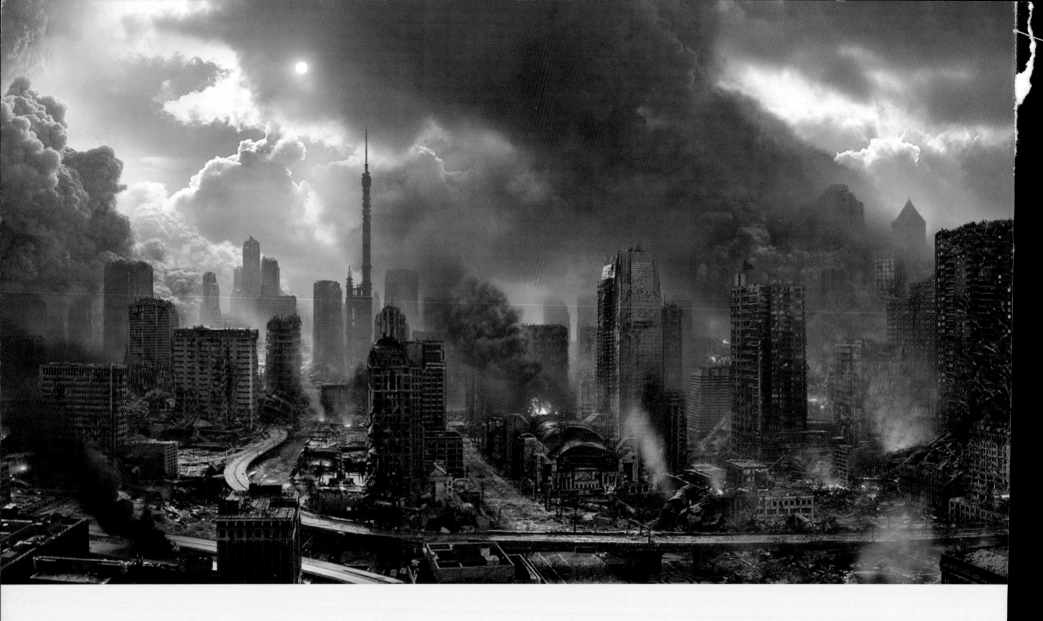

VANQUISHED CITY

To convey a sense of mass destruction, concept artist Deak Ferrand began with a composite sketch culled from images of several Eastern European cities. The studied lines and imposing structural elements of Communist architecture exude a certain strength and resolve that, when dismantled, help convey a feeling of abject devastation more profoundly than a Western city ever could. Ferrand then combined the images of concrete ruin with the beautiful, almost hypnotic ferocity of a well-fed brush fire. Flames in an urban environment are almost always cause for alarm, but here, arrested in time and captured in two dimensions, they radiate a certain terrible serenity, a quiet power that speaks about the ravages of war. Ferrand said that he was given free reign with this piece, and it shows. His brutal vision is severe and undiluted.

Lara Croft: Tomb Raider: Anniversary

PUBLISHER: EIDOS
DEVELOPER: CRYSTAL DYNAMICS

Lara Croft: Tomb Raider is one of the most profitable entertainment franchises in history—and one of a handful of video game properties to successfully make the transition to the silver screen. Its success is due in no small part to the phenomenal popularity of the game's protagonist, who brandishes sass and sexuality with the same able gusto as she does her trademark sidearms.

Originally imagined by artist Toby Gard of Core Design as a clone of Indiana Jones, Lara Croft was later reconceived as a woman because of concerns over copyright infringement. Gard was also influenced by the discovery that many of his male co-workers were choosing to play as female protagonists in games such as Sega's *Virtua Fighter*. He dreamed up a spicy South American native named Laura Cruz, but worries about commercial viability resulted in her evolution into the English noblewoman we all know and love.

Some fans, along with Gard himself (who left Core due to a lack of creative control during the development of *Tomb Raider II*), have expressed outrage about the marketing of Lara's sexuality and her generally ridiculous proportions. With Gard back on board for the last two iterations of the series, Lara has undergone a slight physical

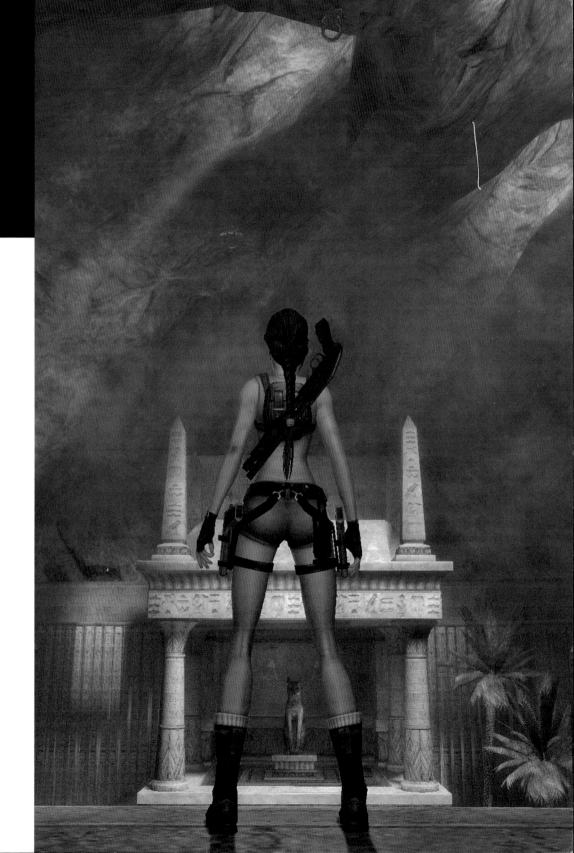

RIGHT: Lara Croft, ready for action.

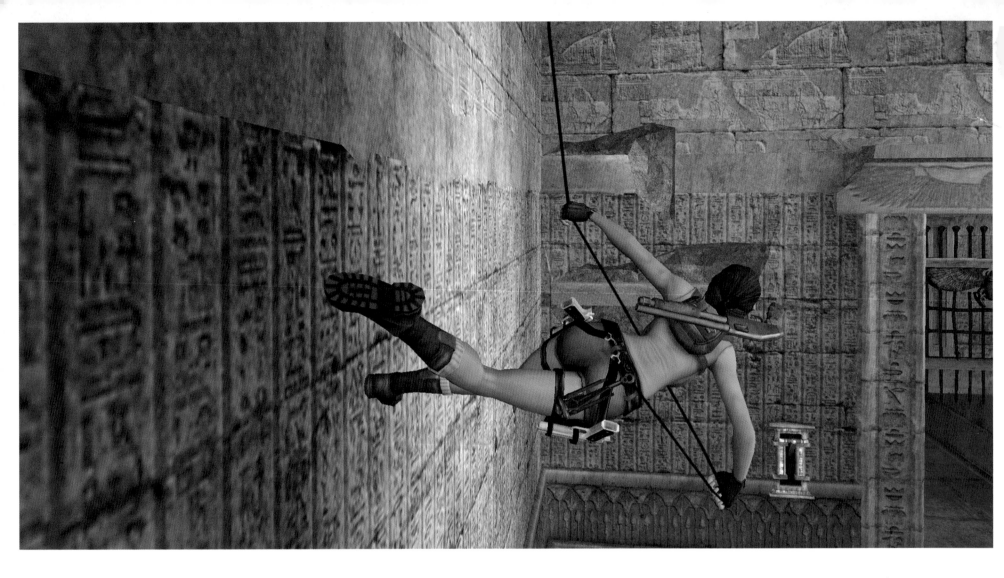

transformation; certain body parts have been scaled back, and others have been augmented to more accurately represent the female form. Said Gard in an interview with Gamasutra.com: "It was never my intention to create some kind of 'Page 3' girl to star in *Tomb Raider*. The idea was to create a female character who was a heroine—cool, collected, in control. I know you could argue that Lara, with her comic-book-style over-the-top figure, is exploitative,

but I don't agree. I think it's ridiculous to say that portraying stylized people is degrading. You can represent an over-the-top hero by augmenting characteristics like a jutting jaw, wide shoulders, and thin waist and that is not [considered] degrading to men. It may well be a stereotype, but it seems to me that people are overanalyzing this whole thing."

ABOVE: The series is famous for its lush archeological settings, but it's the way Lara Croft interacts with these environments that makes the game so eminently involving.

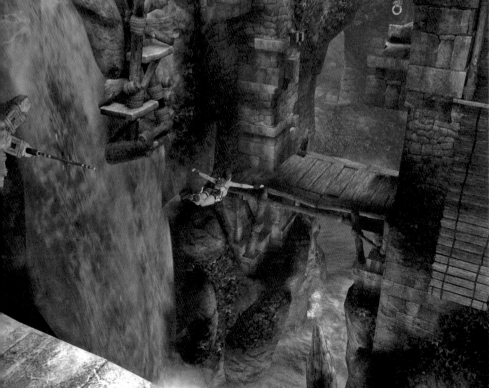

ABOVE LEFT: The entire *Tomb Raider* series imagines ancient societies that were, in their own way, extremely advanced technologically. The artists took great care to craft complex machinery that belies its primitive environments.

BELOW LEFT: This image begs the question: Which is the real star of the *Tomb Raider* series—Lara Croft, or the ever-fascinating world around her?

ABOVE RIGHT: Although the game is fairly linear, players must frequently devise interesting ways to surmount obstacles. Players can get up-close and personal with the game's gorgeous set pieces.

NEXT PAGE: The new Lara Croft: slightly different proportions, but still as deadly as ever.

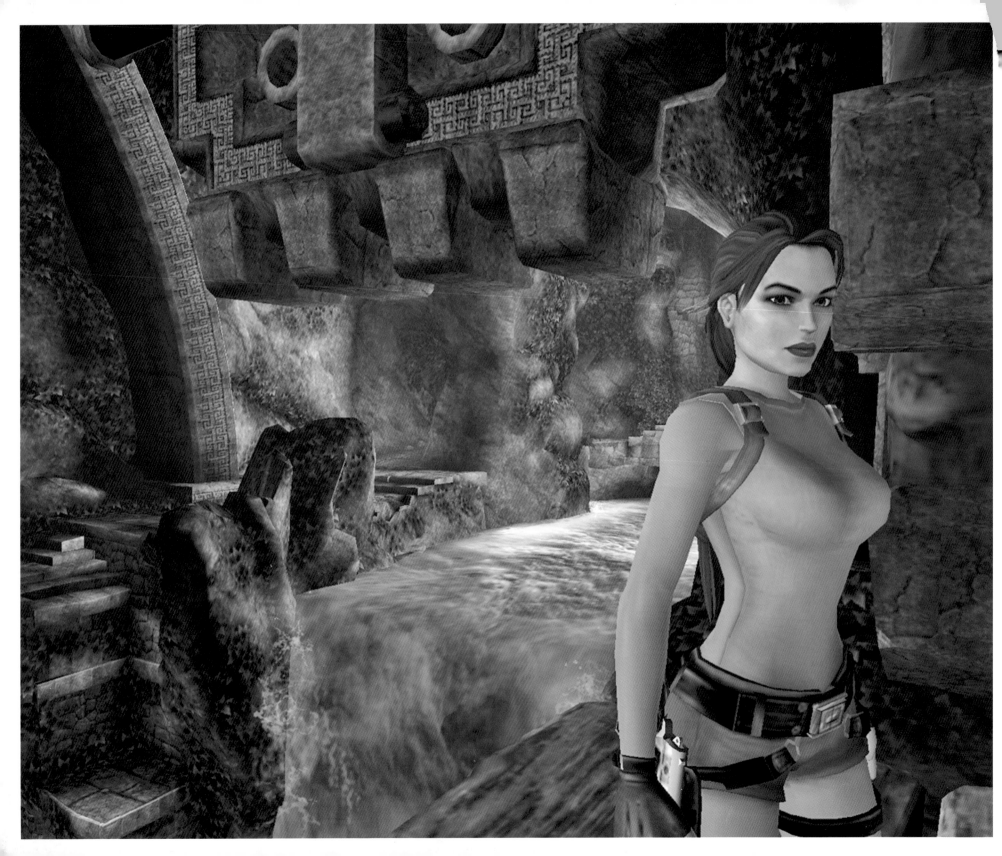

Medieval 2: Total War

PUBLISHER: SEGA
DEVELOPER: CREATIVE ASSEMBLY

Developing a game in which massive armies wage war upon one another is tough to do well. In the past, we've seen games in which dozens of identical warriors race to battle, all with the same height, weight, armor, hair color, and weapons. It's hardly what you'd call realistic, and *Medieval 2* project director Bob Smith was determined to bring a new verisimilitude to his battle scenes. "Removing the clone armies that we've seen in previous *Total War* games and other real-time strategy titles was one of our priorities," Smith said in an interview with GameSpot. "We're very proud of the results. Each troop model is now constructed from a variety of heads, bodies, and limbs. On top of this, there are multiple variants for shields and weapons, too. The engine combines these elements to make each man far more individual, so that each unit of men looks, as well as behaves, like a realistic group of soldiers.

"Elsewhere in the engine, we've made some major improvements in the rendering of settlements in the game. It wouldn't be *Medieval* without vast, monumental cities and castles, and we set out to do them justice by ensuring that we represent them in-game in a far more realistic manner than ever before. Cities and castles are truly integrated within their environment, incorporating cliffs and slopes in their layout. This not only makes for a far more realistic representation of settlements but also introduces new layers of strategy when it comes to siege situations."

RIGHT: And you thought *Braveheart* had a lot of Scots. The sheer scale of *Medieval 2* is staggering. Thousands of soldiers, each often acting independently, are present in any given battle.

ABOVE: Every effort was made to arm warriors with weapons that are appropriate historically and geographically. Each fighting unit is made up of randomly configured soldiers, allowing for a more realistic combat experience.

OPPOSITE PAGE: Close-quarters combat is frenzied and, at first, overwhelming. Contemplate the independent elements of this scene: soldiers, horses, weapons, armor and environment—all interacting. Now, reach over and give your CPU a great big hug.

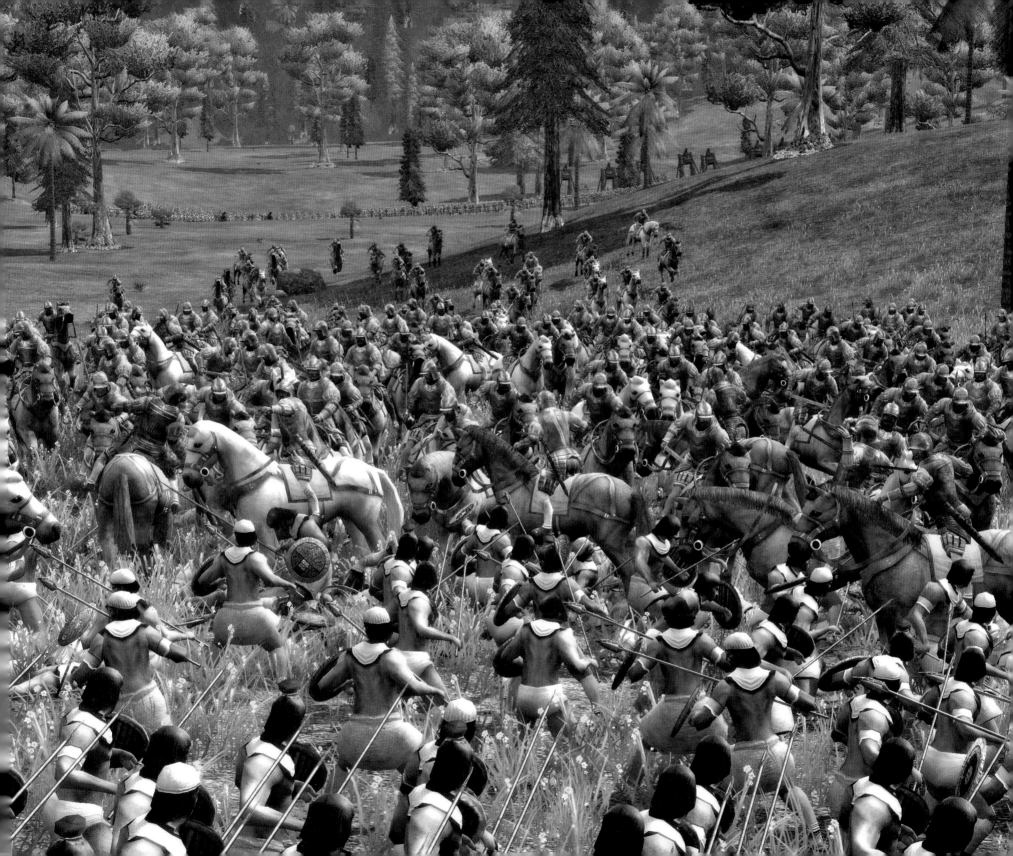

Mortal Kombat: Deception

PUBLISHER: MIDWAY

DEVELOPER: MIDWAY

Perhaps the best-loved fighting game of all time, *Mortal Kombat* is a lot like the Ultimate Fighting Championship—that is, if, at the end of each UFC match, the victor stomped on the head of his opponent's lifeless corpse. When it first appeared in arcades in 1992, *Mortal Kombat* shocked the masses with its copious sprays of blood and its particular emphasis on brutality in combat. Critics have long blasted the MK franchise as being sadistic to the point of obscenity. In fact, the deliriously gore-splattered gameplay was responsible, in large measure, for the establishment of the Entertainment Software Ratings Board (ERSB). Anytime you see an "M" or a "T" on game packaging, you can thank Midway and the fun-sucking vampires at the ERSB.

RIGHT: The beloved and brutal cast of the *Mortal Kombat* franchise.

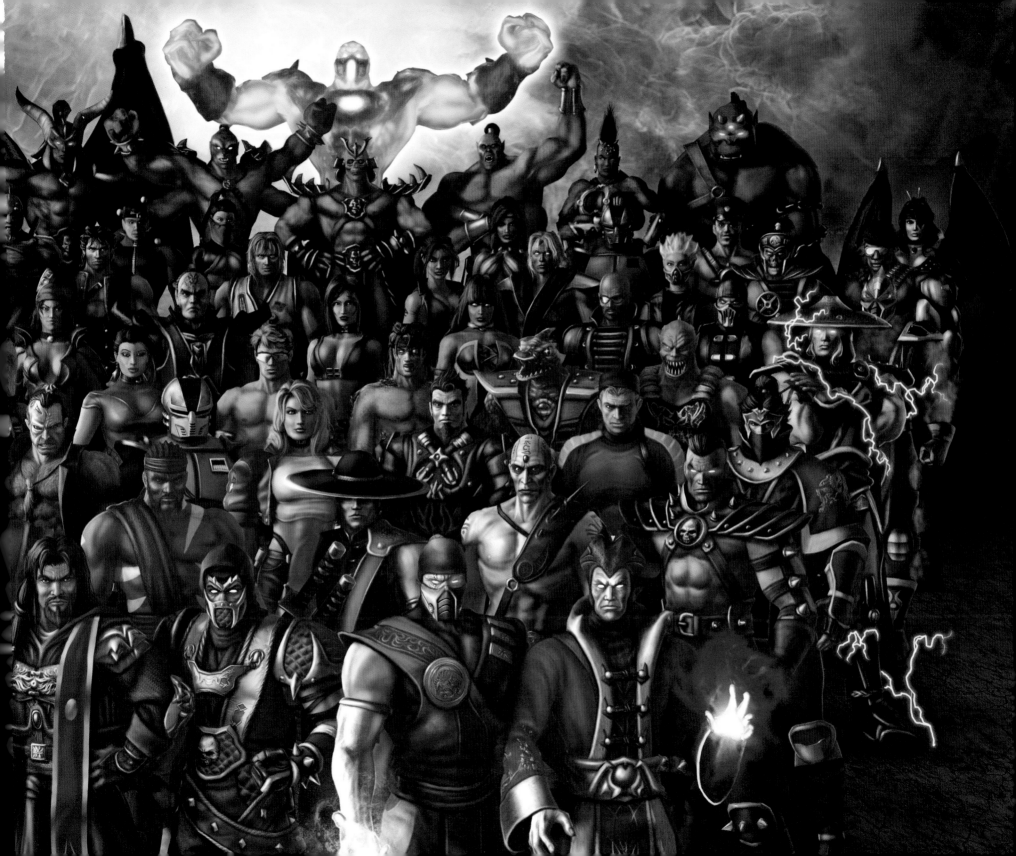

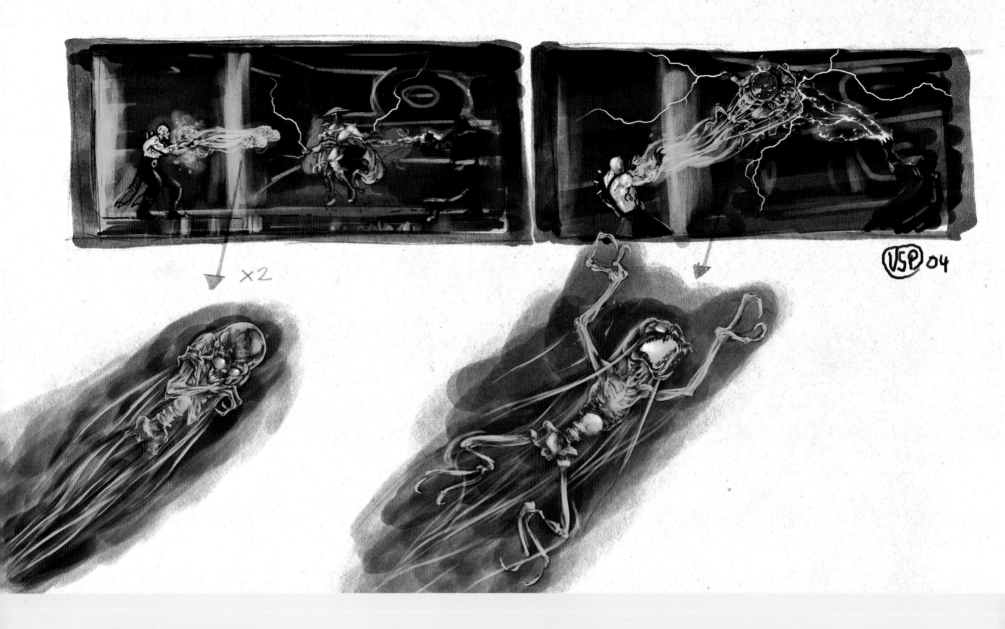

x2

VSP 04

FEARSOME ATTACKS

The piece shown here is from prolific Midway concept artist Vince Proce and features the deadly energy techniques of two of *Mortal Kombat*'s more sinister villains, Shang Tsung and Quan Chi. This piece was meant to define the lead villains' most fearsome attacks—powerful energy emissions that, as a general rule, obliterate anything in their path. The fact that developers would go through the process of presenting concepts for a specific attack speaks to the villains' stature as well as the team's commitment to turning out a killer product.

ABOVE: Concept artist Vince Proce makes a first pass at defining Quan Chi's energy attack, which is meant to take the form of a skeletal monkey imp.

LEFT: Proce next defines Shang Tsung's energy attack, which, he says, was inspired by the flaming Balrog in Peter Jackson's *Lord of the Rings*.

BELOW: Final image: *Radion Lift*, by Vince Proce.

SUB ZERO

Sega's Pav Kovacik had the task of rendering one of the most iconic characters in video game history, *Mortal Kombat*'s Sub Zero, in a new but familiar way. As the steaming breath and white eyeballs suggest, Sub Zero is descended from a mysterious race known as the Cryomancers, who have the ability to both create and control ice. Part of Sub Zero's early popularity was clearly due to his supremely violent finishing moves, which included the ability to rip the spine out of an opponent. This catastrophic exploit, though excessive to the point of silliness, sparked an uproar among parents and activists.

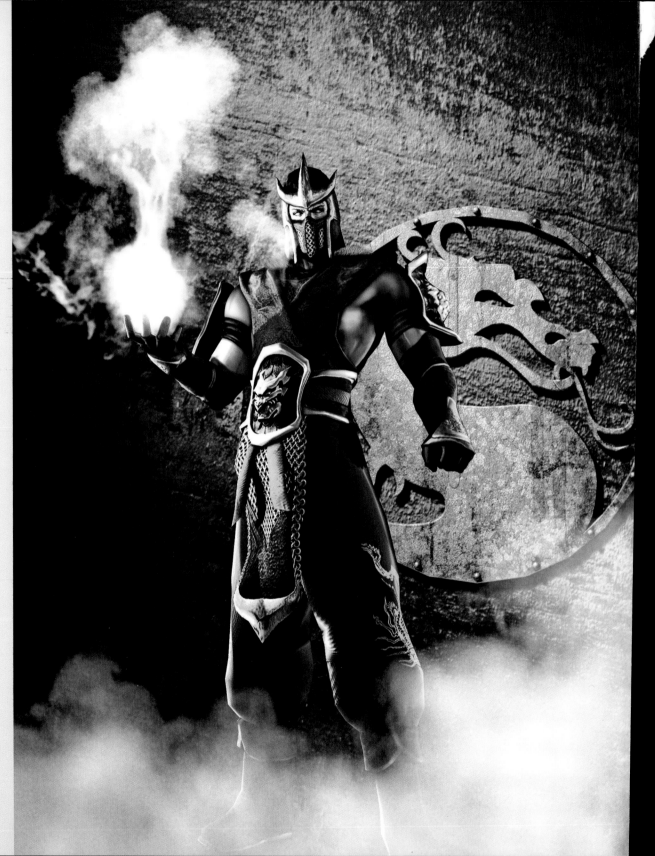

RIGHT: Sub Zero stands before the famous Mortal Kombat seal.

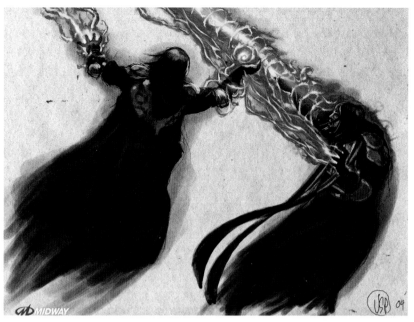

LEFT: Proce next defines Shang Tsung's energy attack, which, he says, was inspired by the flaming Balrog in Peter Jackson's *Lord of the Rings*.

BELOW: Final image: *Radion Lift*, by Vince Proce.

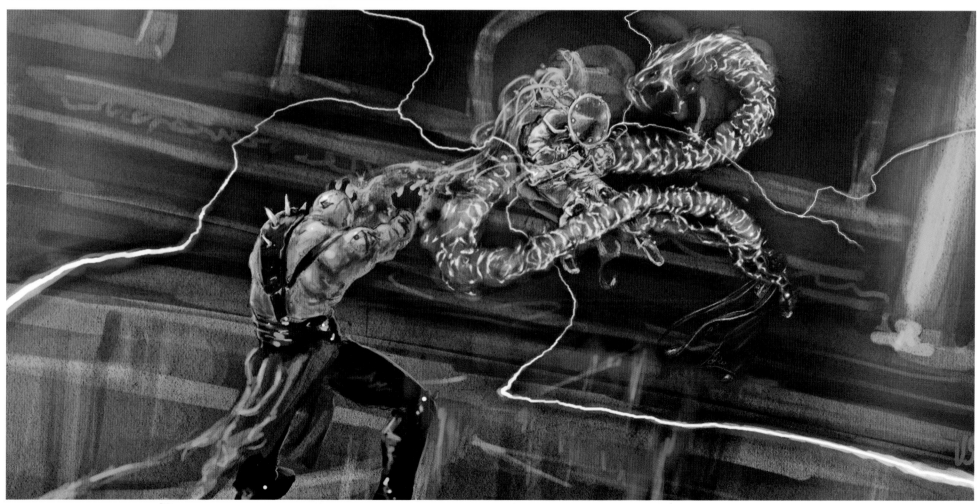

SUB ZERO

Sega's Pav Kovacik had the task of rendering one of the most iconic characters in video game history, *Mortal Kombat*'s Sub Zero, in a new but familiar way. As the steaming breath and white eyeballs suggest, Sub Zero is descended from a mysterious race known as the Cryomancers, who have the ability to both create and control ice. Part of Sub Zero's early popularity was clearly due to his supremely violent finishing moves, which included the ability to rip the spine out of an opponent. This catastrophic exploit, though excessive to the point of silliness, sparked an uproar among parents and activists.

RIGHT: Sub Zero stands before the famous Mortal Kombat seal.

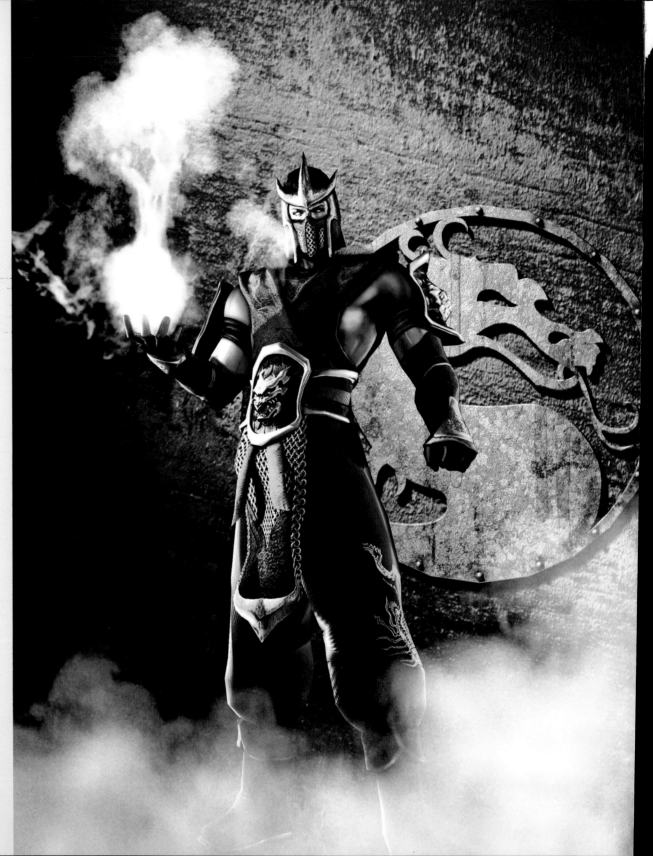

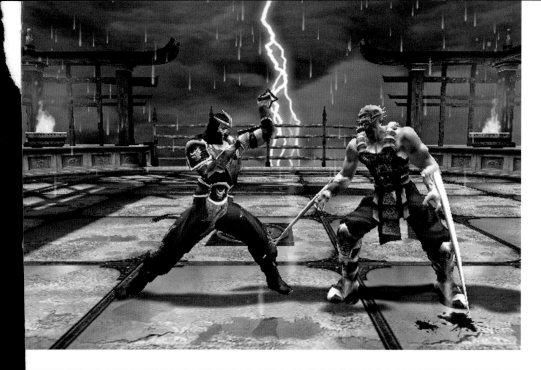

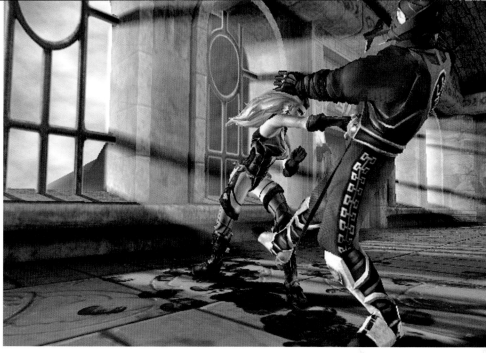

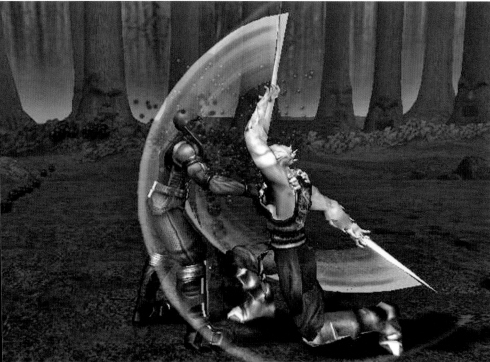

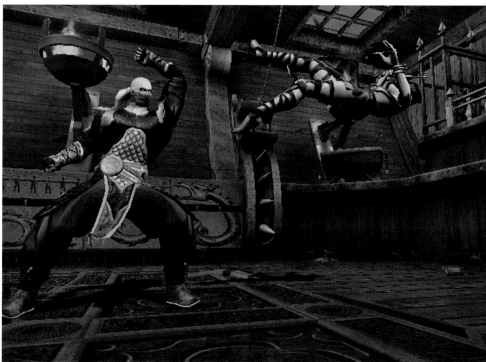

ABOVE: A series of screenshots from *Mortal Kombat: Deception* demonstrates why so many gamers have fallen in love with the franchise: gorgeous environments, ferocious characters, and plenty of gore-splattered, spine-crushing violence.

NBA Live '08

PUBLISHER: EA SPORTS
DEVELOPER: EA SPORTS

The NBA Live series is an ever-evolving basketball franchise featuring many of pro basketball's biggest stars. We spoke with Neil Eskuri, the game's art director, about his role in managing the aesthetic aspects of such an enormous enterprise. According to Eskuri, one of the prevailing design mandates is to create players who look as real as next-gen technology will allow. He walked us through the process of rendering reality.

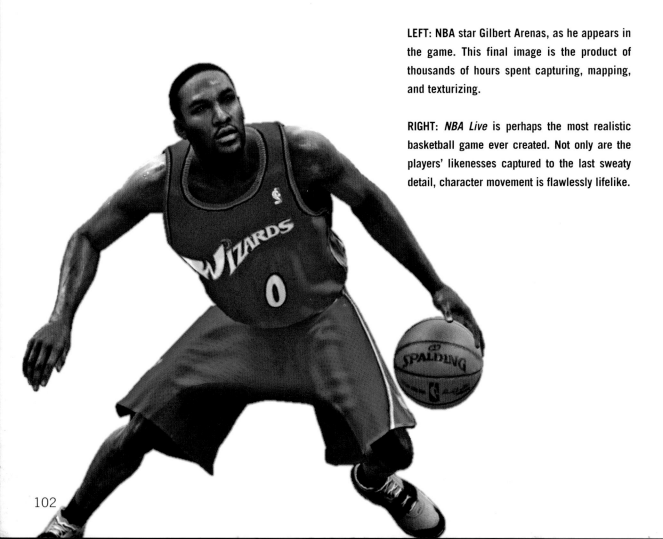

LEFT: NBA star Gilbert Arenas, as he appears in the game. This final image is the product of thousands of hours spent capturing, mapping, and texturizing.

RIGHT: *NBA Live* **is perhaps the most realistic basketball game ever created. Not only are the players' likenesses captured to the last sweaty detail, character movement is flawlessly lifelike.**

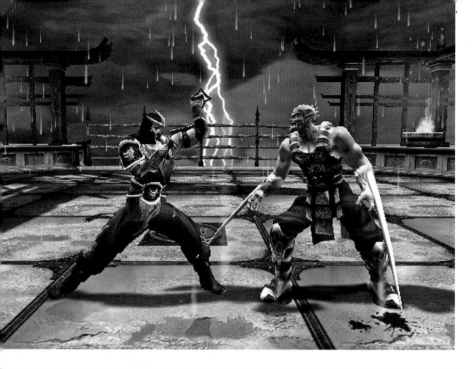
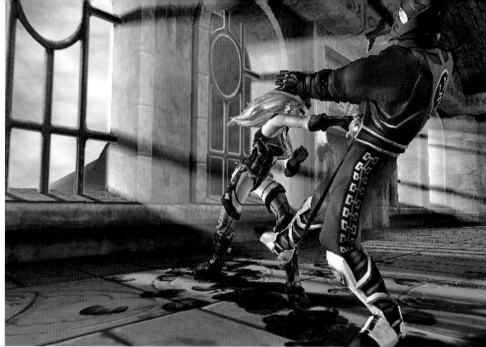
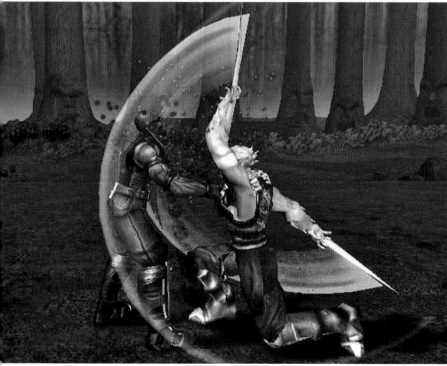
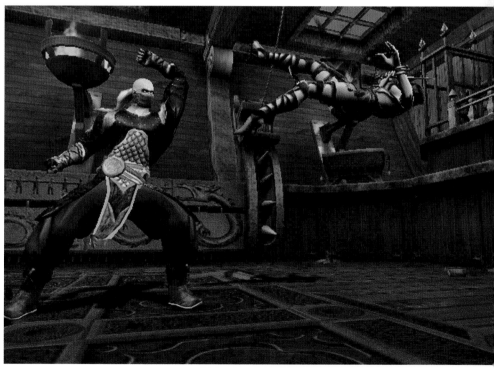

ABOVE: A series of screenshots from *Mortal Kombat: Deception* demonstrates why so many gamers have fallen in love with the franchise: gorgeous environments, ferocious characters, and plenty of gore-splattered, spine-crushing violence.

NBA Live '08

PUBLISHER: EA SPORTS

DEVELOPER: EA SPORTS

The NBA Live series is an ever-evolving basketball franchise featuring many of pro basketball's biggest stars. We spoke with Neil Eskuri, the game's art director, about his role in managing the aesthetic aspects of such an enormous enterprise. According to Eskuri, one of the prevailing design mandates is to create players who look as real as next-gen technology will allow. He walked us through the process of rendering reality.

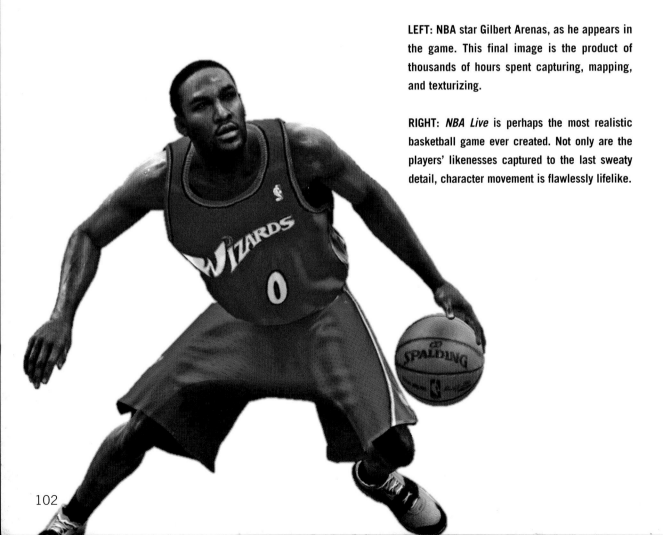

LEFT: NBA star Gilbert Arenas, as he appears in the game. This final image is the product of thousands of hours spent capturing, mapping, and texturizing.

RIGHT: *NBA Live* **is perhaps the most realistic basketball game ever created. Not only are the players' likenesses captured to the last sweaty detail, character movement is flawlessly lifelike.**

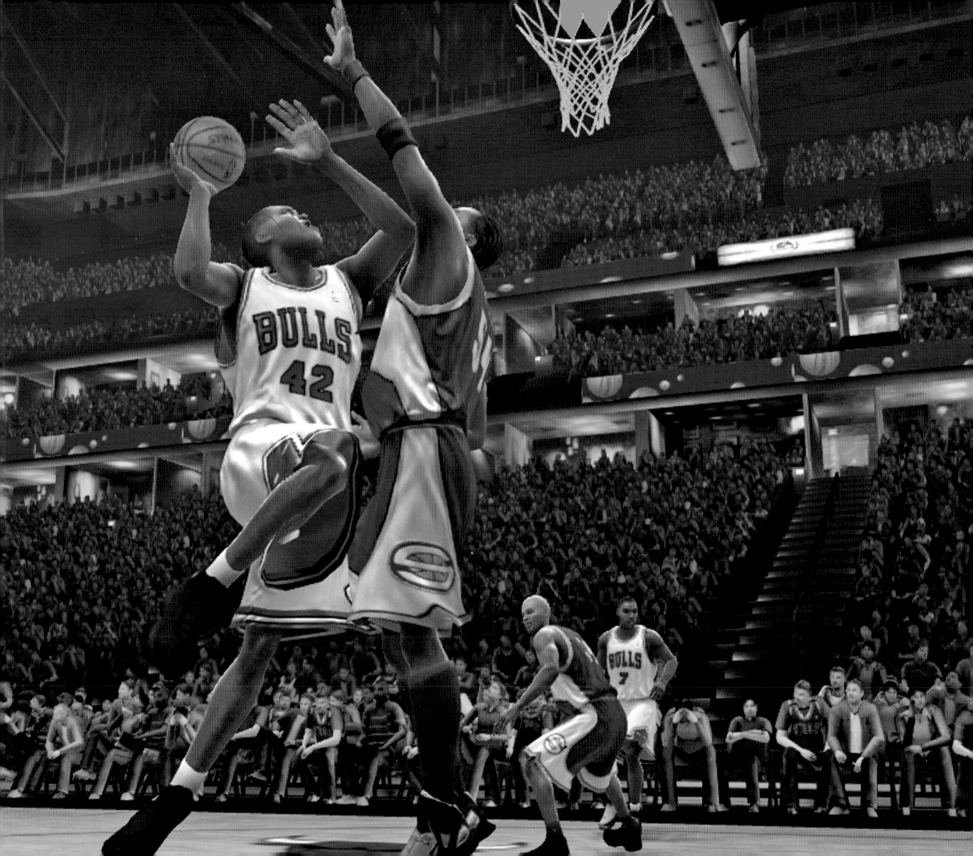

Figure A

Figure B

Figure C

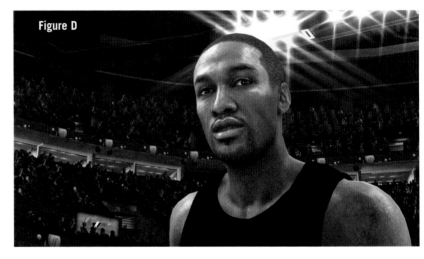

Figure D

"We start by taking reference photos of our players, using a flat light to eliminate any shadows across the face. These references help us with the structure of the face and head as well the base color for the skin tone. Figure A positions our subject, Gilbert Arenas of the Washington Wizards, in a basketball court, with the main direction light coming from above.

"From here we start to add the different layers of light and maps to the model. Figure B has a normal map applied, which adds such details as pores and wrinkles to the character's skin. There's also a broad specular component added to the light-ing to simulate the brighter areas of the arena.

"Figure C has a rim light and a tighter specular component that enhance additional details in the skin and increase the separation of the player from the background.

"Several layers are added to Figure D. A bounce light emulates the light coming from the court below the player. We've added subsurface scattering along the ears, nose, cheek, and forehead, which gives the illusion of light penetrating just below the surface of the skin. Then we added the eye's diffuse and highlight components to bring life to the face.

"Finally, a sweat map is added for small beads of sweat and rivulets down the skin, along with the lighting and mapping of the jersey [Figure E]. There's a lot going on in those milliseconds of com-putation." But it's not all texture mapping and sub-dermal lighting for the team at Electronic Arts. They occasionally push away from their computers and allow themselves a little fun. "We have this dunk contest every year among the crew," Eskuri said. Of course, we don't come near what an NBA player could do, but that doesn't matter. We lower the bas-ket and see what people have to show."

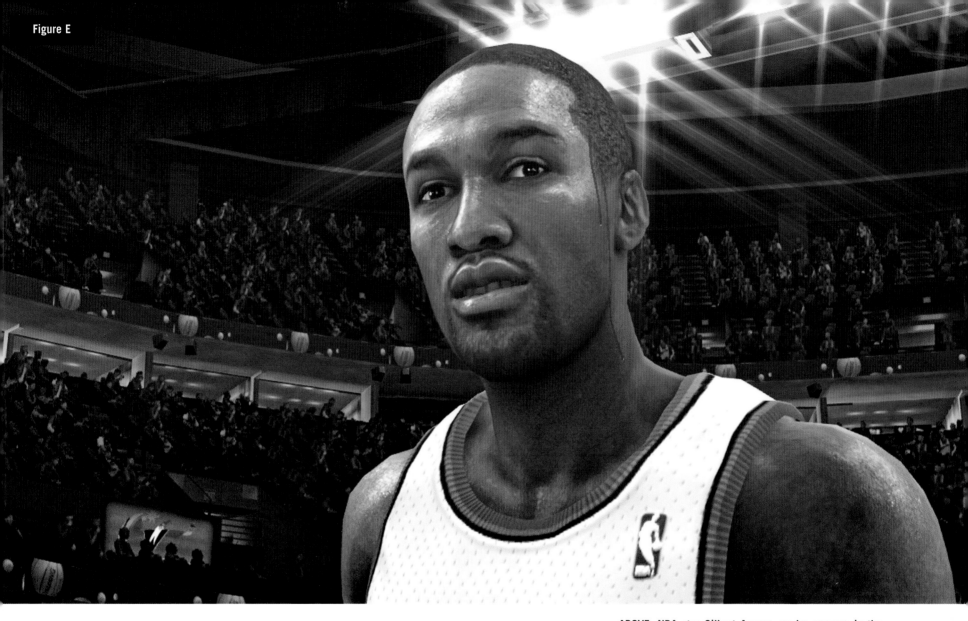

ABOVE: NBA star Gilbert Arenas, as he appears in the game. This final image is the product of thousands of hours spent capturing, mapping, and texturizing.

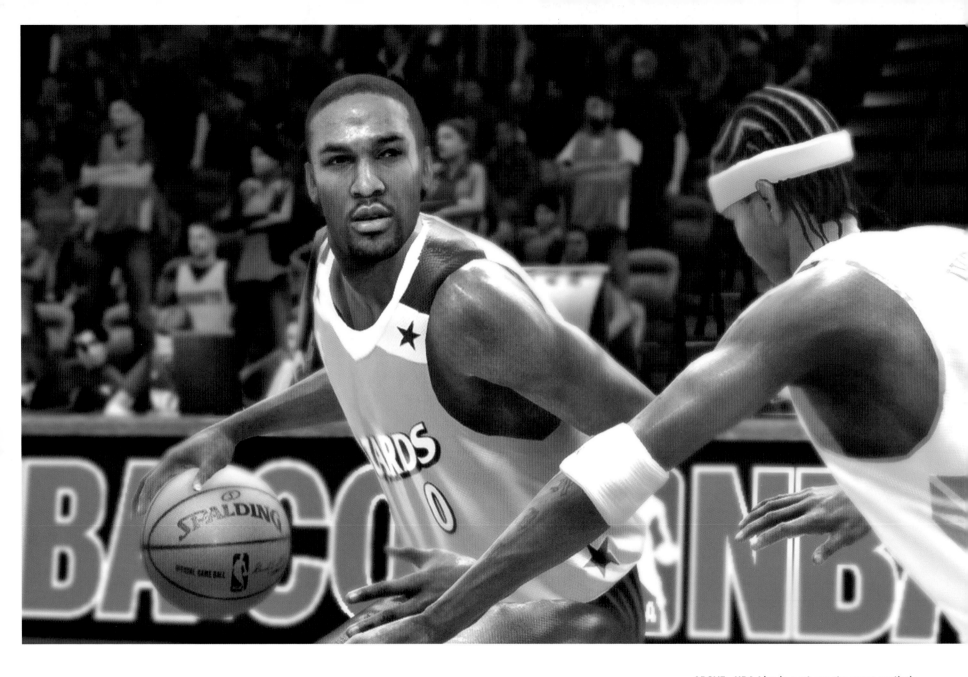

ABOVE: *NBA Live* is perhaps the most realistic basketball game ever created. Not only are the players' likenesses captured to the last sweaty detail, character movement is flawlessly lifelike.

Rampage: Total Destruction

PUBLISHER: MIDWAY

DEVELOPER: PIPEWORKS SOFTWARE

The *Rampage* franchise has been entertaining gamers for more the 20 years with its peculiar brand of smash-'em-up action. Although graphics have improved substantially, the gameplay formula remains largely unchanged. Players take control of a humorously rendered but nevertheless ferocious monster and attempt to level a given city, its population, and their opponents through the use of kicks, punches, and other "special" moves. What's radically different with *Rampage: Total Destruction* is the number of available monsters with which gamers can wreak havoc. In the PS2 and GameCube versions, there are 30 available monsters; on the Wii, the gruesome brood grows to 40. Old favorites, like Ralph the Wolf, Lizzie the Lizard, and George the Ape, are still present, but now you can choose from Brian the Brain, Squirmy the Worm, Plucky the Chicken, and even a creature named Philbert the Ungulate, who, I believe, is some kind of fish. Or a llama.

RIGHT: Why does every monster in *Rampage: Total Destruction* seem so pathologically angry? Pictured here is Rocky, one of the game's well-muscled miscreants bent on world destruction.

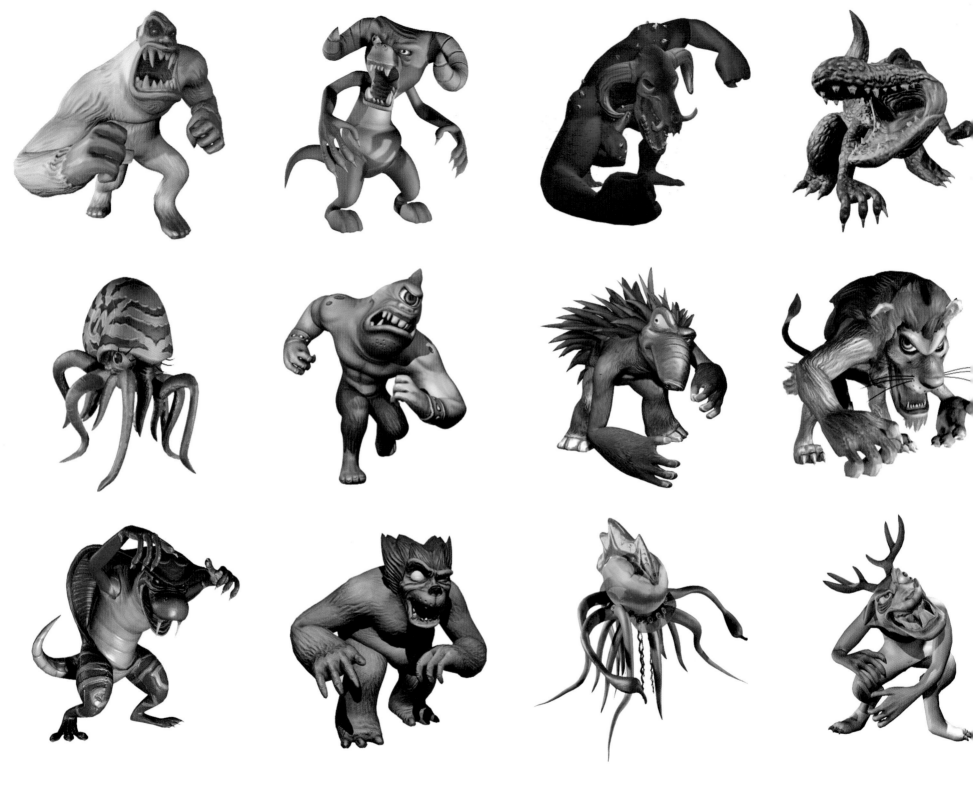

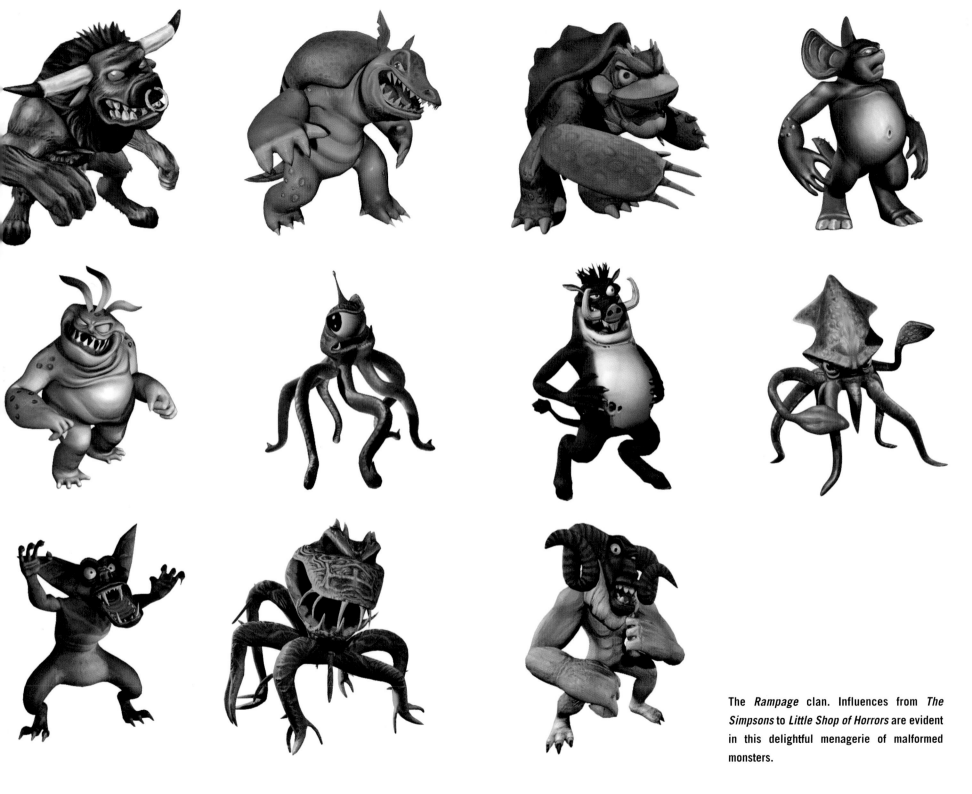

The *Rampage* clan. Influences from *The Simpsons* to *Little Shop of Horrors* are evident in this delightful menagerie of malformed monsters.

Reservoir Dogs

PUBLISHER: EIDOS

DEVELOPER: BLITZ

In 1992 Quentin Tarantino and his unique, twisted genius burst onto the scene with *Reservoir Dogs*, the story of a handful of colorfully named crooks and the heist of a lifetime. Although Tarantino was not involved with this video game adaptation, developers were intent on creating a title that was thematically true to the filmmaker's original vision. Of course, the game is less a re-creation of the film than an adaptation. The movie's seminal moments are intact, but much of the game's plot revolves around events hinted at, but not featured in, the film. In an interview with Computerandvideogames.com, project manager Dave Manuel discussed the challenges inherent in adapting an action film for a video game audience: "The experience of watching a linear nonaction film and playing an interactive action game will naturally be different," he said. "We believe the player will find the missions we have created intense, whether they are shooting their way through, trying to keep things under control, or driving under pressure. One of our core design goals was to convey a sense of continued 'knife-edge' tension throughout all the escape missions. . . . We spent a lot of time coming to an appropriate order for the levels, which took into account the game's narrative and pacing. Also, we re-created scenes from the film as full-motion video, for that helped unite the game and the film in terms of storyline."

RIGHT: Trying to remember the car chase scene in *Reservoir Dogs*? Don't bother, it didn't happen. The game is much more an adaptation of the film than it is a re-creation. As such, developers were able to increase the action quotient, incorporating heart-pounding sequences such as this chase scene.

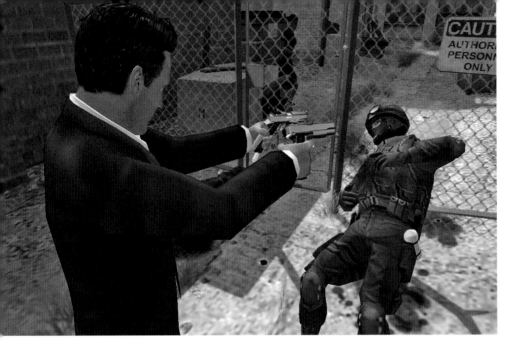

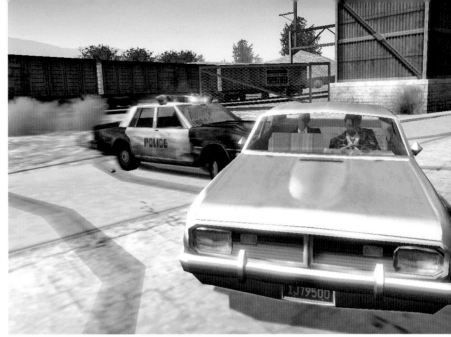

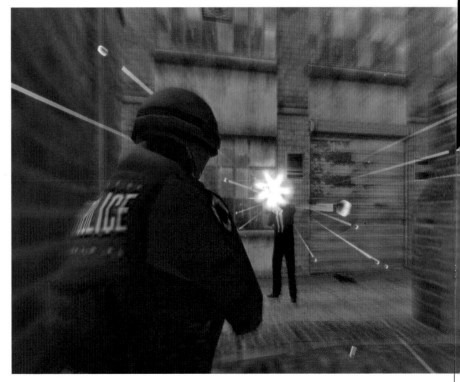

ABOVE LEFT: Developers were criticized for the game's gratuitous violence toward police officers, though producers were quick to point out that almost all choices about whether or not to commit such violent acts lie with the player.

BELOW LEFT: The game's gritty urban environments practically drip with criminal character.

ABOVE RIGHT: Classic '70s muscle cars complement the main characters' tough, gruff exteriors.

BELOW RIGHT: The action is furious throughout, as evidenced by this *Matrix*-style bullet-time screen grab.

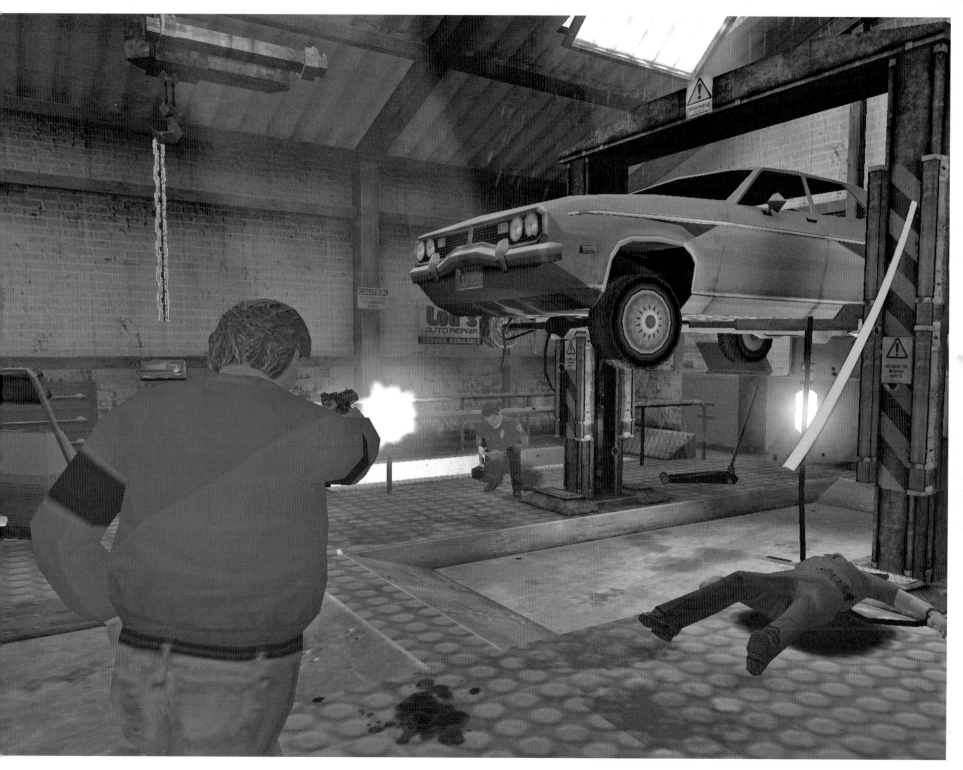

ABOVE: Interior locations are where the game really shines. This auto repair shop is lit from above by an ancient skylight and covered with years of industrial grime—and blood.

ABOVE: *Reservoir Dogs*, the film, made barren warehouses famous, but the game improves on the aesthetic by incorporating diffuse lighting, aged brickwork, and worn tile flooring.

Ridge Racer 7

PUBLISHER: NAMCO BANDAI
DEVELOPER: NAMCO BANDAI

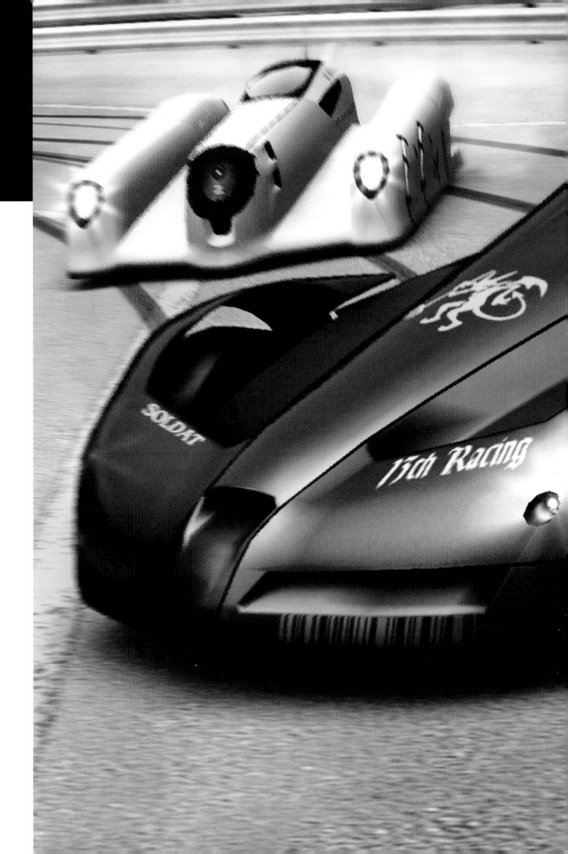

The latest installment of *Ridge Racer* (created exclusively for Playstation 3) takes full advantage of the ability of next-gen consoles to render graphics in high definition. Through a translator, we spoke with art director Hideki Nakamura. "Since *Ridge Racer* has a realistic art design, people might think the design process is easy because all we have to do is base everything off real photos," Nakamura explained. "But games must be an entertaining and moving experience. In order to touch people's emotions, we need to come up with something that's beyond mere logic. Getting this inspiration requires day-to-day effort and a lot of brainstorming. I think a lot of artists' inspirations come from something abstract, something that cannot be described by words.

"Our goal was to create a racing game with the concept of 'real unreality.' Drifting through tight corners at 150 MPH and enjoying the night view while flying hundreds of meters after a jump—obviously, *Ridge Racer* is truly an unreal experience. To make sure this unreality isn't just a fantasy, we see to it that the visual designs are elaborate and real so that the players can relate to them. We actually added someone with real car-design experience to our development team. The various parts available for car customization in the game were also designed by someone with aftermarket parts-design experience." This meticulous attention to detail—combined with a universe in which cars can defy the laws of physics—may be the key to *Ridge Racer*'s enduring popularity.

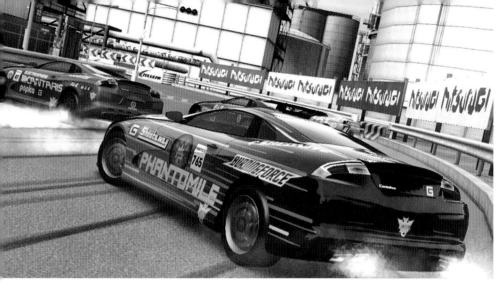

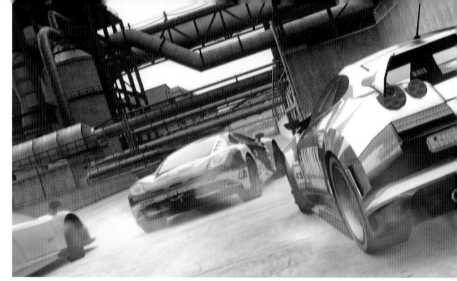

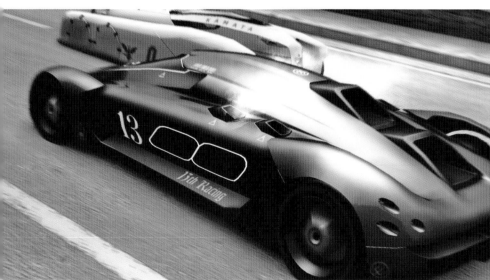

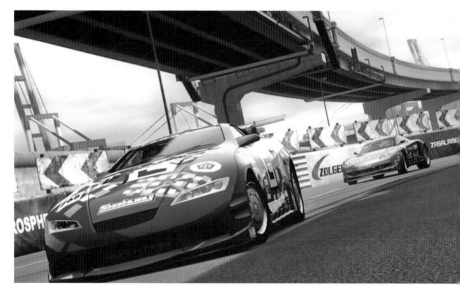

PREVIOUS PAGE: Visually compelling and viscerally thrilling, the cars in Namco Bandai's *Ridge Racer 7* exude a sense of speed and movement even when at a standstill.

ABOVE LEFT: A huge part of the racing dynamic in *RR7* is the drifting system, whereby thousands of pounds of metal and gasoline fly around tight corners, with tires smoking and screaming.

BELOW LEFT: Tight camera shots create a tremendous impression of speed—though so does the fact that the cars are traveling at near sonic velocity.

ABOVE RIGHT: There are no left-hand-turn-only NASCAR-style tracks here, just elegantly designed routes through crowded urban centers.

BELOW RIGHT: Though developers found inspiration in many of the world's top performance vehicles, no name-brand cars appear in the game, allowing players to focus more diligently on driving.

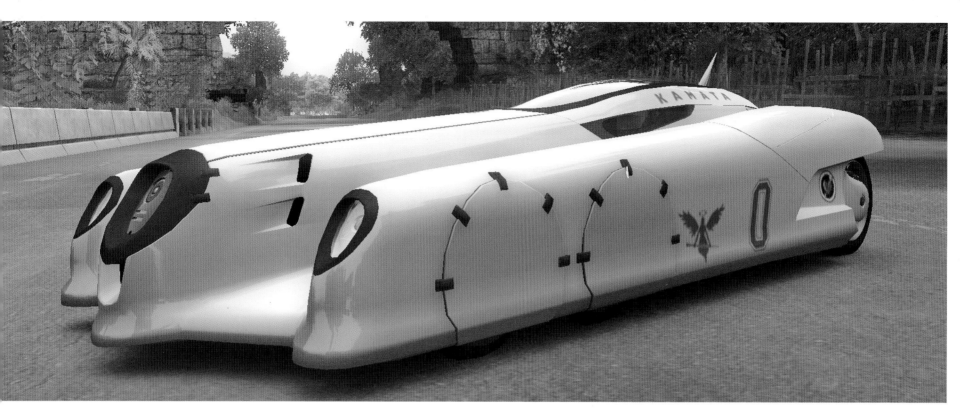

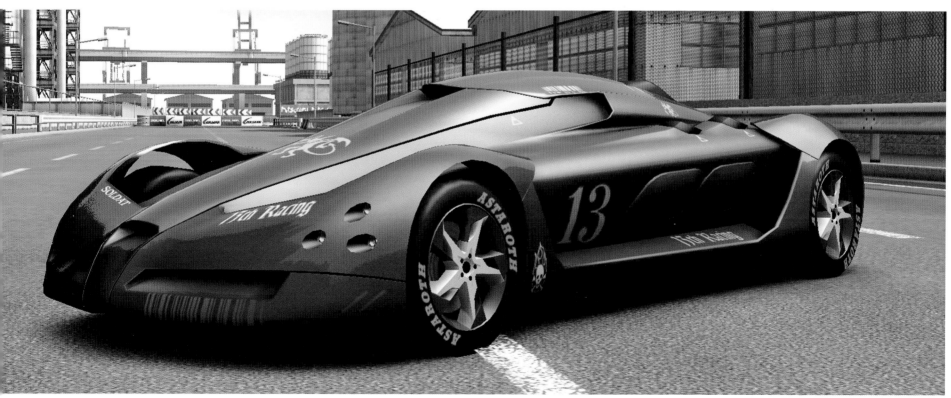

ABOVE: A closer look at two of the killer vehicles available to advanced drivers in *Ridge Racer 7*.

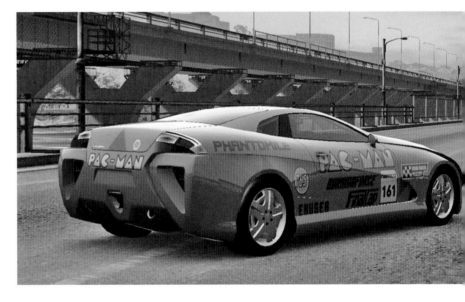

ABOVE: Among the artists working on *RR7* was an experienced car designer, who balanced the often mutually exclusive worlds of physics and aesthetics. Although the vehicles are clearly grounded in current automotive design principles, they embody an otherworldliness that puts the game in a class by itself.

The Sims

PUBLISHER: EA
DEVELOPER: MAXIS

To call Will Wright's *The Sims* a successful franchise is an understatement. The entire series, with all its sequels and expansion packs, has sold more than 75 million units. The game is unique because it has no set rules or objectives. Players simply create an avatar (or select from pre-made characters) and live their lives as best they can. The game was a natural progression of *SimCity*, in which players control the inner workings of a sizable metropolis. According to Worthplaying.com, it was inspired in part by Wright's experience with the great Oakland fire of 1991. Having lost his home and most of his possessions in the blaze, Wright began considering the complexities of human existence. He set out to design a game that could capture the subtleties and nuances of everyday life. Visually, the game is pleasantly simple, with bright colors, idealized neighborhoods, and a certain cartoonish quality that pervades the characters. Wright spoke with IGN.com about the appeal of *The Sims*: "I think there's something almost spooky about having a game in which you can put yourself, your house, and your family into it," he said. "You're playing a strange representation of your life. I know a lot of people who actually take a model of their real life, and there's something very humorous, strange, and twisted about it that I really like."

RIGHT: In another game, this man would be preparing to disembowel a gruesome alien invader. Here in *The Sims*, he's just a guy trimming his hedges.

ABOVE LEFT: Even the most mundane daily events, such as feeding your parrot, take on a certain in-world gravity in *The Sims*. Bright pastels and plenty of sunshine dominate the palette, giving the world a cheery, energizing feel.

ABOVE RIGHT: As in real life, societal interaction is a huge part of life in *The Sims*. The game's diversity of digital humanity is simply staggering.

BELOW RIGHT: Even bustling metropolises are filled with soft corners and muted colors, quite unlike the ominous urban sprawl in most other modern video games.

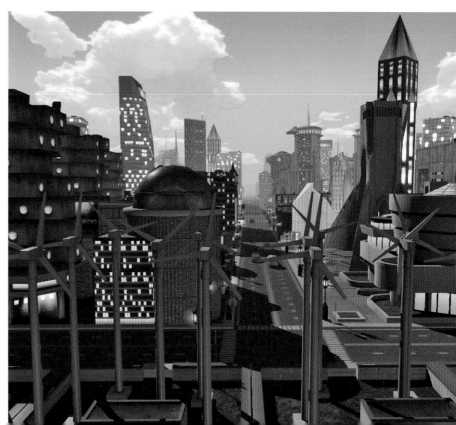

Sonic the Hedgehog: Next Generation

PUBLISHER: SEGA
DEVELOPER: SEGA

Sonic the Hedgehog is one of the most recognizable characters in gaming and has been Sega's official mascot for more than 15 years. (Other mascot ideas submitted by the design team included a bunny, an armadillo, and, no joke, a gigantic Theodore Roosevelt.) Creator Yuji Naka spoke with *Sega Visions* about how Sonic came to be: "At first we used a character that looked like a rabbit, with ears that could extend and pick up objects," Naka said. "As the game got faster and faster, we needed to come up with a special characteristic to give our character some power over his enemies. I remembered a character I had thought about years ago who could roll himself into a ball and slam into enemies. Hedgehogs can roll themselves into a ball, so we decided to go from a rabbit to a hedgehog. Because our new character could move really fast on the screen, we were looking for a name that suggested speed. One of the designers said 'supersonic,' and the 'sonic' part stuck."

RIGHT: Notoriously hard to photograph at a standstill, Sonic has become one of the most iconic video game characters of all time. His trademark red sneakers and blue dreadlocks carry a promise of great speed.

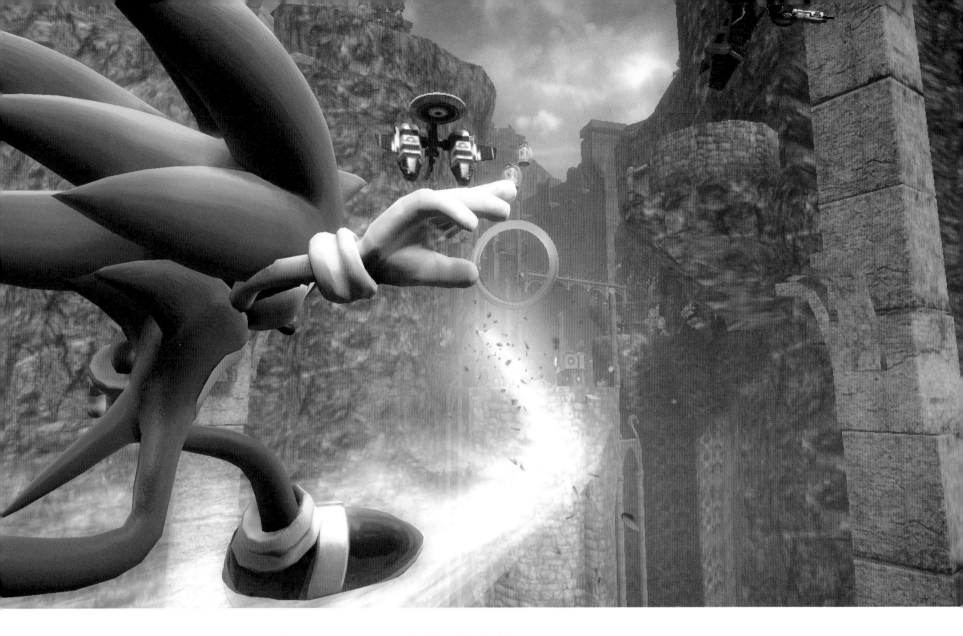

PREVIOUS PAGE, ABOVE: While Sonic has undergone only modest changes throughout the years, the world in which he lives has been completely transformed. Cleverly rendered enemies and striking landscapes now take center stage.

PREVIOUS PAGE, BELOW: Sonic's universe is a rich tapestry of diverse environments, from verdant grasslands to barren cityscapes.

ABOVE: Gone are the *Sonic* franchise's side-scroller days. Today's artists take full advantage of next-generation 3D technology to craft wondrously complex worlds, perfectly suited to Sonic's strengths.

Stranglehold

DEVELOPER: MIDWAY

PUBLISHER: MIDWAY

Midway's *Stranglehold* is a thrill-packed shooter that serves up healthy portions of the three Bs of successful action games: bullets, blood, and body count. That will come as no surprise to fans of Hong Kong action god John Woo, whose movie *Hard Boiled* is the spiritual predecessor to *Stranglehold*. Woo, whose bullet-riddled films set new standards for violence (*Hard Boiled* was banned in Sweden), collaborated heavily with developers, ensuring that the gore and firepower were up to his stringent standards. Actor Chow Yun Fat is present in the game, reprising his role as Inspector Tequila Yuen, a troubled cop with a penchant for gun battles that spill out spectacularly into the streets. Visually the game draws heavily on the Woo canon; it's full of dark, urban environments and gorgeous backgrounds that practically beg to be shot to hell. But as impressive as the background visuals are, the game's greatest strength is character art. Inspector Tequila is rendered with unparalleled realism, and the game's cast of villainy is given equal treatment, each exuding his unique brand of menace and depravity. Rather than fighting indiscriminate hordes of identical bad guys, the game utilizes a random body-part generator, meaning that it's unlikely you'll be blowing the scalp off the same guy twice. Nice touch.

RIGHT: One of the most visually compelling games in recent history, *Stranglehold* features some of the most realistic graphics ever captured in pixels. Artists didn't just craft a realistic human being, they created a human being capable of expressing the full spectrum of emotions—most commonly fury.

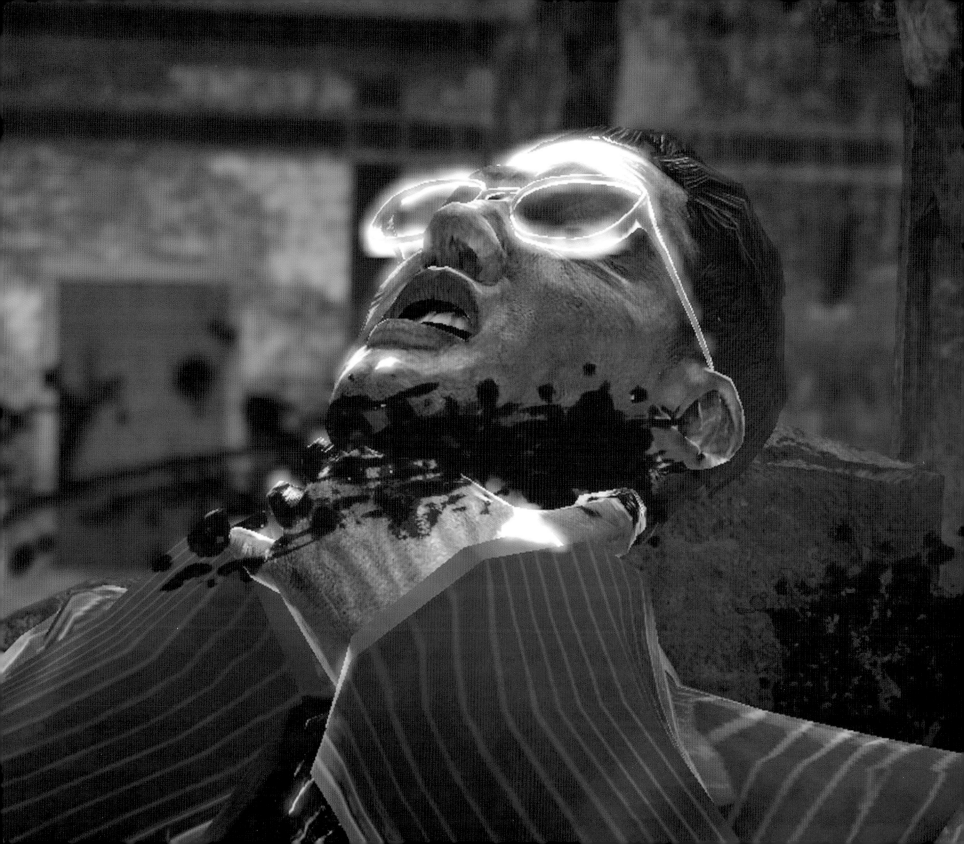

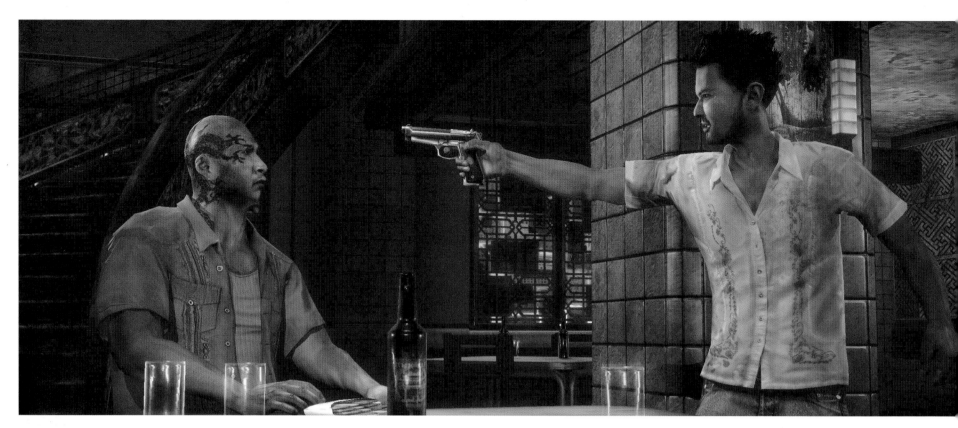
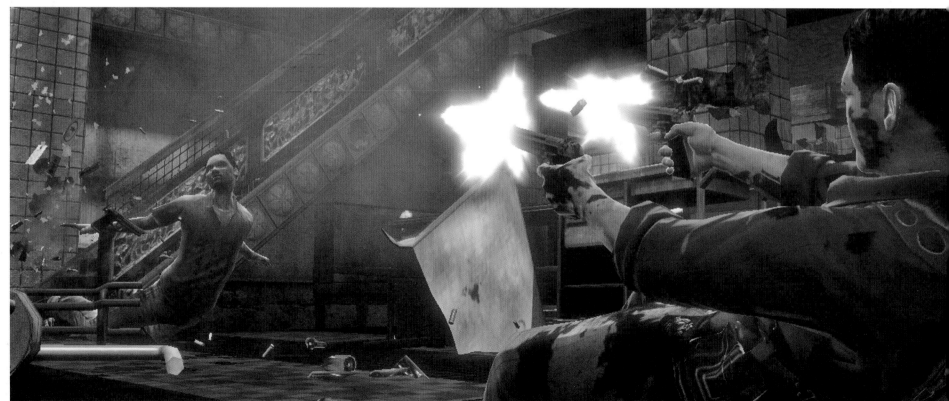

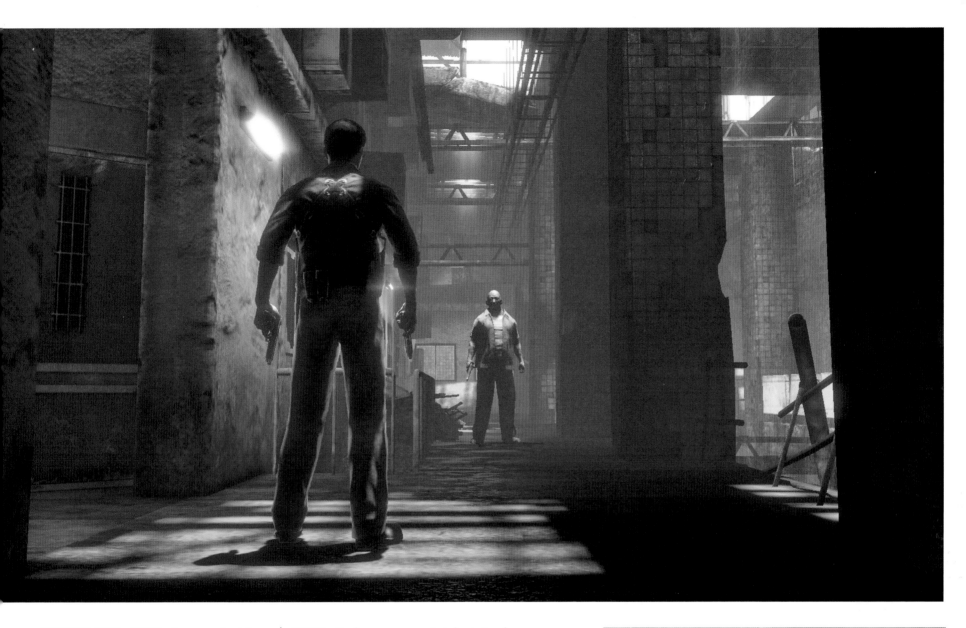

PREVIOUS PAGE, ABOVE: Gorgeous backdrops frame the action in *Stranglehold* to such a degree that you often don't know what to look at first. (Suggestion: Pay attention to the guy with the guns.)

PREVIOUS PAGE, BELOW: Another of the game's innumerable highlights is the convincing physics system. Bad guys fall with an almost morose realism as shards of carpet, wallpaper, and glass gleefully scatter to the four winds.

ABOVE: Designers succeeded in balancing intense action sequences with quiet moments of foreboding and dread.

RIGHT: Even slowed down 1000 percent, the game maintains a feverish pitch. Gunfire erupts almost serenely and bullets fly past as lazily as hummingbirds. Armor-piercing, hollow-point hummingbirds.

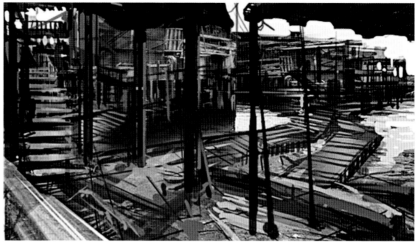
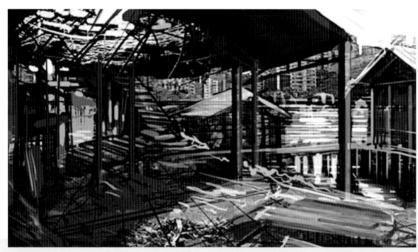
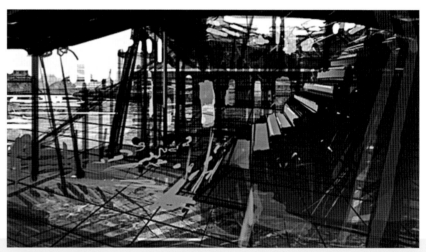

FLOATING 2

The piece featured here is a concept rendering from Stephan Martinere, depicting a virtual floating city in a bay. Martiniere's teams regularly utilize the latest iterations of popular design software that allow artists to build their concept pieces in layers. This technology allows them to create multiple versions of the same image without starting over each time.

Martinere briefly described the design process. "My team uses Photoshop and Painter as well as Z-brush and 3DS max," he said. "Being able to create paintings in layers greatly improves the process. It allows the artists to explore many possibilities without necessarily redoing the concepts. Each painting is different. Based on complexity, it can take from two to five days, sometimes fewer if it's a sketch, some-

ABOVE AND OPPOSITE PAGE, ABOVE: Early concept sketches outline basic shapes and the structure for the Tai-O market flotilla, a virtual floating city built into the bay.

times more if we want to explore many possibilities and variations. We usually have more flexibility in the schedule during the exploratory 'blue sky' period."

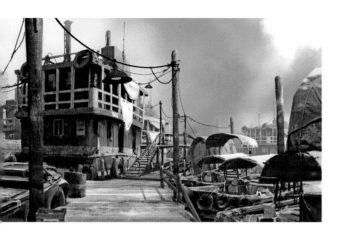

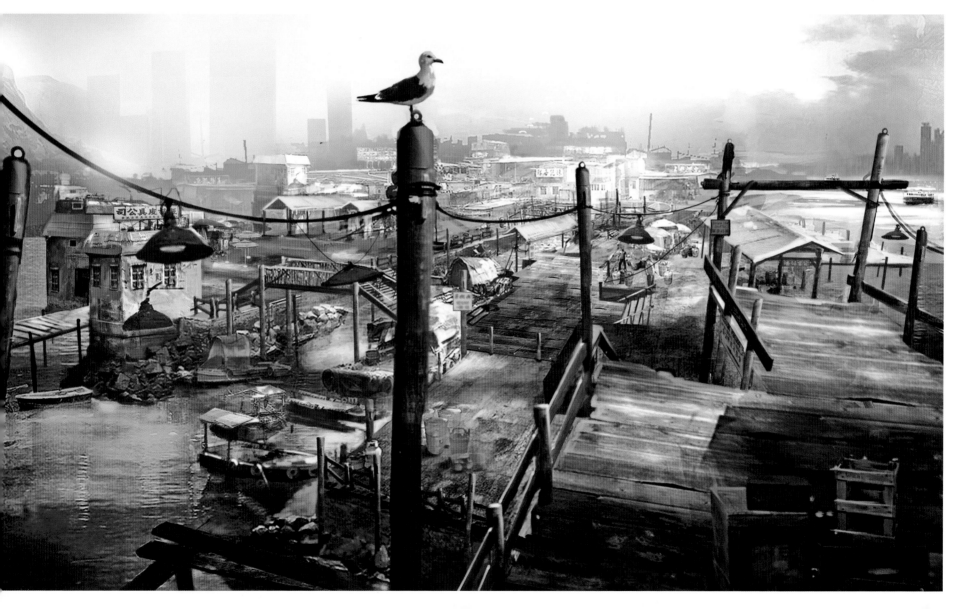

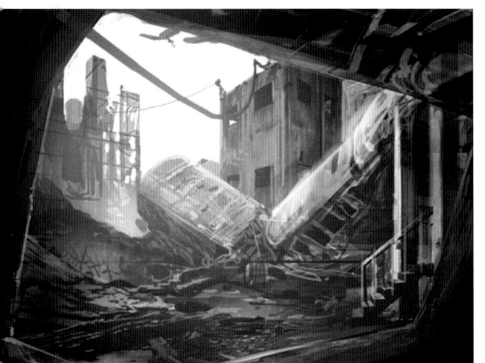

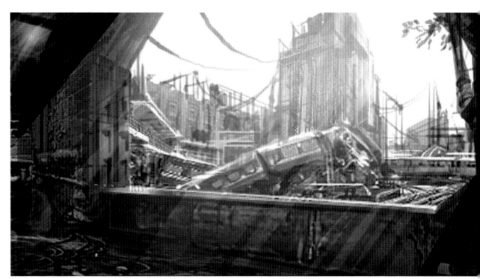

TRAIN GRAVEYARD

Featured here is a concept illustration for the train graveyard by *Stranglehold* visual design director, Stephan Martiniere. "The challenge for me was to give each place its own unique mood and color sig-

nature," he said. "I felt that as the drama unfolded and built up, these distinctive artistic ingredients would help pace the story and enhance its emotional content."

ABOVE: First attempts at defining the size and shape of the discarded train cars.

BELOW: Pulling back, we're treated to a rough view of the decrepit environment. Lighting and scale are emphasized.

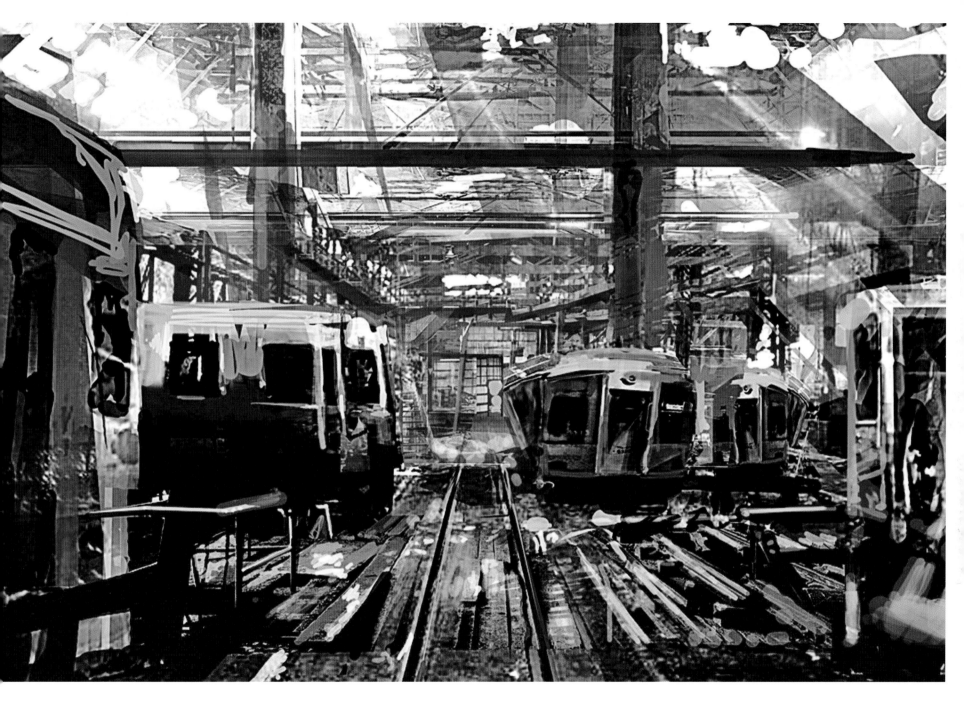

ABOVE: Detailing and shadow are incorporated, lending the environment a sense of reality.

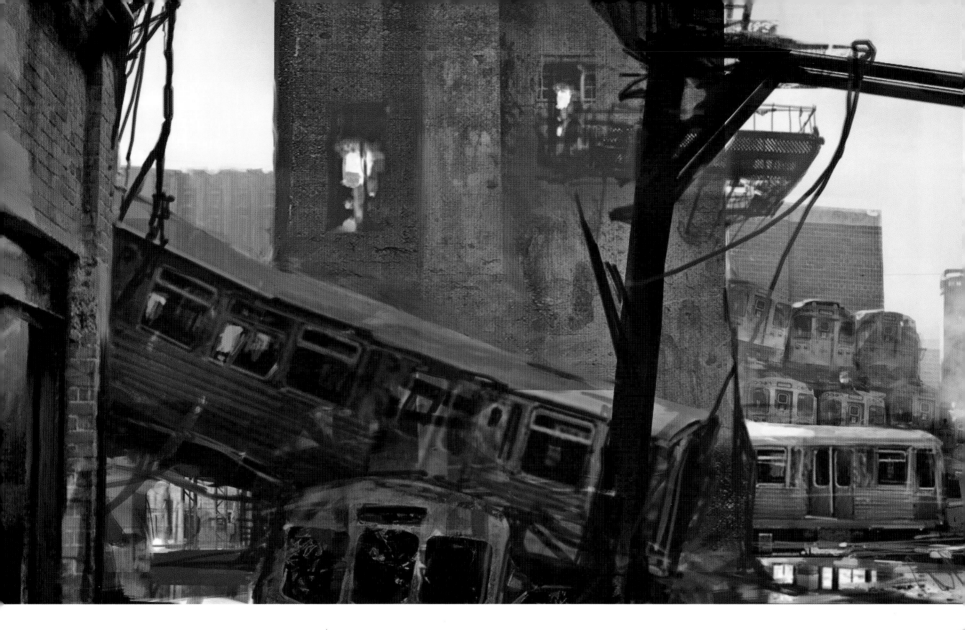

ABOVE: Final series: *Train Graveyard*, by Stephan Martiniere.

RIGHT: Inspector Tequila spends nearly as much time flying through the air as he does on the ground. Yet for all his aerial acrobatics, every movement seems as soundly choreographed as a Hong Kong action film.

OPPOSITE PAGE, BELOW: The *Stranglehold* control scheme is exceptionally well designed. Even flying through the air, one is able direct a hail of bullets in the direction of one's foe—or thereabouts.

Team Fortress 2

PUBLISHER: VALVE/ELECTRONIC ARTS
DEVELOPER: VALVE

In *Team Fortress 2*, players can choose from nine separate character archetypes, each with its own strengths, weaknesses, and personality quirks. However, the game's true legacy is its signature graphics. Drawing heavily from the industrial artistry of the 1950s, and looking a bit like an excessively violent Pixar feature, *Team Fortress 2* is different from anything else on the market. It's just plain fun to watch.

Featured here are the heroes of Valve's multiplayer masterpiece as conceived by character artist Moby Francke, who spoke at length about crafting the initial character concepts. Francke worked exclusively on paper before importing his designs into Photoshop. "Initially I used traditional gouache paint, an opaque watercolor," he said. "Its drying time is similar to that of acrylic paint, but it has the vibrancy of oil. The color and consistency of gouache make it perfect for blocking in flat color shapes and painting thin to thick. Initially I wanted to approach the character design as traditionally as possible because we wanted the game to have a hand-painted look. But once the designs were stamped, Photoshop was used to produce the in-game texture assets."

The unique aesthetic personality of *Team Fortress 2* gave artists a chance to work outside the proverbial box, allowing them to experiment with color, shape, and texture. For inspiration, Francke turned to a select group of commercial masters. "I couldn't resist using N. C. Wyeth, Dean Cornwell, J. C. Leyendecker, and Harvey Dunn for inspiration," he said. "I've admired these amazing artists for years. They were among the best commercial artists of their time. I give a lot of credit to [them] because their lifetime of work has inspired generations, and will continue to do so."

RIGHT: Quite unlike anything else currently on the market, *Team Fortress 2* is a feast for the eyes. Bright, primary colors and fifties-style design cues are an absolutely inspired counterpoint to the heavy-handed, shoot-'em-up gameplay.

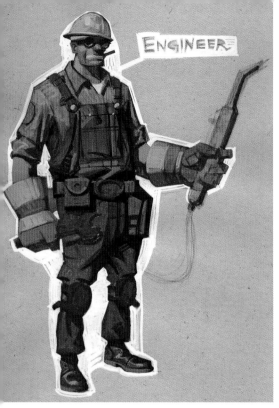

ENGINEER

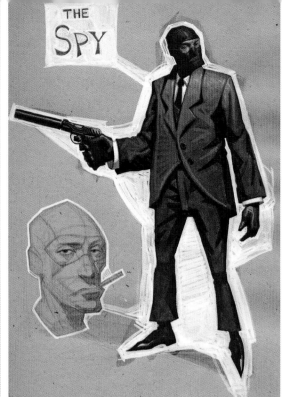

THE SPY

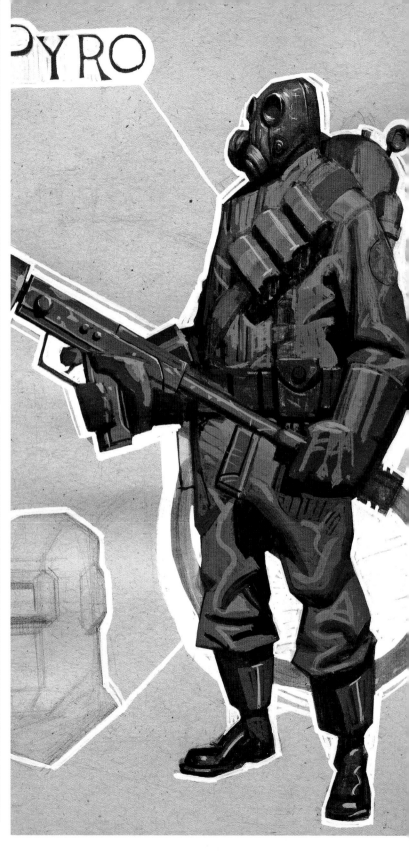

PYRO

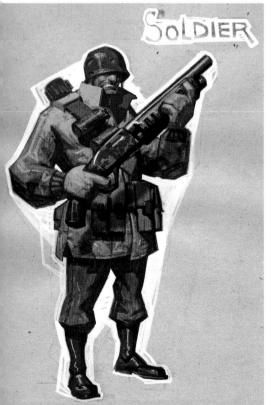

SOLDIER

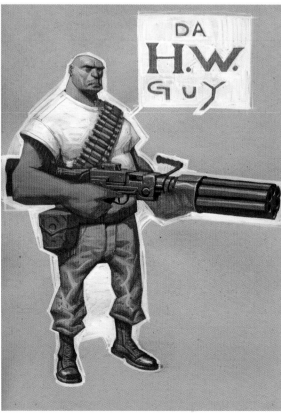

DA H.W. GUY

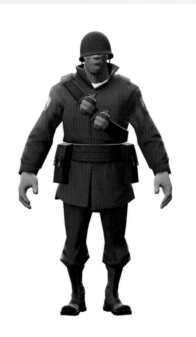
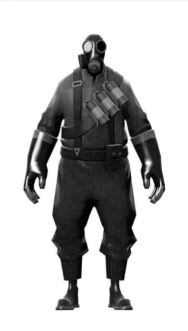
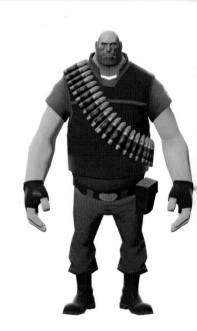

PREVIOUS PAGE: A series of concept illustrations serves as an early discussion of the *Team Fortress 2* cast. It's interesting to note how little the characters changed from initial concept to final in-game form.

ABOVE: One of the most difficult phases of character development is the transition from two-dimensional concept sketches to 3D models. True

fidelity to the concept artist's vision will depend entirely on the modeler's skill.

BELOW: Once the character models have been created and approved, texture artists go to work adding color, shading, and (you guessed it) texture.

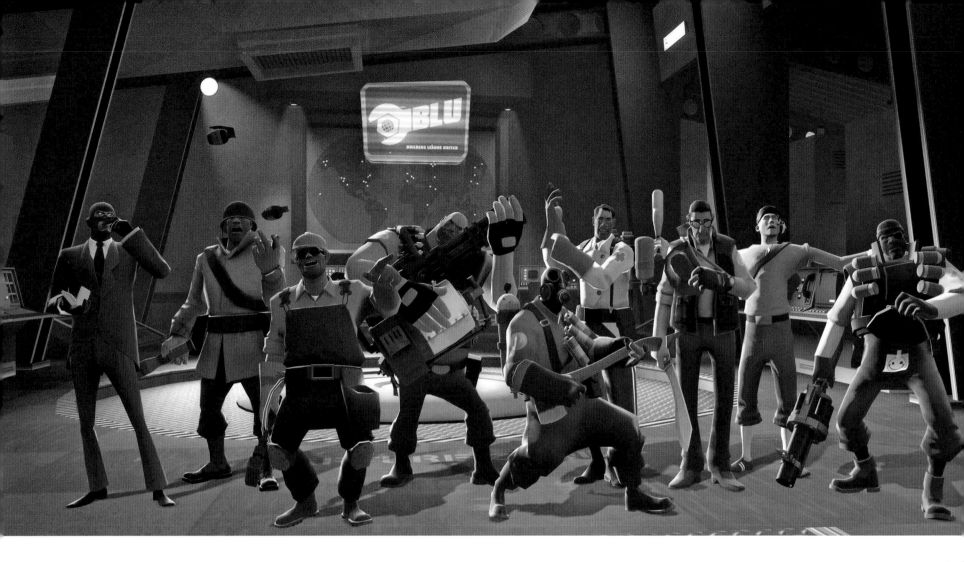

ABOVE: Despite such a large cast, it's clear that each individual has a well-defined personality and design aesthetic.

BOTTOM LEFT: Demoman and Pyro square off in what appears to be an abandoned mining town.

BOTTOM RIGHT: Each character was designed with a set of strengths, some of which are especially deadly to other specific classes. Here, the Spy prepares to dispatch the solitary Sniper.

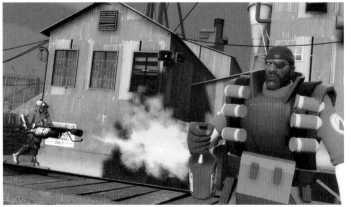

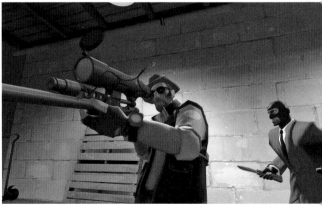

INITIAL SHAPE/
SILOHUETTE STUDIES

EXT. BARREL

STAGE 1

PARTS
BREAKDOWN

PRELIM SENTRY STAGES

MAIN
HOUSING
SPLITS

MINIGUN BARRELS
EXTEND LIKE
ACCORDIAN

ROCKET BOX
EMERGES
FROM INSIDE
REAR DRUM

FRONT
PIECES
RETRACT

WINGS
EXTEND

BACKEND
DROPS

BASE/LEGS
DROP &
SETTLE

BASE/LEGS
RAISE

FEET
EXTEND
& PLANT

1 2 3

PRELIMINARY
MODEL CONSTRUCTION

SENTRY bUILD STAGeS 1-3

ANATOMY OF A GUN

The colorful, "industrial cartoonish" aesthetic of Team Fortress 2 was both a boon and a challenge to designers. On one hand, artists had the opportunity to work in a completely new visual environment, with a color palette that included more than morose greens and grays. On the other hand, because they were working in a completely new visual environment, it would be impossible to fall back on established character, weapon, or background archetypes. Everything, in

fact, would need to be created from scratch. The piece shown here is from Valve artist Eric Kirchmer and features one of Team Fortress 2's most spectacular weapons: the Sentry Gun.

Kirchmer was responsible for inventing a gun that had both destructive prowess and personality. "I wanted it to look kind of campy and friendly at first—almost as if it were the engineer's pet dog or something," he said. "Slowly it becomes this rack of fury that has no campy, friendly, or petlike features at all. It

ABOVE LEFT: Kirchmer's initial passes establish silhouette, size, and functionality.

ABOVE RIGHT: Next, finalized versions of the gun are rendered in three dimensions.

just shoots lots and lots of business. The animation [team] did a great job giving it exactly this personality."

Additionally, in establishing design parameters for the Sentry Gun, Kirchmer did copious research. "I started by looking at some World War II

ABOVE: Kirchmer's instruction manual for the sentry gun.

machine guns that were collapsible and portable," he said; he later expanded his research to 1960s home appliances and even contemporary office furnishings. "At one point I was in our company conference room, and I realized that part of our projector could be adapted for the firing component. It started to come together from there."

Kirchmer even designed a complete instruction manual for his gun. Although the manual appears nowhere in the game, it reflects an attention to detail that's evident in every scene.

ABOVE: Kirchmer's instruction manual for the sentry gun.

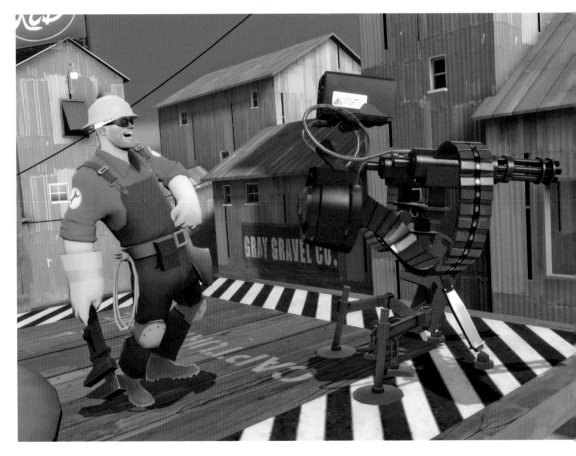

Final image: *Sentry Gun*, by Eric Kirchmer.

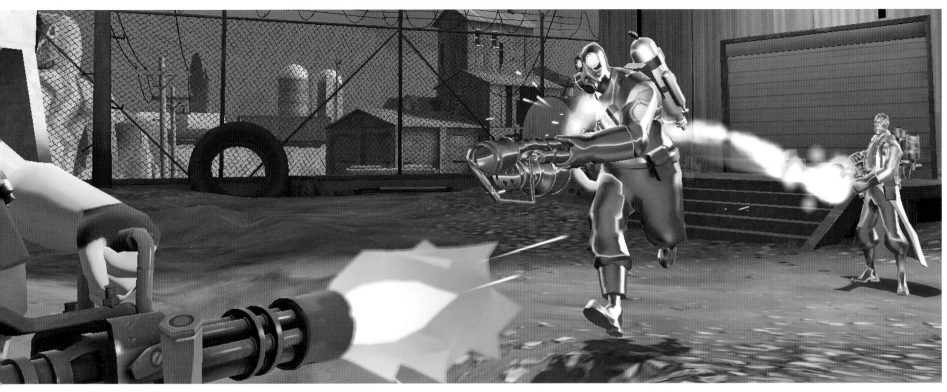

ABOVE: Despite a diverse cast of characters with wildly dissimilar strengths and weaknesses, teamwork is a fundamental part of online or cooperative gameplay.

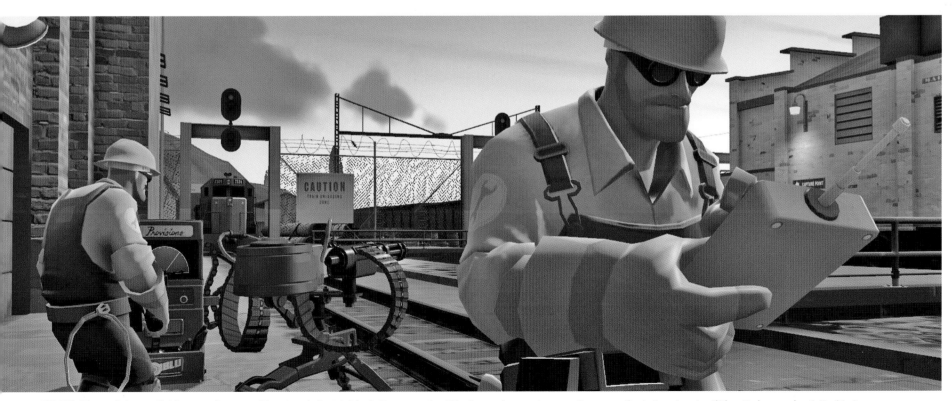

BELOW: Many of the available maps have a midcentury industrial feel. Here, a pair of Engineers have set up a rather complicated system for filling their enemies full of holes.

Universe at War: Earth Assault

PUBLISHER: SEGA

DEVELOPER: PETROGLYPH GAMES

With a plot culled from some of the greatest works of science fiction, *Universe at War: Earth Assault* is an engrossing real-time strategy game that pits intergalactic foes against one another in a battle for Earth. Wedged perilously in the middle—outgunned and outnumbered—is humanity, caught almost completely off-guard by the sudden appearance of not one, but three hostile alien species. Creative director Adam Isgreen spoke with Computerandvideogames.com about how he and his team managed to balance the epic with the intimate: "[The battles are] massive enough to cause city-wide destruction, but not so massive that you ever feel like you're controlling completely disposable forces," he said. "It was important to us to make the Hierarchy walkers feel like the massive battle stations they are, but also to ensure that you could see and visually understand anything that happened in the game. We have many units that have special abilities, and since they can be very powerful when used correctly, we wanted to always maintain a view where the player could understand what was going on."

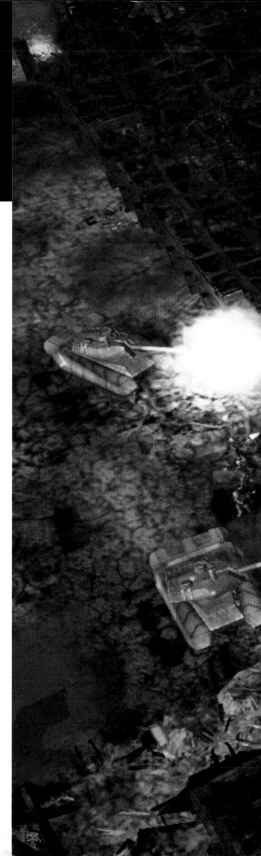

RIGHT: The magnitude of the action in *Universe at War* is nothing short of epic, presenting a unique challenge for designers. Rather than creating a world on scale with the human perspective, artists instead had to pull way out, capturing the colossal elements without neglecting the details.

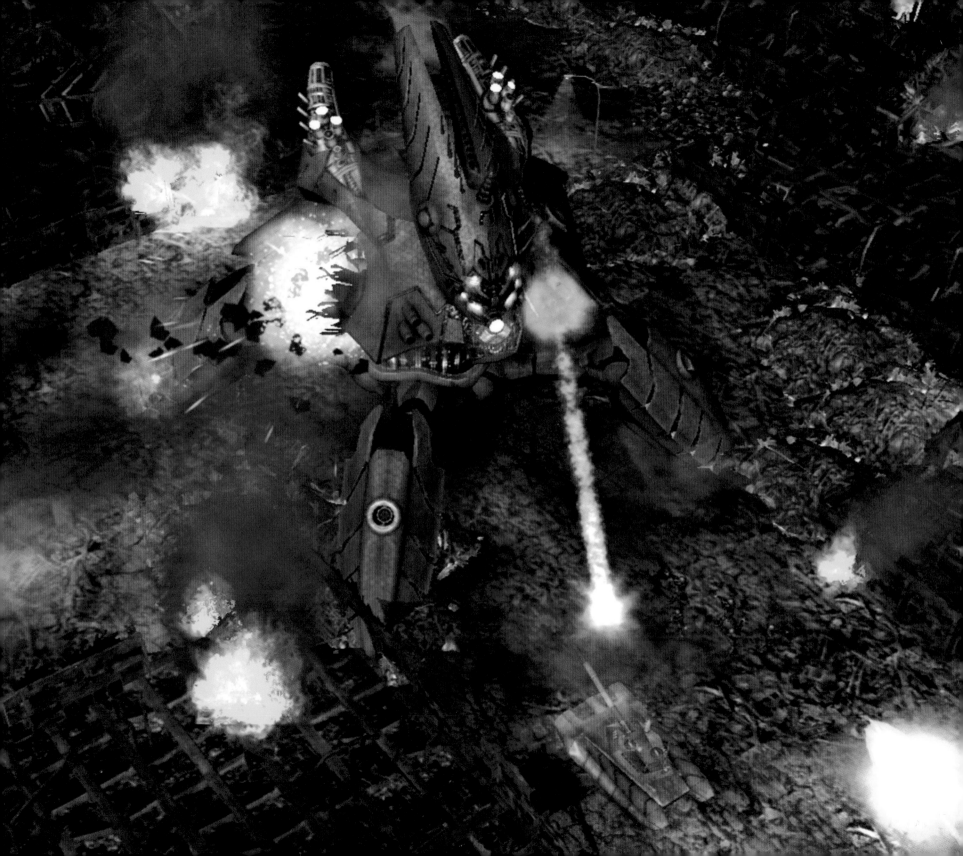

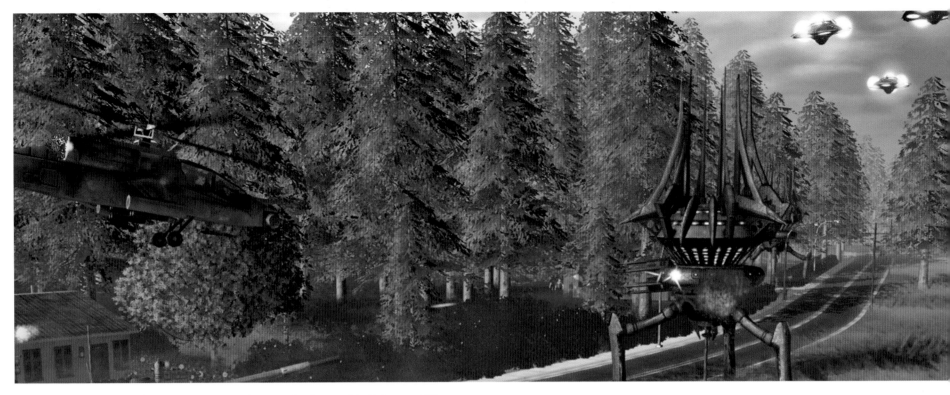

ABOVE: Earth's verdant environment serves as unfortunate battleground in *Universe at War*.

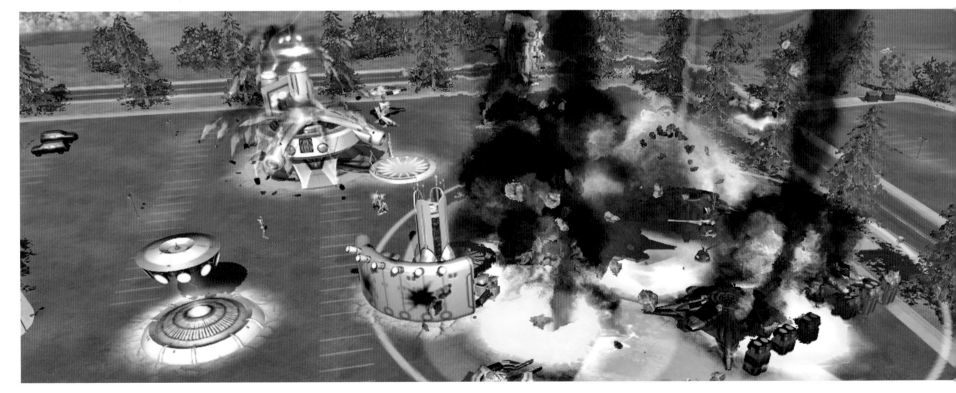

BELOW: The in-game foes are truly otherworldly, each faction with its own design scheme and specialized weaponry.

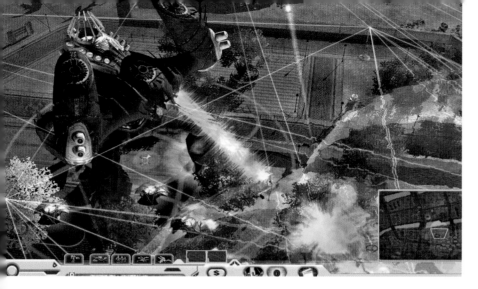

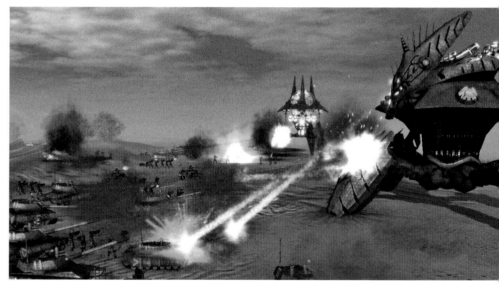

ABOVE LEFT: Japanese-inspired mech-warriors play an important role in combat operations, terrifically mobile and just plain cool to shoot at.

BELOW LEFT: Like the game's enormous environments, the combat is also suitably vast, with ground-to-space attacks (and vice versa) a standard part of the military arsenal.

ABOVE RIGHT: Designers incorporated a large array of energy weapons and defensive contrivances into the game. Unlike traditional projectile-based warfare, here combat is a glowing, vibrant thing.

BELOW RIGHT: Undermanned and underpowered, humanity is no match for the invading hordes. In terms of scale, the military apparatus of humankind appears pitiful.

ABOVE: Glowing red body panels and a sinister-looking visage suggest cruelty and a sort of mechanical bloodlust.

BELOW LEFT: In addition to the sheer physical size of the invading hordes, their numbers, too, are visually overwhelming, inspiring an almost absolute sense of hopelessness.

BELOW RIGHT: Although the in-game weapons are impressive to behold, their destructive prowess is utterly breathtaking.

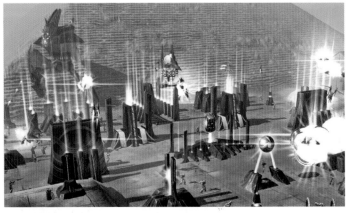

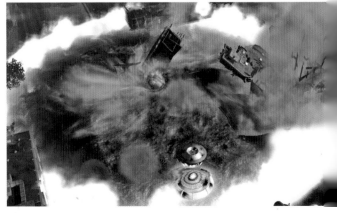

Viking: Battle for Asgard

PUBLISHER: SEGA
DEVELOPER: CREATIVE ASSEMBLY

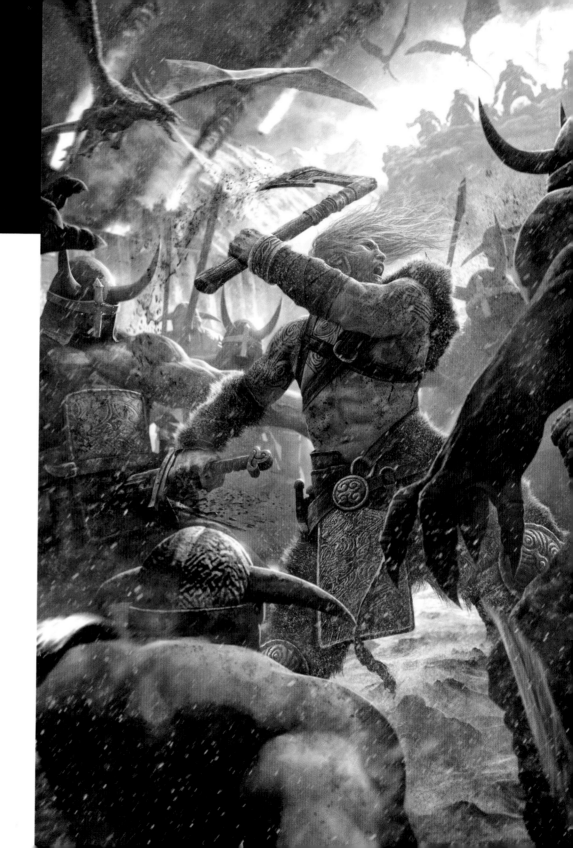

Viking: Battle for Asgard is, surprisingly, one of the first video games to draw extensively from the epic canon (and gratuitous violence) of Norse mythology. It is a visually arresting, action-packed romp across the realms of fantasy, folklore, and ancient warfare and features breathtakingly fast and furious combat sequences. Although primarily a first-person slasher, each mission in *Viking* is bookended by a spectacular battle sequence in which the player controls whole factions of Norse warriors. Developer Mark Suthers spoke with Gamesradar.com about these sequences: "We try to capture the feel of something like the *Lord of the Rings* movies—battles that send goose bumps down the spine," he said. "We want to put that feeling into a game, to represent the scale and music of a movie. In *Viking* we have one thousand men charging across the battlefield—the music is pumping and the blood is spurting. That's an epic movie feeling."

RIGHT: The key art for *Viking* sums up the entirety of the gaming experience: huge battles, mythical creatures, and brutal violence set against the backdrop of a near-arctic environment.

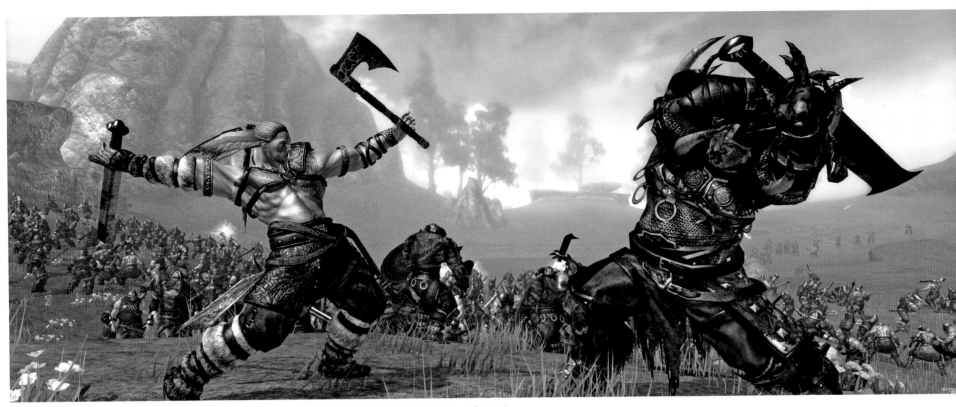

ABOVE: Animalistic foes and melee weapons are the name of the game in many of the game's epic battle sequences.

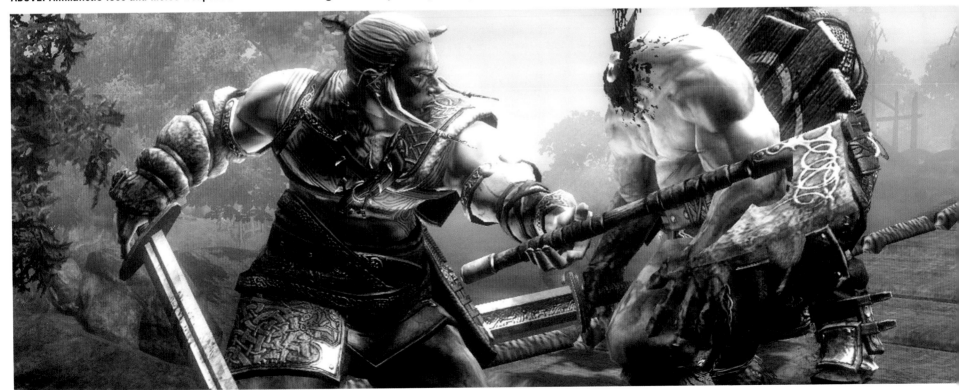

BELOW: Designers didn't shy away from the grisly specter of gore and violent confrontation. Heads roll, arteries splatter, and intestines litter the landscape.

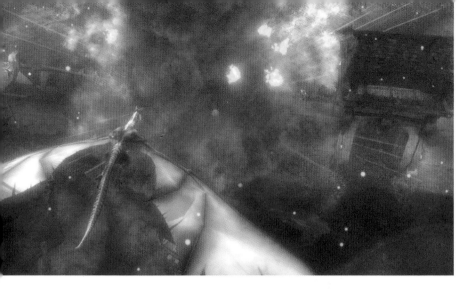

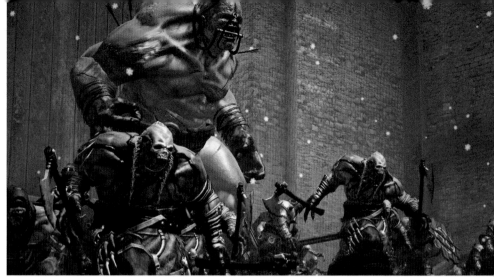

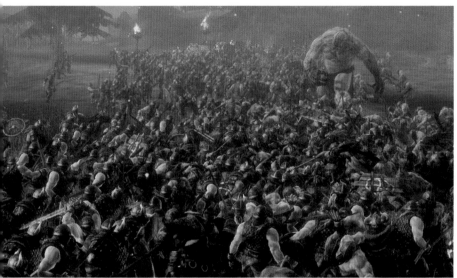

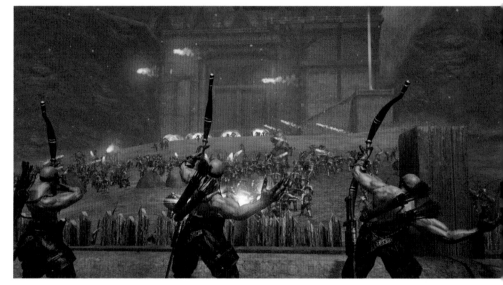

ABOVE LEFT: An over-the-dragon view of the unfolding battle below gives one an idea of the scope of the action designers.

BELOW LEFT: Literally thousands of soldiers take part in many of the battles in *Viking*, a design challenge ably met by artists and programmers.

ABOVE RIGHT: Despite a focus on large-scale warfare, artists didn't skimp on the design of individual foes. They are both fearsome and oddly mesmerizing.

BELOW RIGHT: Vicious melee combat is emphasized, but designers had the forethought to include ranged attacks as well, especially helpful for those squeamish about getting a few thousand gallons of blood on their shoes.

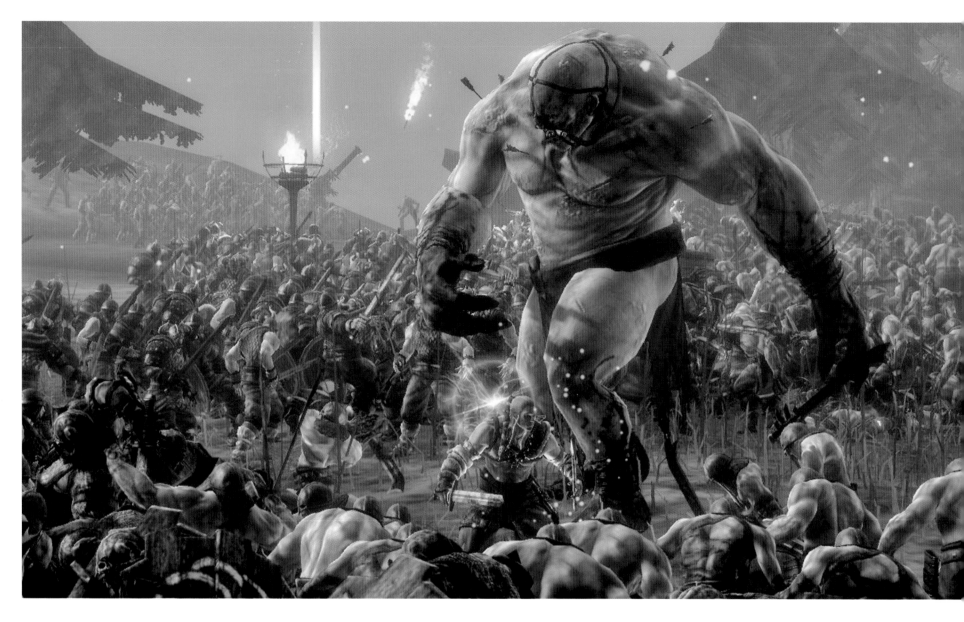

ABOVE: Gorgeously rendered giants play an appropriately large role in skirmishes.

BELOW LEFT: Not all is bloodshed and wanton evisceration in *Viking*. Skarin must negotiate a massive world filled with great natural beauty.

BELOW RIGHT: Much of the "civilized" world in *Viking* is visually arresting as well, an appealing blend of medieval and mythical design cues.

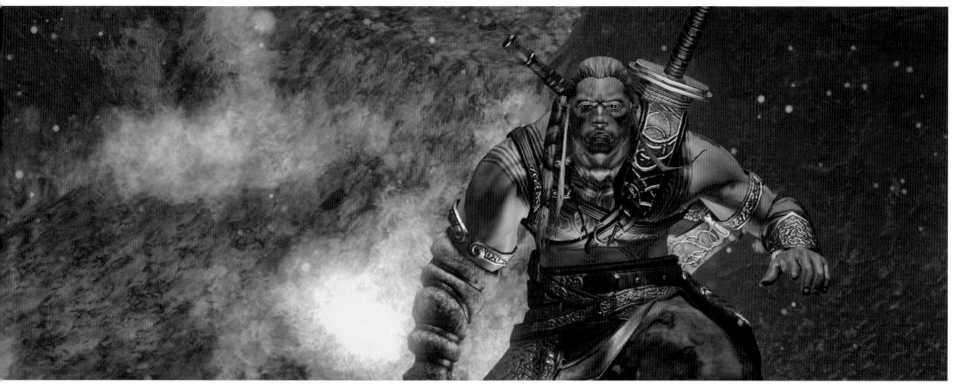

ABOVE: Skarin emerges from an explosive encounter.

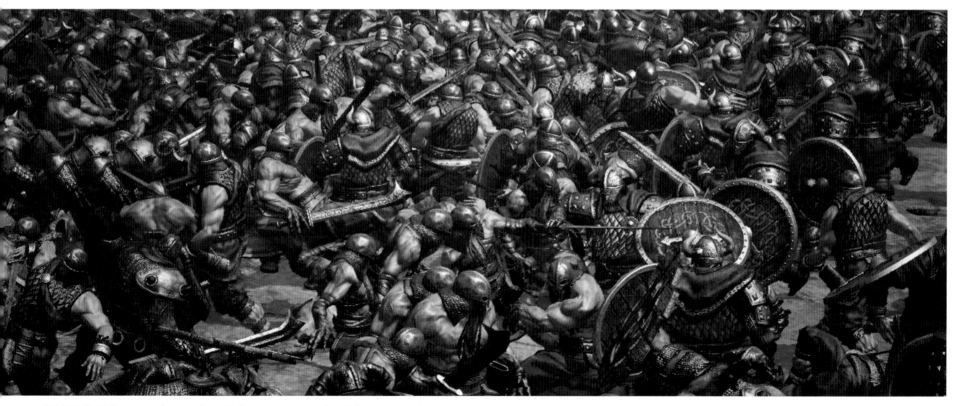

BELOW: Bold Norse warriors confront Hel's malevolent hordes. It is carefully choreographed chaos.

Warmonger: Operation Downtown Destruction

DEVELOPER: NETDEVIL

PUBLISHER: NETDEVIL

Warmonger is a first-person shooter designed to feature the most destructible environments ever made, and it succeeds, in large measure, thanks to the mighty processing prowess of the Unreal Engine 3 and the AGEIA PhsyX engine. The story unfolds in 2029, when global companies maintain their own corporate armies, ready to deploy them to defend worldwide commercial interests. The two largest companies have come to blows over the fate of Iranian oil fields—and their battlefield is the United States. Gamers must take back an entire city, one enemy-infested block at a time, blasting foes (as well as the poor, innocent scenery) with equal aplomb. Chris Sherland, NetDevil's *Warmonger* team leader, spoke with Firingsquad.com about the challenges his crew faced in creating totally destructible environments: "The thing we are striving for is to bring destruction into play as if it were a game character. One thing that play testers are saying a lot is that *Warmonger* feels 'unsafe' to play. Not that your spine is going to fly out while you play, but that, in-game, your concepts of cover and concealment are up for grabs and challenged."

RIGHT: Does this screen grab look a little different from everything else in the book? It should. *Warmonger* is made up of a series of totally destructible environments, meaning that you can interact with virtually every element you see. No gorgeous-but-untouchable backdrops here. You can shoot the crap out of anything in sight.

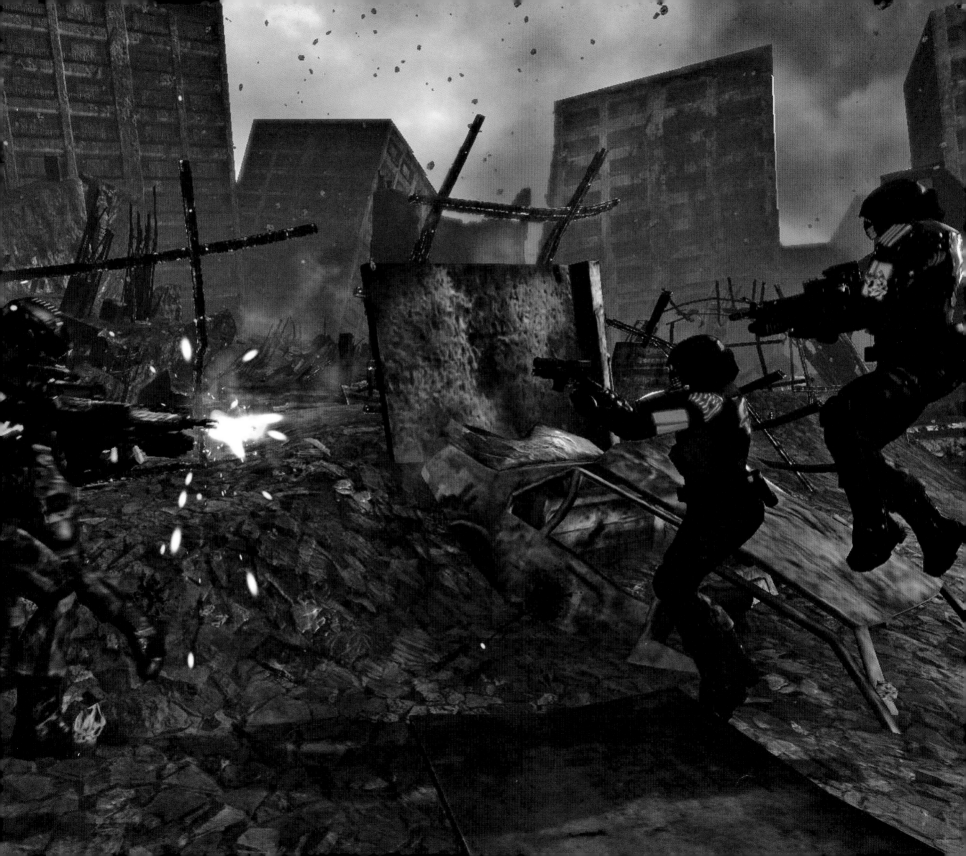

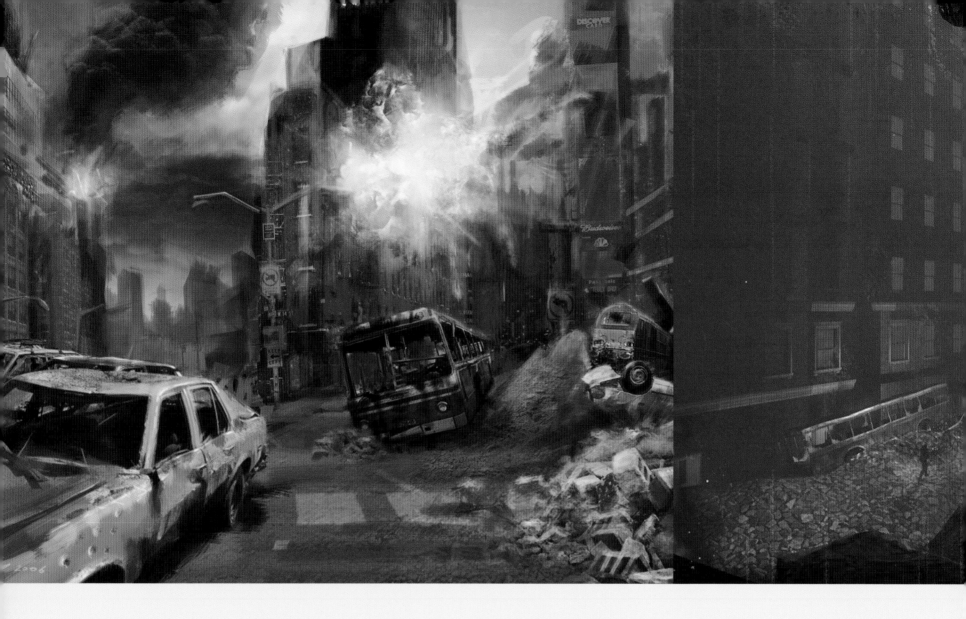

UNTITLED CONCEPT ART

The piece selected here is from Peter Grundy, a digital veteran who has worked 15 years in the industry. As studio art director for NetDevil, Grundy was responsible for designing a world environment that was not only great to look at but also able to fit within some rather stringent parameters. "*Warmonger* was a very difficult project to art direct," explained Grundy. "The main goal was to create destructive environments, [and] oftentimes this technology came at the expense of maintaining a visual integrity." Grundy created the featured image early in development to give his team an idea of what they were trying to accomplish despite processing limitations.

"They were done in the early phase of the project to try to help the whole team get an understanding of what we were trying to create," he said. "With that in mind, I threw together photo references and painted with loose Photoshop brushstrokes over the top. By the

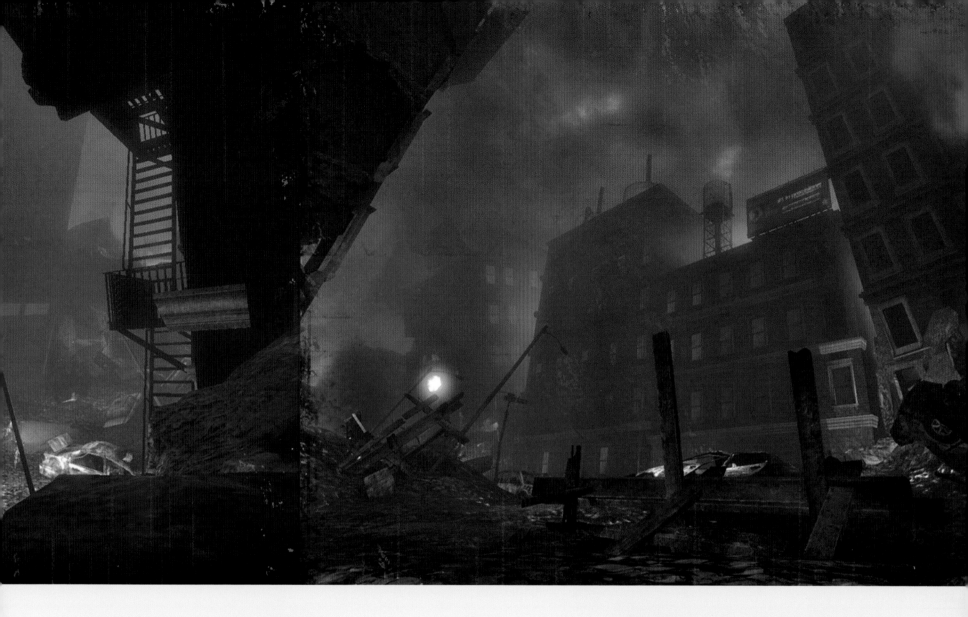

time you're done using this technique of painting and photomontage, it's often hard to determine what has been painted and what is a photograph. It utilizes Photoshop overlays, alphas, colorizing, [and] scaling along with sketching and painting techniques, and the final result gives you a feel for an environment."

ABOVE LEFT: Final image: *Warmonger* concept art, by Peter Grundy.

ABOVE CENTER AND RIGHT: These screens demonstrate how Grundy's image was interpreted and rendered in-game.

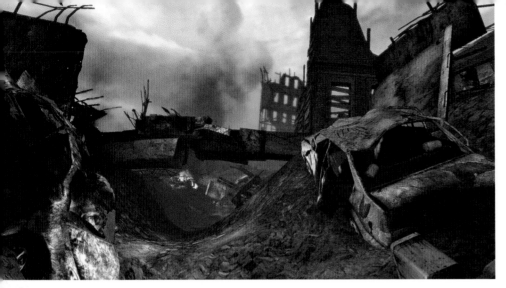

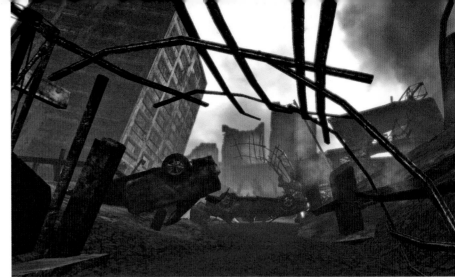

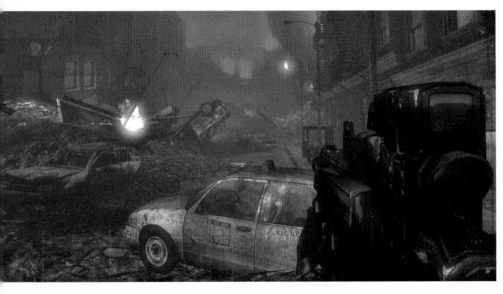

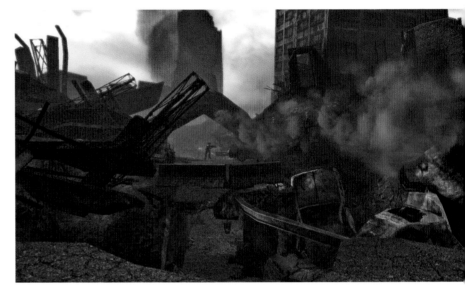

ABOVE LEFT: The destruction in the aptly named *Warmonger: Downtown Destruction* is far-reaching and total.

BELOW LEFT: Artists didn't simply design a barren wasteland; in fact, it's almost as if they created a fully functioning city—and then blew it to hell.

ABOVE RIGHT: Tenuously hanging structural elements are a recurring design theme. Shoot them down to dispatch an enemy or to block his escape.

BELOW RIGHT: The sun is a far-distant memory in *Warmonger*, a dim glow shining meekly through layers of smoke and greasy haze.

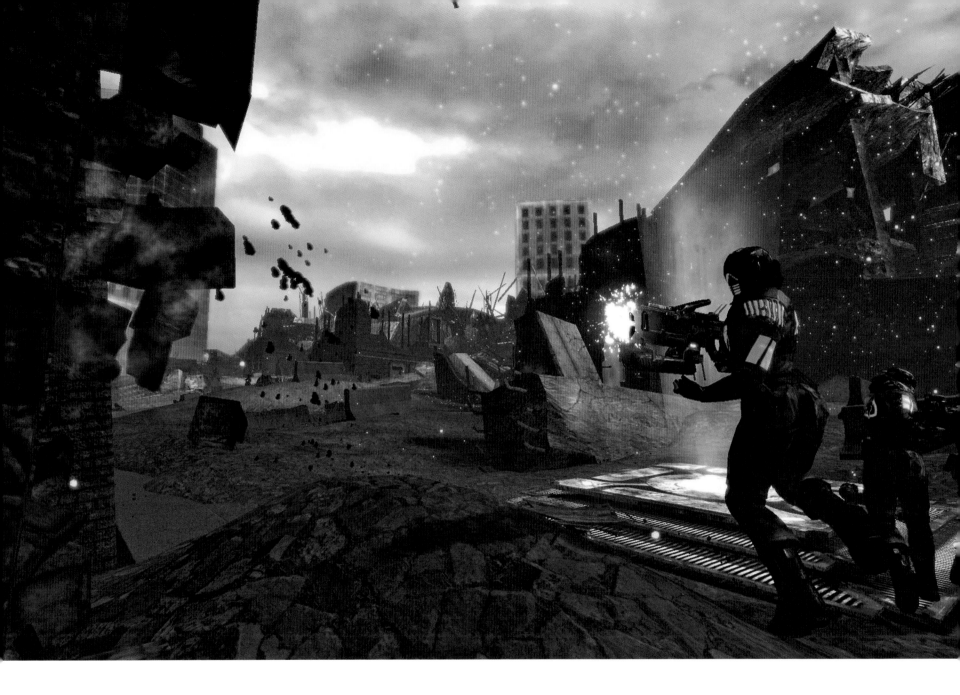

ABOVE: Sparks fly, bullets soar, and plaster dis-
integrates. It's a chaotic, and common, scene
in *Warmonger*.

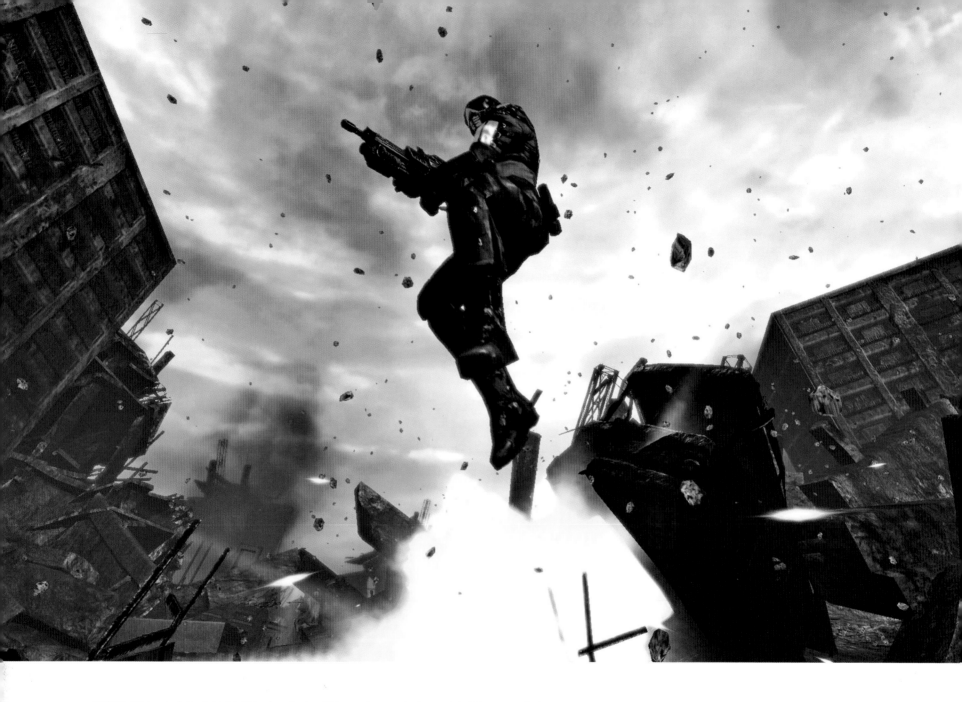

ABOVE: The promise of comprehensive destructible environments has existed for years but was mostly limited to the most simplistic interactions—such as having your bullets make uniform holes in nearby walls or the occasional breakable plate-glass window. In games like *Warmonger*, destructible environments actually factor into gameplay.

Acknowledgments

First and foremost, I would like to dedicate this book to Liz—perhaps the only wife in the world who allows a PS3, a 360, and a Wii to be attached to every television in the house.

The Art of the Video Game changed formats several times from its conception in January 2007 to its completion in January 2008. The gorgeous (if I may say so) final version you hold in your hands was helped greatly by Jason Rekulak, a man oft-described as the "Best-Looking Editor in America," though never out loud or by anyone of consequence. I'd also like to thank designer Doogie Horner, who managed to turn nine packed CDs into a romping, rousing page-turner of a book. And kudos to copy editor Mary Ellen Wilson for cleaning up my manuscript—a feat that would leave most people dead of adjective poisoning. Of course, *The Art of the Video Game* wouldn't exist at all if it weren't for the gallant efforts of the rest of the Quirk team: Bryn Ashburn, David Borgenicht, Mindy Brown, Brett Cohen, Robin Klinger, Margaret McGuire, John J. McGurk, Melissa Monachello, Sarah O'Brien, Jessica Schmidt, Lacey Soslow, and Lizz Souders. A special thanks also goes out to publishing's greatest treasure, the prolific and formidable Seth Grahame-Smith, who introduced me to the talented folks above.

Though they are far too numerous to mention individually by name, the PR, marketing, design, and production staffs at the various video game companies were uncommonly helpful and enthusiastic about this project. Without their assistance in procuring art and interviews, the pages of this book would be almost entirely empty.

And finally, thanks to the incredible artists whose work is collected herein. Video games are the next great frontier of art, and the folks on the preceding pages are true pioneers.

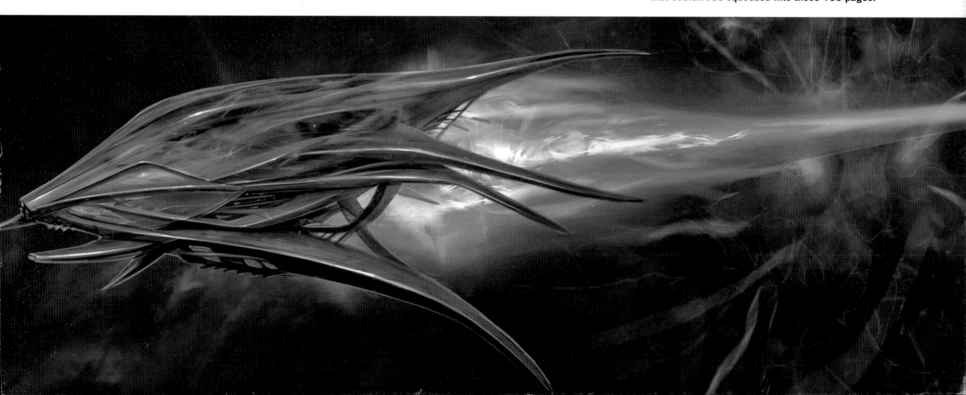

BELOW: A gorgeous spacecraft from *Jumpgate: Evolution*, just one of the many awesome games that couldn't be squeezed into these 160 pages.

IMAGE CREDITS

Jacket front, top row, left to right: Image from *Hellboy*, courtesy of Krome Studios and Konami. Copyright 2008. Image from *Killzone 2*, courtesy of Sony Computer Entertainment and Guerrilla Games. Copyright 2008. Image from *Guild Wars*, courtesy of ArenaNet. Copyright 2007. Second row, left to right: Image from *Hellgate: London*, courtesy of Flagship Studios. Copyright 2007. Image from *Hellboy*, courtesy of Krome Studios and Konami. Copyright 2008. Third row, left to right: Image from *Eve Online*, courtesy of CCP. Copyright 2003. Image from *Jumpgate: Evolution*, courtesy of NetDevil. Copyright 2008. Image from *Hellgate: London*, courtesy of Flagship Studios. Copyright 2007. Bottom row, left to right: Image from *Team Fortress 2*, courtesy of EA and Valve. Copyright 2007. Image from *Turok*, courtesy of Touchstone Studios and Propaganda Games. Copyright 2008. Image from *Mortal Kombat: Deception*, courtesy of Midway. Copyright 2004.

Jacket back: Image from *Eve Online*, courtesy of CCP. Copyright 2003.

Jacket, front flap, top: Images from *Universe at War: Earth Assault*, courtesy of SEGA and Petroglyph Games. Copyright 2008. Bottom: Images from *Ridge Racer 7*, courtesy of Namco Bandai. Copyright 2006.

Jacket, back flap: Sub-Zero illustration by Pav Kovacik. Courtesy of Midway. Copyright 2006.

Page 1: Image from *Hellgate: London*, courtesy of Flagship Studios. Copyright 2007.

Page 2 and pages 89–92: Images from *Lara Croft Tomb Raider: Anniversary*, courtesy of Eidos and Crystal Dynamics. Copyright 2007.

Page 5: Image from *Guild Wars*, courtesy of ArenaNet. Copyright 2007.

Pages 16–17: Images from *Hellboy*, courtesy of Krome Studios and Konami. Copyright 2008.

Pages 18–19: Images from *Ace Combat 6: Fires of Liberation*, courtesy of Namco Bandai. Copyright 2007.

Pages 20–27: Images from *Conan: Hyborian Adventures*, courtesy of Eidos and Funcom. Copyright 2008.

Pages 28–31: Images from *Battlestations: Midway*, courtesy of Eidos. Copyright 2007.

Pages 32–34: Images from *Beautiful Katamari*, courtesy of Namco Bandai. Copyright 2007.

Pages 35–37: Images from *Blacksite: Area 51*, courtesy of Midway. Copyright 2007.

Pages 38–42: Images from *Call of Duty 4: Modern Warfare*, courtesy of Activision and Infinity Ward. Copyright 2007.

Pages 43–46: Images from *FIFA '08*, courtesy of EA Sports. Copyright 2007.

Pages 47–52: Images from *Half-Life 2*, episodes 1 and 2, courtesy of Valve and EA. Copyright 2004–2007

Pages 53–61: Images from *Hellboy: The Science of Evil*, courtesy of Krome Studios and Konami. Copyright 2008.

Pages 62–75: Images from *Hellgate: London*, courtesy of Flagship Studios and EA. Copyright 2007.

Pages 76–83: Images from *Kane & Lynch: Dead Men*, courtesy of Eidos. Copyright 2007.

Pages 84–88: Images from *Killzone 2*, courtesy of Sony Computer Entertainment and Guerrilla Games. Copyright 2008.

Pages 93–95: Images from *Medieval 2: Total War*, courtesy of SEGA and Creative Assembly. Copyright 2006.

Pages 96–101: Images from *Mortal Kombat: Armageddon* and *Mortal Kombat: Deception*, courtesy of Midway. Copyright 2006 and 2004, respectively.

Pages 102–106: Images from *NBA Live '08*, courtesy of EA Sports. Copyright 2007.

Pages 107–109: Images from *Rampage: Total Destruction*, courtesy of Midway. Copyright 2006.

Pages 110–114: Images from *Reservoir Dogs*, courtesy of Eidos. Copyright 2006.

Pages 115–118: Images from *Ridge Racer 7*, courtesy of Namco Bandai. Copyright 2006.

Pages 119–120: Images from *The Sims*, courtesy of EA.

Copyright 2000–2006.

Pages 121–123: Images from *Sonic the Hedgehog: Next Generation*, courtesy of SEGA. Copyright 2006.

Pages 124–133: Images from *Stranglehold*, courtesy of Midway. Copyright 2007.

Pages 134–141: Images from *Team Fortress 2*, courtesy of EA and Valve. Copyright 2007.

Pages 142–146: Images from *Universe at War: Earth Assault*, courtesy of SEGA and Petroglyph Games. Copyright 2008.

Pages 147–151: Images from *Viking: Battle for Asgard*, courtesy of SEGA and Creative Assembly. Copyright 2008.

Pages 152–158: Images from *Warmonger: Operation Downtown Destruction*, courtesy of NetDevil. Copyright 2007.